A. B. C. of Chinese Painting:
Book 1
by
Ning Yeh

For fastest and easiest way to order this book and its listed supplies, please call:

OAS/Ning Yeh Art Studio
(714) 962-5189
(714) 969-4470
or
1-800-969-4471

Other books by Ning Yeh:
The Art of Chinese Brush Painting (First Album)

**An Album of Chinese Brush Painting:
80 Paintings and Ideas** (Second Album)

Chinese Brush Painting: An Instructional Guide (First Instructional Book)

Ning Yeh's Workshop Series 1 (12 Step-by-step Booklets)

First Edition, 1992
Copyright 1992 by Ning and Lingchi Yeh
Huntington Beach, California
Library of Congress Card Catalog Number: 92-93344
ISBN: 0-9617307-1-9
All Rights Reserved
Printed in Taiwan

A.B.C. of Chinese Painting

Book 1

An Easy
Step-by-step
Learn by Yourself
Instructional Manual

by
Ning Yeh

Preface

Five years ago, I wrote my first instructional book: *Chinese Brush Painting: An Instructional Guide*. The book is now in its fifth edition, and has been considered by many artists as one of the most helpful books. I am grateful for the outpouring of response and support from all corners of America. The book accompanied a very successful TV series which won an "Emmy" Award (Best Instructional Series).

This time, I shall publish the book first. There shall be a TV series later.

This is not a sequel to the first instructional book. It is a new beginning, or a better beginning. I think I have grown since the publication of my first instructional book.

I had a great time working these lessons; I love their simplicity, their matter-of-factness, and most of all, their sense of humanity which is shared universally by people who see things and interpret them as their friends. None of the lessons contain abstract concept or laws of beauty. Instead, everything is based on common sense. I like mountains who behave like a grandpa, three peaks greeting one another like sisters. I like trees posing to invite guests. I like flowers who show faces of ladies who are slightly drunk... Down-to-earth things warm my heart. I like them because they behave like we do.

I have enjoyed brush painting for more than 30 years. It is my fountain of youth. It helps me to lift up my spirit when I feel down, and carries my sense of celebration to a new climax when I am inspired. It provides constant challenge and, if I am lucky, instant reward. It offers me attainable goals, a vehicle to experience life and nature. It gives me fresh outlook and prospective. Above all, it is a lot of fun.

These lessons are the crystallization of a dream. A dream to bridge the old traditional and new modern spirit of China, the pragmatic Western technology and the romantic Eastern philosophy. I can sense the fruits of my hard labor joyously shared by my fellow passengers en route to the Silk Road.

A farmer went through a lot of trouble and finally was granted an ordinance to share his secret of ultimate joy with the emperor. The emperor received him one early winter morning. "Please come outside with me, Your Majesty," the farmer humbly requested. When all the officials went outside with the emperor, they found the farmer lying down on the stone block with his bare body under the morning sun. The farmer exclaimed: "Isn't this the ultimate joy!" Everyone laughed. But the emperor was moved. For he knew the farmer offered his best, and his willingness to share with his emperor was wholeheartedly, truly genuine.

Do not expect pictures of a bare body in the winter morning sun to be included in these lessons. There are still certain things I would not do (Twenty years ago, maybe).

I thank Mickey Jackson, who defies the relentless assaults I take on the English language, has the audacity to write a footnote after proofreading my last manuscript: "I forgot how delightful it is to work on your materials." Our very own Monica Vallejo at OAS has become my 24 hour Dictionary on the Phone. She has developed into an expert on Chinese art and culture.

My son Evan is now a senior at Berkeley. His attitude has changed from "My folks have this Chinese thing..." (As mentioned in my Red Book*) to seriously taking courses on Chinese history at Cal. His enthusiasm has been inspirational. The Cal teams have never won until this year, but he is having great fun playing for the Cal band. My daughter Jashin is almost 16. She has been very sweet in limiting the answering services role of her dad by occupying all the home phone lines continuously for hours. My wife Lingchi gives all her support both at home and at OAS. My family members are all active and well in Taiwan. Their support has always been vital to me.

A pot of wine among the flowers:
I drink alone...
I raise my cup to invite the moon to join me;
It and my shadow make a party of three.

Would you be my moon?

Ning

January, 1992

*I have nicknames for all my books:

The **Yellow Book** is my first album: *The Art of Chinese Brush Painting.*

The **Blue Book** is my first instructional book: *Chinese Brush Painting: An Instructional Guide.*

The **Red Book** is still my pride and joy: *An Album of Chinese Brush Painting: 80 Paintings and Ideas.*

The **Loose Book** is actually 12 separate instructional booklets, published in 1991: *Ning Yeh's Workshop Series 1.*

The **New Book** is this one: *A. B. C. of Chinese Painting: Book 1*, my second and most recent instructional book, needs a nickname.

Keys

This book is designed with detailed illustrations and easy to follow step-by-step methods. Of course, we will also learn together with laughter, humor and enthusiasm.

Lesson 1 explains all the materials needed and how to prepare them (except brushes). It offers a list of recommended basic materials. It examines various raw and sized rice paper, and shows examples of works done on different rice paper available from OAS (Oriental Art Supply). It includes a checklist on rice paper.

Lesson 2 explains the best Hard, Combination, and Specialty brushes. It details the ways to work with a brush: holding and preparing the brush, controlling the moisture, and loading the colors. It offers basic exercises and demonstrations for using Hard brushes (Happy Dot, Orchid Bamboo) for sharp lines; and Combination brushes (Flow, Large Flow) for fuller dots and shapes. A demonstration of landscape (Pine in the Moon), features Specialty brushes used in landscape and shading.

Lesson 3-10 offers step-by-step instructions on the Iris, Tulip, Poppy, Lotus, and Hydrangea. These wonderful flower studies provide a sound foundation for all other flowers.

Each subject begins with a finished *Art Work*. It is the objective of our lesson. We need to refer back to various elements of its composition constantly.

Each lesson starts with a list of materials. Study the *Setup Photo* to lay out your materials. The proximity of related colors helps the loading process.

Next, follow the Preparation section to prepare your paper and colors. Test each prepared color to match the special *Color Dots Chart* for each subject.

The spirit, idea, and elements of the subject are discussed. Then the exciting Steps section begins.

Based on the Art Work, the Steps section starts with a *Steps Diagram* which shows the sequence of the composition. Every element is identified by numbers or letters. The lesson proceeds through each element with detailed instructions.

It is helpful to practice the different elements a few times before we put the whole composition together. Use the same paper and colors for both practice and composition. This way, you know what to expect.

Every element is broken down into sample strokes with a *"Nitty-Gritty" Diagram*. See the stroke for color variations and shapes. Study the Nitty-Gritty Diagram to see the following:

The *sequence of strokes* within a shape:
Each stroke is numbered. The current strokes under study are diagramed in a different color than the previous stroke.

The *placement of the brush tip*:
A small red triangle suggests where the tip of the brush is pointed at the start of a stroke. If two red triangles appear in one shape, they represent the tip changing direction during the stroke (if I was awake at the time of drawing). This book could be named as the Search for Red Triangles. These little red devils have caused me many sleepless nights. I would be pretty upset if you would tell me "What Red Triangles?"

The *direction of the strokes*:
The movement of the stroke is done with a dark arrow.

Study the text with the sample stroke and its accompanying Nitty-Gritty diagram.

The text gives information on *the right brush* to use. It explains *how the different colors are loaded* into the tip of the brush. The sequence, the length (1/3 of the bristle, for example), and the intensity (weak, medium, strong, thick) of the colors are listed.

How the brush is held (vertical or tilted to certain angle) also is important. Usually, when we work on lines, the brush tip stays in the center with the brush held vertically. When we work on large shapes, the brush tip travels along one side of the shape with the brush held at an angle.

There is another consideration related to *how the brush tip travels*: At times, the brush tip travels all the way from the beginning to the end of a stroke. Other times, the brush tip may only reach certain portions of a shape. Since we often double- or triple-load the brush tip with different colors, how we manipulate the tip is crucial to the variation of colors within a shape.

Where we exert pressure affects the shape and the color variation of a stroke. In our text, you will often find the term "lowering the boom." It tells you it is time to apply the pressure down.

How the brush tip is formed makes a difference to the shape of a stroke. The brush tip usually is grouped to a fine point when we do a stroke. At times, the text will call to your attention that the stroke is done by having the tip split open.

If there are no immediate references, the assumption is that the information follows the previous diagram. The richness of information provided through the text, the sample stroke, and its accompanying Nitty-Gritty Diagram is unprecedented. Still, do whatever comes natural to you.

I had intended to focus this book on flowers, and end the book with 10 lessons. However, my love for landscape painting urges me to offer a starting point for my students who are enchanted by the misty, dream-like quality in the Oriental sceneries.

Lesson 11 offers a window for landscape paintings. It offers three exciting short subjects: Misty Mountains, Umbrella Ladies, and Farmer and Water Buffalo. Study is focused on shading (wash) to produce misty clouds and moody background. Students will work on sized rice paper. Recommendation for more topics is listed at the end of the lesson.

There are two special projects which are too wonderful to keep as family secrets. I share them as special bonuses in Lesson 12 and Lesson 13.

Lesson 12 shares the fascinating secret of a unique way to paint from the back side of Best Shuen rice paper. Using Oil Pastel as a resist, the lesson brings out the sensation of a winter wonderland.

Lesson 13 reveals a rubbing technique by utilizing the special merits of two opposite types of rice paper. It is breathtaking and remarkably easy.

I enjoy the spontaneity of my work. In a few minutes, a couple of strokes, a flower flourishes. It is done without a second thought, without a fixed plan, without pain... What a sensation. Could I leave it like that? Oh Noooo... Now comes the ultimate challenge; I have to share this. I have to recreate the spontaneity, to speak the unspeakable, to teach the unteachable. And... I think I have done a fair job.

When you complete a lesson, you will have a painting that both you and I will be proud of. But it is only the starting point. The work is good, but, it is studied. **You need to work 10-20 times to internalize the strokes. Then, you need to let go all the "should" and "should not" worries. That is when you will acquire the true spirit of this art.**

I learned early that my students appreciate well-organized information. I do not worry that people will be bound by my instructions. Many of you will do your own thing, because We are Americans.

Supported by years of classroom experience, a great selection of the best equipment and supplies through OAS, and tested with both beginning and advanced artists, these lessons are indeed "a piece of cake."

You will be led into a incredible artistic pursuit which will bring hours of enjoyment, immeasurable spiritual satisfaction, and most important of all, a series of masterpieces.

OAS, our mail order office, gets compliments for nearly every call it receives. People tell us that we are doing a great job in adding bright moments of inspiration and fun in their lives. They mention that, although there are many good art books around, few take the extra care in providing all the details in each of the steps. They enjoy the anecdotes, the philosophy, and humor which we share along with our lessons. They appreciate the fine quality of our materials and services, and the fact that everything comes directly "From Me to You."

Have a great time with these lessons, and thank you!

Ning

OAS

Mail order the Finest Equipment for Chinese Painting
Selected by Artist Ning Yeh

**P.O. Box 6596
Huntington Beach Ca. 92615
Tel. (714) 962-5189 (714) 969-4470
1-800-969-4471**

Contents

Preface
Keys

About Ning Yeh

LESSON 1
GETTING STARTED 1
Setup Materials & Rice Paper

STUDIO SETUP

Fig. 1-1 Material Set up on Your Table

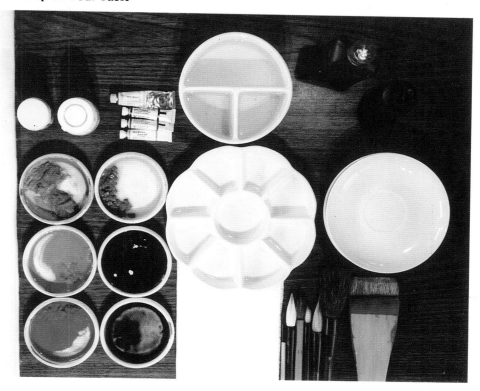

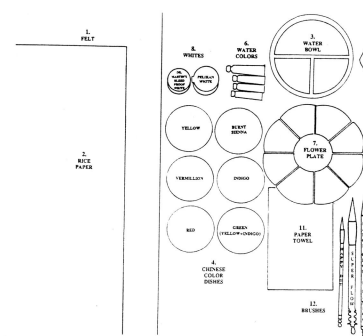

Fig. 1-2 Material ID

1. Felt
2. Rice Paper
3. Water Bowl
4. Chinese Color Dishes
5. Spray Bottle
6. Watercolors
7. Flower Plate
8. Whites
9. Ink
10. Saucers
11. Paper Towel
12. Brushes

Table and Chair

Chinese painting is done flat. Prepare a surface at least the size of a card table. I like a formica surface that is easy to clean, and an adjustable chair (or use a cushion). I prefer to stand to do large paintings.

Felt

We use felt under the rice paper to prevent excess moisture from staining the painting. I prefer light gray or white color, treated with Scotch Guard.

I carry a loose felt (24" x 36") to class and mount it onto the painting surface with masking tape. At home, I use a Fome-cor board and wrap the felt tightly all around it. When paint does get on top of the felt, I use a wet paper towel to wipe it off.

Water Bowl

The porcelain Water Bowl with 3 divisions is a space saver. I use the smaller sections for rinsing ink and colors, and the larger section for clean water. The OAS Water Bowl has a hollow center so the weight is light. It has rounded corners for easy cleaning. I use the large one at home and carry the small one to class (Fig. 1-3).

You can get by with two plastic containers, such as the ones for cottage cheese (If you can stand to swallow the contents). Do not use a tall container. You need to see how deeply the brush is dipping into the water.

Chinese Color Chips

The Chinese chips produce the best colors to use with rice paper. Some watercolor tubes or cakes are grainy and separate from water when working with rice paper. For best results, I strongly recommend the 5 basic chip colors: **Yellow, Vermillion, Indigo, Red**, and **Burnt Sienna** (Fig. 1-3).

Color Dishes

Each Chinese chip color needs a container so it can stay clean for repeated use. The porcelain "Color Dishes" in a set of 5 are the best containers (Fig. 1-3). They are light, but they do not shift when one mixes colors. They can be stacked up with a lid on top. Their graveled edge is great for wiping off excess moisture. The larger ones are better since they have more area left for blending.

Spray Bottle

Choose a pump spray bottle that produces a fine mist (like hair spray or perfume spray). We use the spray bottle to wet the colors and occasionally to prepare paper for shading wash.

Putting Color Chips in Dishes

Four colors: **Vermillion, Indigo, Red**, and **Burnt Sienna** come as little square chips in little boxes. Pour the entire package into a dish (We use a lot of Vermillion and Indigo, I suggest 2 packages for each color). Tilt the dish so the chips can gather to one side. Use a spray bottle, or put 3 or 4 drops of water onto all the chips. The chips will glue onto the dish when they are dry (Fig. 1-3).

To produce the colors, simply re-wet the chips and work the colors with a brush. These chips last a long time; they are the most economical watercolors.

The **Yellow** comes in chunks. It is by far the best color to work with indigo to produce all necessary greens for our flowers. Try to keep the Yellow as solid pieces. Small pieces can get on your brush and create a mess. Soak the yellow in a dish for a few hours. Eventually, it becomes soft like clay at its bottom. You can press and flatten the chunk in line with the height of the dish. Re-wet the Yellow chunk when you prepare to paint with 3-4 tablespoonfuls of water. Wait for 10 minutes or longer, then blend the softened Yellow into the water.

Fig. 1-3 Water Bowls, Color Dishes, and Flower Plates

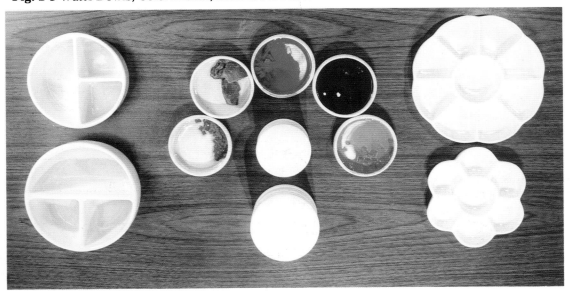

When Yellow liquid is blended in its original dish, pour the liquid into another dish if needed, stop pouring when the liquid starts to show impurities. Our flower lessons will need ample Green. Prepare a dish of Green by adding Indigo into the Yellow (Fig. 1-4).

Fig. 1-4 Preparation for Chinese Yellow and Green

Q: How come there are things growing in my Yellow?
Yellow is extracted from a special plant called Ocean Rattan. It is an organic matter. When it is wet and placed in a sealed area, fungus will grow. The color is still good, just rinse the surface.

Do not ask this question of your teacher anymore; it only shows that you have not been practicing.

Q: How come my Indigo has an unpleasant smell?
Indigo is a vegetable; farmers pile it up and keep it moist. When it gets rotten, it becomes the most beautiful indigo color. Rotten vegetables do smell bad. Do not put your nose too close to the color. For the sake of beauty, a little smell is tolerable.

Next time, when a critic says that your painting stinks---you know what he is talking about.

Watercolors
Use watercolors fresh. Check the material list for each lesson.

Flower Plate
I use a porcelain Flower Plate (Fig. 1-1, 1-3) for additional Western watercolors. It is a space saver, of proper weight and is easy to clean. The slated surface creates a shore area for the colors and helps to prevent overloading.

It is helpful to study the various colors used in each lesson and **arrange the colors in the suggested sequence**. Since we often double or triple load our brush with different colors, we do not have to jump all over the place trying to look for the next color.

White
There are two kinds of White used in our lessons. Pelikan's concentrated designer color 730/50 (or OAS White) is a treasure

that produces the smoothest White and works wonders with all the other watercolors. It comes in a jar or in a tube. The watercolor Chinese White does not have the body. Other poster whites do not work well with rice paper. We also use Dr. Martin's Bleed-proof White for center (pollen) dots for flowers. It has a rich body to capture the viewer's attention.

Ink
Traditionally, we produced ink by grinding an ink stick with water onto a slate (ink stone). It was a mentally calming exercise. Now, the Japanese have perfected the ready-made bottled ink; it is easy to use and carry. The **OAS Best Bottle** surpasses the ground ink in both its velvety quality and richness. These days, we go for instant tranquility.

Saucers
I keep a stack of white saucers with smooth, flat surfaces. I use one for ink, and the others for mixing and wash. We can work easier with our wide wash brush by using a flat saucer.

Paper Towel
Prepare a roll of very absorbent paper towel. Fold a couple of sheets under a plate. We use it for wiping off the excess on our brush, for testing colors, and for grouping the brush tip.

Other Accessories
Optional accessories include: A pair of scissors, paper weights, masking tape, a brush stand, and a book stand.

BASIC MATERIAL RECOMMENDATION LIST

Item	Recommendation
Felt	24" x 36" gray or white
Water Container	OAS, large size or equivalent
Chinese Color Chips	Yellow (2), Indigo (2), Red, Vermillion (2), B. Sienna
Color Dishes	OAS, large set or equivalent
Watercolors	Tubes, Winsor Newton\Koi see each lesson
Flower Plate	OAS, large or equivalent
White	Pelikan (jar or tube), and Dr. Martin Bleed-Proof
Ink	OAS: Best Bottle
Above Items Available	**at OAS**
Spray Bottle	Fine mist, (like Vitalis Pump Spray for men)
Saucers	4 or more white, flat ones
Paper Towel	Absorbent type (like Job Squad)
Other Accessories	Optional

RICE PAPER

We do Chinese painting on absorbent rice paper. It presents the most dynamic qualities of brush strokes. It also captures the most spontaneous color blending. Other paper allows wet colors to stay on the surface; they become flat and lose spontaneity.

Absorbency is the most crucial factor in determining what rice paper to use. The **raw** rice paper is the most absorbent. With the addition of sizing, the paper becomes less absorbent.

The sizing does not change the appearance of the paper. Most Chinese artists use their tongue to test one corner of the paper. The raw paper allows the moisture to go through completely, while the sized paper allows the moisture only partially through or not at all.

When you go to the Orient, you can show your expertise in a paper studio and impress some people. I'd pick up the left corner, since most Chinese are right-handed, God knows how many tongues have gone through the right corner.

Based on absorbency, the rice papers can be listed from **raw** to **sized** in this order: Best Shuen > Rub > Practice Roll> Colored Shuen > Double Shuen > Cotton > Ma > Jen Ho > Glass.

Raw Paper for Spontaneous Strokes
Best Shuen & Double Shuen
The raw Shuen paper is most popular in China (Shuen is the founding village of this paper). It is the most sensitive paper. The artist needs to double or triple load colors with different intensity, working each stroke decisively and allowing different parts of the brush to work with the paper. The paper cheerfully displays all the variations in transparent fluidity and original spontaneity.

These are truly the most honest papers. You cannot work over a stroke, for the paper will tell the whole world---even a hundred years from now.

This is what Chinese brush painting is all about. Why does one need more if the first chance is really the only one? The rhythm of a stroke is a happening, a serendipity. It comes out of the brush naturally. God created a Half Dome and left it alone. It became the symbol of Yosemite National Park; God did not go back to make it into a Full Dome, and everyone thinks it is good. If you go back to change a stroke, you are admitting that you have made a mistake; then it can only be worse.

Best Shuen
I do flower paintings on Best Shuen. It shows the maximum range of color variations. Each shape shows lively motion and transparency. The vitality of colors it captures is incomparable. It is truly the best paper for flowers (See Fig. 1-5, 6).

Double Shuen
I have asked my friend--the paper master--to reinforce the Shuen paper to double its thickness. It's now called the Double Shuen. It is mistake-proof. Easy to use and to mount with its thickness and reduced absorbency. It is now the most popular paper for **flower** and **animal** paintings (See Fig. 1-7, 8).

Fig. 1-5 Lotus Painting on Best Shuen

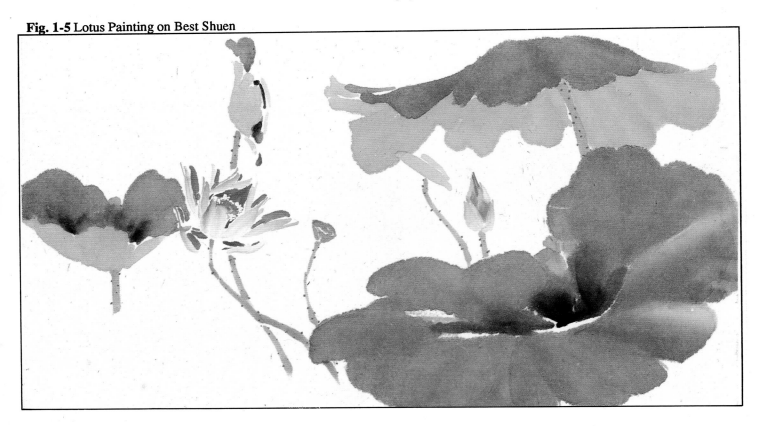

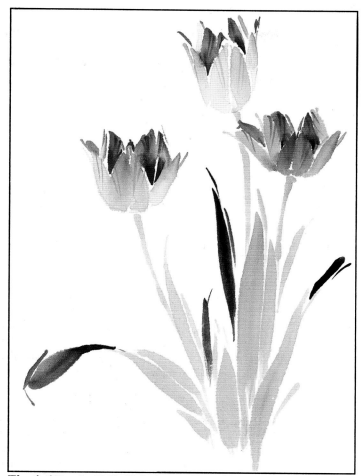

Fig. 1-6 Purple Tulip Painting on Best Shuen

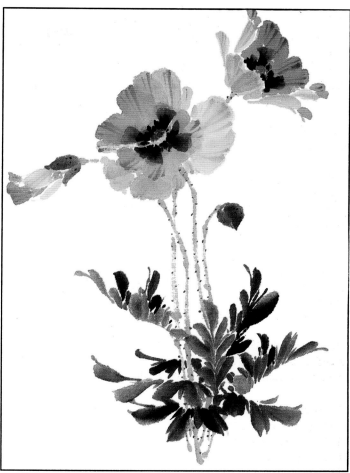

Fig. 1-7 Drunken Poppy Painting on Double Shuen

Fig. 1-8 Hydrangea Painting on Double Shuen

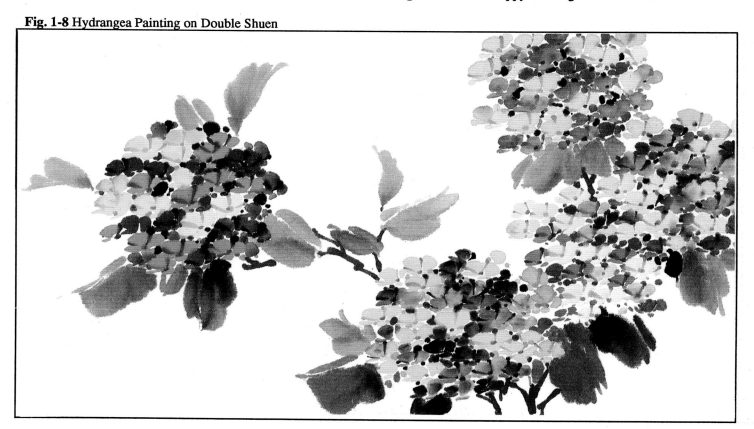

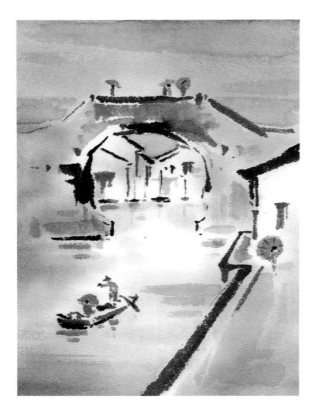

Fig. 1-9 Suzhou's Rain (Venice of the East), on Cotton Paper

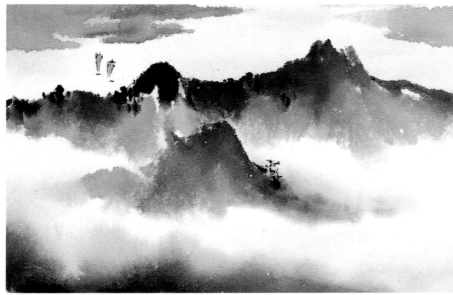

Fig. 1-10 River Beyond Misty Mountains, on Cotton Paper

I usually start my students with Double Shuen. Eventually, artists who enjoy flower painting should take advantage of the Best Shuen. Compared to the Double Shuen, **working with Best Shuen requires you to use much less moisture, more intense colors and faster speed.**

Practice Roll
The Practice Roll is a machine-pressed paper that has an absorbent nature similar to Double Shuen. It comes in a continuous roll. It is convenient to use for practice. However, it does not have the fine quality and texture of the hand-made Double Shuen paper.

Sized Papers for Washing & Shading
Cotton
Let's face it, some students simply cannot stop going back to fix a stroke or adding more color to a painted shape. According to my observation, about 1/4 of my class have shown the intention, with about 1/10 actually daring to try in front of me. Some did not show any sign of guilt or remorse.

I have suggested hypnotic therapy to some repeat offenders. Alas, can one stop Sylvester from thinking about Tweety Bird? This is a free country. A teacher neither can induce psychologic terror nor exercise corporal punishment.

Cotton paper is coarse and less sensitive. It is more forgiving. When a stroke is wet, one can go back and alter or add. It is also less expensive. However, Cotton paper does not give the velvety shine like work done on Shuen paper.

Compared to Shuen, Cotton paper is tougher. When it is wet, the paper can take repeated strokes and produce even shading without showing streaks.

I like to use Cotton paper to do simple scenes which require shading or wash. The paper renders an interesting textured quality for strokes. The semi-absorbent nature of the paper makes shapes softer. Background shading and mist are easily accomplished by wetting the paper. See Fig 1-9, 10.

I sometimes draft complicated scenes with Cotton and put it underneath my painting paper. Since rice paper is thin, one can see through it and follow the draft.

Ma and Jen Ho

The two most useful sized papers are Ma and Jen Ho. Sizing is added to reduce the absorbent nature of the raw paper and to allow the repeated application of colors and strokes.

I use Ma paper to do my figure studies. It gives a special texture for my line work. It is wonderful for capturing light shining through hair.

I use Ma and Jen Ho interchangeably for most of my landscape paintings or anything that requires a shaded background. Both Ma and Jen Ho are tougher than Cotton. For more complicated compositions which require repeated shading and wash, I rely on Ma or Jen Ho.

Jen Ho Paper is great for the particular misty quality of Oriental scenery. It is partially made of pineapple fibers. It is the paper I grew up with.

Ma is white; Jen Ho is off-white. Ma is a better paper than Cotton, although in appearance it is hard to tell them apart.

The following four paintings are done on Jen Ho paper (they can also be done on Ma paper with similar results). These are part of a series of instructional booklets entitled "Ning Yeh's Workshop Series 1." Each lesson offers an exciting project from start to finish.

Fig. 1-11 Roses in a Vase, on Jen Ho Paper

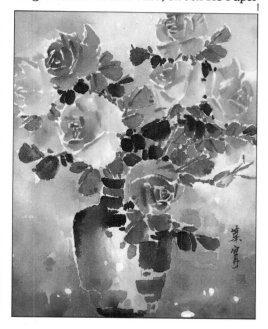

Fig. 1-12 Autumn in the Park, on Jen Ho Paper

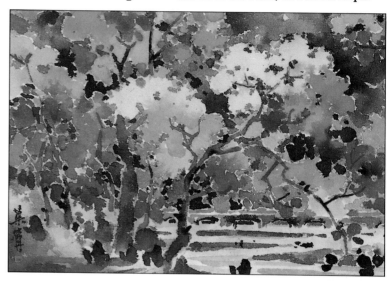

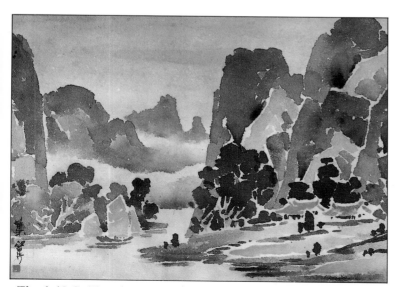

Fig. 1-13 Guilin Mountains, on Jen Ho Paper

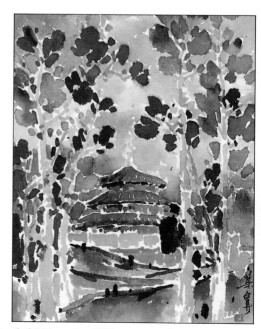

Fig. 1-14 Temple of Heaven, on Jen Ho Paper

Specialty Papers
Glass and Rub
There are two very interesting papers I use together for special projects (See Lesson 13). One is called Glass. Glass paper is fully sized, and it does not allow moisture to go through. It does not wrinkle when it is wet.

Another paper is called Rub. Rub paper is very absorbent, tough, yet very smooth. In my special project, I paint on Glass paper. Since it is non-absorbent, the colors stay wet and float on the surface of the paper. I place the Rub paper on top of the wet Glass paper and press. The Rub paper absorbs the image on the wet Glass, meanwhile creating some added texture.

Fig. 1-14 Waterfalls: Painting on Glass Paper

Fig. 1-15 Mirror Image of Waterfalls absorbed by Rub Paper

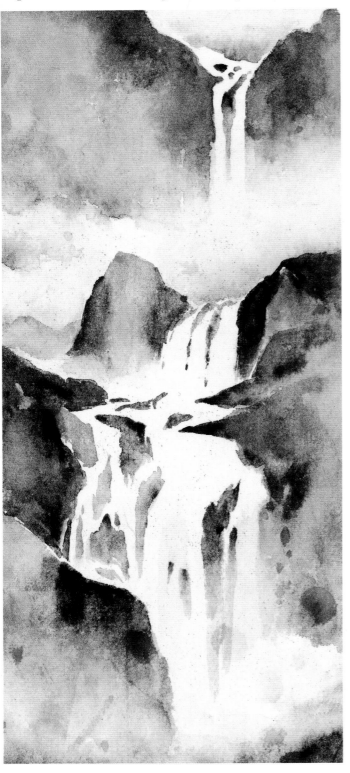

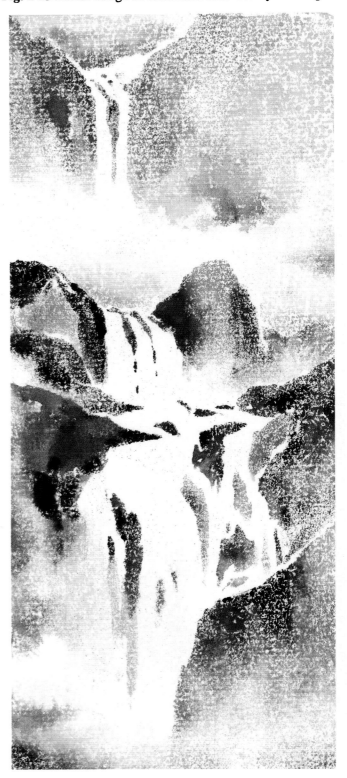

Colored Shuen

There are four different colored Shuen papers. I use them mostly to do flowers, especially white flowers. These are single-layered Shuen paper which is dyed into Brown, Rose, Olive, and Jade colors.

They offer exciting contrast to light-colored florals, or a more muted background for dark-colored subjects (Fig. 1-16).

Fig. 1-16 Paintings on Colored Shuen: Mum (on Brown), Hydrangea (on Olive), Lotus (on Jade), Poppy (on Rose)

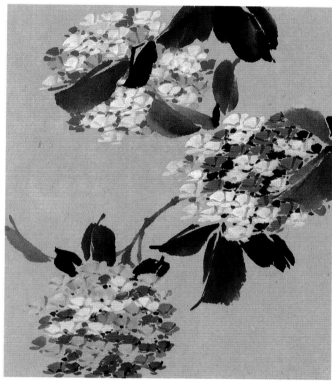

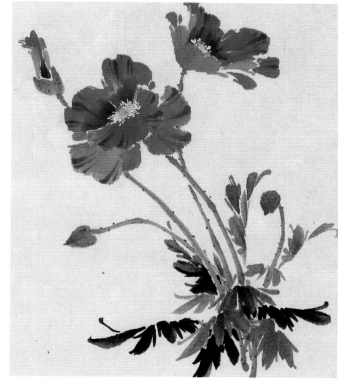

How to Handle Rice Paper

It is hard to identify the different rice paper. I mark each sheet of the paper at the corner with pencil--the name of the paper and the date, since paper different periods may have some minor variation. We need to realize that each sheet of hand-made paper is basically different. The paper may come as full sheet (24" x 48" or larger) package, if you order a large quantity. Mostly, it is cut into smaller sheets (approximately 18" x 24") and comes in a roll (The Practice Roll comes in a continuous roll).

Develop a large folder to keep your paper, with sections to separate the different types of paper. Flatten the paper by reversing the roll, and keep the sheets in the folder.

Do not fold the paper, for the crease will interfere with your strokes. However, occasionally, an artist may deliberately crease the paper to create a natural texture for mountains, rocks, and trees. After mounting, all the creases will be flattened. The viewer can only see the wonderful spontaneous texture and wonder how the artist achieved such results.

I have always admired Cheng Bam-chow's orchid blades, and tried in vain for many years to get that special variation of pressure within a blade which his works show so well. I finally had to resign to the fact this late Ming Dynasty artist was a gifted genius whom I could never emulate. A few years back, I was collecting rice papers in different studios in the Orient, I had to fold them in haste. When I tried orchid blades on the folded paper, there they were---the Bam-chow blades in my dream. I began to realize that Cheng was not a very neat person. How could someone who was drunk half of his life, getting hurt constantly from falling off his little mule, be able to keep his paper flat?

We always try to paint on the front side of the paper. It is the smoother side. If you cannot tell which side is smoother, then it does not matter. Both sides of the paper produce the same result anyway.

I am always impressed with students who take the initiative to experiment with the same subjects on different paper. Of course, some are simply in perpetual confusion. Chinese things do develop in the States in peculiar ways. Just think of Chop Suey. Every road leads to Rome, if you know how to go about it. And, I intend to show you.

After the painting is done, rice paper becomes very wrinkled. We need to go through a wet mounting process to paste the painting onto a **Mounting** paper and flatten it through stretching.

My first instructional book, <u>Chinese Brush Painting--An Instructional Guide</u>, offers detailed steps for mounting in the last chapter. There is also a video tape made for the lesson. Our paintings look at least 10 times better after they are mounted.

The right paper is most essential. In the first 10 Lessons, we stay with the raw paper. You should get several Double Shuen Large Rolls and/or Best Shuen Rolls. Use a Practice Roll if you like to keep the cost down. My suggestion, however, is to practice with the paper you intend to do a masterpiece on, so you know the paper well.

From Lesson 11 onward, we'd like you to work on a variety of paper. I have asked OAS to prepare an Assorted Roll of different rice papers used in these lessons. Still, do consider each paper in separate rolls. I do not think you need to prepare for possible boo-boos. You just want to do more masterpieces.

OAS RICE PAPER CHECK LIST

	Collection	
PA	Assorted Roll (7 types: Double Shuen, Best Shuen, Cotton, Ma, Jen Ho, Rub, Glass, 2 sheets each)	Must
	Raw Paper	
P1	Double Shuen Full Sheets (10 Sheets, 27"x54")	Large Painting
P1P	Double Shuen 100 Sheets Package (27"x54")	Best Buy
P2a	Double Shuen Small. Roll (13"x27")	Go with Artist Set*
P2b	Double Shuen Large Roll (18"x27")	Must, Most Useful
P10	Best Shuen Full Sheets (10 Sheets, 27"x54")	Large Painting
P10P	Best Shuen 100 Sheets Package (27"x54")	Best Buy
P10A	Best Shuen Roll 12 Sheets (18"x27")	Lesson 12, and 3-10 (optional)
P3	Practice Roll	Economical
	Sized Paper	
P12	Cotton Full Sheets (10 Sheets, 24"x48")	Large Painting
P12A	Cotton Roll (12 Sheets,16"x24")	Lesson 11,12,13
P6	Ma Full Sheets (10 Sheets, 30"x54")	Large Painting
P6A	Ma Roll (12 Sheets,18"x30")	Landscape, Lesson 11
P5	Jen Ho Full Sheets (10 Sheets, 24"x48" or more)	Large Painting
P5A	Jen Ho Roll (12 Sheets,16"x24" or more)	Landscape, Lesson 11
	Specialty Paper	
P18A	Glass Roll (12 Sheets,18"x27")	Special Project Lesson 13
P19A	Rub Roll (12 Sheets,18"x24")	Special Project Lesson 13
P4B	Brown-Color Shuen Roll (12 Sheets,18"x27")	For Variety
P4J	Jade-Color Shuen Roll (12 Sheets,18"x27")	For Variety
P4O	Olive-Color Shuen Roll (12 Sheets,18"x27")	For Variety
P4R	Rose-Color Shuen Roll (12 Sheets,18"x27")	For Variety
P7	Mounting Paper (10 Sheets)	Must

*Artist Set is the equipment used in the TV Series "Chinese Brush Painting with Ning Yeh," and Ning's other instructional book.

LESSON 2
GETTING STARTED 2
Brushes and Demonstration of Basic Strokes

BRUSHES

We use **Hard** brushes for sharp lines and pointed shapes, and **Combination** brushes for fuller strokes and shapes.

Often, I hold the hard brush vertically and use its sharp tip, and hold the combination brush at an angle and use its side. When loading it with different colors, the combination brush gives me shapes with beautiful color blending.

Best Hard Brushes
See Fig. 2-1.
These brushes are valued for their sharp tips and bouncing resilience. I use hard brushes for lines and sharp pointed shapes.

Best Oversized Hard Brush
Dragon
The Dragon is a super size treasure made of sable and other tough bristles, used to do big, bold leaf strokes.

Best Small Hard Brush
Happy Dot
The Happy Dot is an absolute delight, a brush so well-designed that it does all fine lines and dots with extreme ease and delicacy. It is a dream brush for all artists for painting and calligraphy.

Best Medium Hard Brush
Orchid Bamboo
The best all-purpose brush with bouncing resiliency, the Orchid Bamboo's tough hair comes from the tail of the Yellow Wolf in the cold region of Manchuria. The name highlights its incomparable delivery of the blades of orchid and bamboo.

Best Large Hard Brush
Large Orchid Bamboo
A hard brush supreme, the most versatile, the Large Orchid Bamboo can handle all the blade-like, pointed shapes. It can do all the strokes the Orchid Bamboo can, but it can also handle larger strokes.

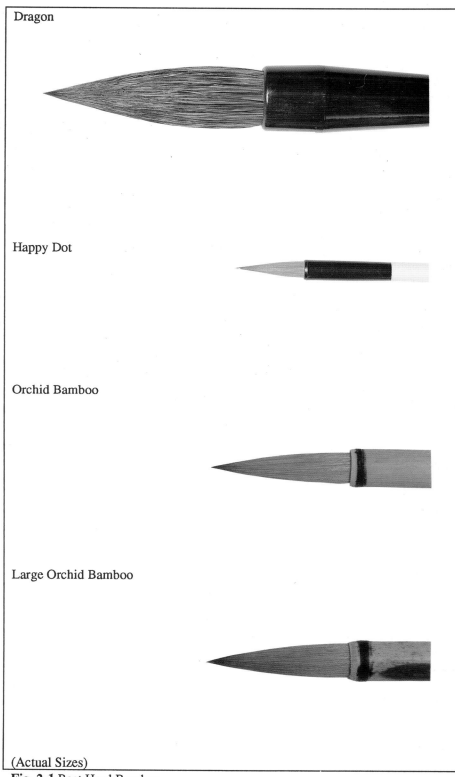

Dragon

Happy Dot

Orchid Bamboo

Large Orchid Bamboo

(Actual Sizes)

Fig. 2-1 Best Hard Brushes

Best Combination Brushes

See Fig. 2-2.

The Combination brushes are made of mixed hair. The center is formed with hard bristles, surrounded with soft hair outside for more absorbency.

The OAS Flow series are the best combination brushes; each brush is made of 24 types of animal hair:

Best Small Combination Brush
Flow
An exquisite brush for line, dot, and calligraphy, its flexibility allows more variety and interest in forming shapes. The tip of this brush has a spirit of its own. It adds character to all lines and dots. It works well with small elements for all kinds of painting. A wonderful brush for branches, small petals, pollen, and small birds.

Best Medium Combination Brush
Large Flow
The best brush for flower and animal paintings, this brush offers a wider range and sensitive flexibility for delivery of fuller lines and shapes. It has been a secret weapon in my family's generations of fame. It handles the full shapes of leaves, petals, animals, and birds.

Best Large Combination Brush
Super Flow
The largest brush among the Flow series, the Super Flow works well with large shapes.

We should have Happy Dot, Large Orchid Bamboo, Flow, and Large Flow Brushes in order to enjoy the full benefit of the lessons offered in this book.

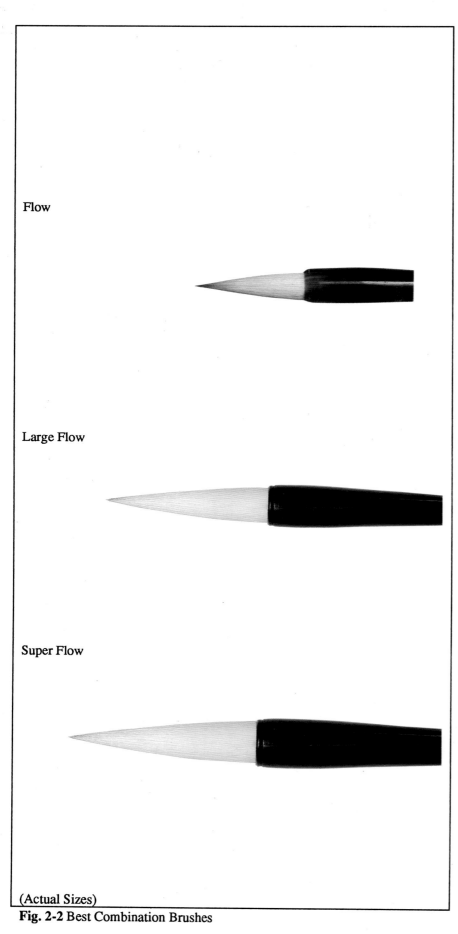

Flow

Large Flow

Super Flow

(Actual Sizes)

Fig. 2-2 Best Combination Brushes

Specialty Brushes
See Fig. 2-3.
Best Detail
This brush is used to do fine lines and small dots. I use it to save the fine point of my Happy Dot Brush.

Best Detail

Mountain Horse
Used for tree trunk, rock texture, and hair for figure studies, this "punk hair"-like brush is the toughest. Special texture is created by using the brush dry, with its tip splitting, and chipping the paper.

Mountain Horse

Landscape
Smaller and more pointed than the Mountain Horse, the Landscape brush can handle similar tasks on a small scale. It is also a good brush for lines and calligraphy. The brass ring makes the brush last forever.

Landscape

Wash
I use a 2-1/2" wide flat brush for background shading.

Wash

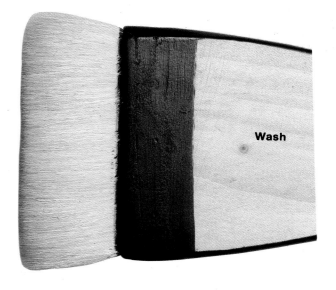

Wash

(Actual Sizes)

Fig. 2-3 Specialty Brushes

CHECK LIST FOR BRUSHES (OAS)

	Best Quality	
H1C	Best Small Hard: Happy Dot	Must
H2C	Best Med. Hard: Orchid Bamboo	Optional
H2d	Best Large Hard: L.Orchid Bamboo	Must
	Best Extra Large Hard: Dragon	Optional
C2c	Best Small Comb: Flow	Must
C2d	Best Medium Comb: Large Flow	Must
C2e	Best Large Comb: Super Flow	Optional
	Specialty	
H1a	Best Detail	Optional
H1b	Landscape	Optional
H2f	Mountain Horse	Optional
F1	Wash 2.5"	Must

Q: Can I use watercolor brushes to do Chinese painting?
The Chinese brushes are constructed differently. The center portion of the bristles are shorter and the rim longer. When the brush is wet, the outside rim comes to the middle and forms the point. The tip of a good Chinese brush has a spirit and vitality designed especially for the vertical execution of the strokes. (All these big words...the answer is no.)

Q: I have this beautiful set of brushes from China. Can I use them to paint?
You may try one. I do suggest that you get a Happy Dot and a Large Flow brush to compare. I fear that many of our students are frustrated by using the set of brushes brought back by relatives who visited China. The brushes looked beautiful when the vendors passed them through the bus window. But just keep them as souvenirs.

Considering the countless hours you spend on the enjoyment of practicing Chinese painting, one really should get the right equipment. Value your time and effort. You will do wonderful work with our instructions.

Q: I have the OAS Artists Set; can I use the brushes in the set to do the lessons in this book?
You can use the Idea Brush as your hard brush. Compared to the Orchid Bamboo, the Idea Brush is shorter and has less resiliency. The Idea Brush and Orchid Bamboo Brush use the same Yellow Wolf tail. The Orchid Bamboo is the tail end portion where the hair is tougher and longer; the Idea uses the top portion where the hair is softer and shorter.

You can use the Flower and Bird (dark bristle) Brush as your combination brush. Its size comes in between the Flow and the Large Flow. It does not have the same responsiveness as the Flow series.

Q: What is a Soft Brush, and what is it used for?
Most likely what you get from most Oriental shops are the soft brushes. They may be white, made of goat hair; or brown, made of rabbit hair. They do not have the "bounce" needed for painting strokes. They are used in Chinese character writing. I

include a large soft brush in my Artist's Set for bamboo trunk studies. It is inexpensive, and it looks great.

Brush Preparation and Care
A new brush comes with a cap to protect the bristles. This cap is useless after you have put the brush to use.

Soak the bristle portion of a new brush in cold water until the hairs becomes unglued. The brush is then ready to use.

After painting, rinse the brush with water. Wipe off the excess water with a paper towel, and regroup the tip back to a fine point. When the brush is dried, store it in a holder, wrap it with a bamboo screen, or hang it up if the handle comes with a loop.

WORKING WITH THE BRUSH
Holding the Brush
Use the first section of your thumb and index finger to hold the middle section of the brush handle. Maintain the handle in a vertical position.

Slide the middle finger downward from the index finger so that its first section presses against the front of the handle.

Bring the ring finger to the back of the brush handle, with the base of the nail pushing against the handle. Place the small finger next to the ring finger. The small finger need not make contact with the handle of the brush. See Fig. 2-4.

Fig. 2-4 Correct Finger Positions

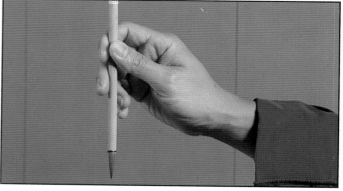

Preparing the Brush (Controlling the Moisture)
Let us use a sheet of Double Shuen to learn how to work with our brush. Hold your Large Flow Brush, and let us begin.

Please follow this procedure every time you start to paint. Soak the entire bristles, then wipe dry on a paper towel. Make sure all the hairs are straight and group into a point.

At this point, I usually ask my students to squeeze the body of the brush from the root of the bristle to the tip. If there is more than one drop of water being squeezed out, it means the student has not wiped off the moisture properly. I suggest the student to punish him\herself.

In watercolor painting, colors are easy; it is the proper use of water that is hard, and it is particularly important when one is using the very sensitive rice paper.

After drying the brush and forming the tip, we will load the proper moisture. The length to be submerged into water rarely exceeds half of the bristle length. It is important to be able to observe how deep you are putting the tip of the brush in the water. Dip the tip (about 1/3 of the length) into water 2 to 3 times. Get rid of the excess moisture by stroking the bristle at the edge of the water bowl.

In the initial practice of a lesson, try a few strokes on rice paper only with water. By isolating the moisture, one can truly see whether the brush is too wet or too dry. Altering the speed may also help.

Let us load the brush with moisture. Place the handle diagonally and allow the tip of the brush to point to nine O'clock. Set the brush tip down on the paper with pressure, and do a shape by using the side of the bristle to move from the top down with the same pressure.

We now begin to realize that the brush has its natural limitations. At best, only half of the total length of the bristle is in contact with the paper; if you press harder, you simply lose control of the tip area of the brush.

Now you know why we do not want to load water more than half way up, because the top half of the brush simply does not get involved with the making of the stroke or shape. If the body of the bristle gets too wet, the excess moisture will only be a menace to what the brush tip wishes to accomplish. Remember, we always want a wet tip, rarely a wet body.

Color Degrees

I use the terms weak, medium, strong, and thick to describe the intensity of the colors. They can be tested as follows, using Chinese Red as an example: See Fig. 2-5.

Fig. 2-5 Intensity of Colors

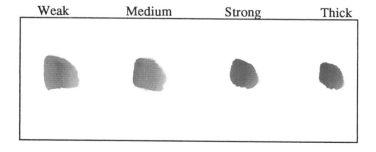

| Weak | Medium | Strong | Thick |

Condition of the Colors

We will go through extensive discussion at the beginning of each lesson on how to prepare our colors for each subject. In general, we need to keep the strength of all the colors in order to present their vitality and richness and to show contrast.

For Chinese Chips

Use a spray bottle (fine mist, like hair spray---stay away from the industrial size bottles) to wet the Chinese chips (Except Yellow, which always needs to be soaked for a while). I usually pump about 3-4 times on each of the chip colors. The moisture never forms a wet pool in the dish; it just makes the chips wet and become softened. If you put too much water, tilt the dish to let the chips stay on the shore area. We do need to occasionally re-spray to keep the chips in a moist condition.

For Watercolors

Use all the watercolors fresh from the tubes. I use my finger to blend my watercolor to keep its thickness. This practice is macho and distasteful for ladies with proper upbringing, especially when one sticks out one's middle finger. I suggest softening the watercolor with a slightly wet brush.

All the colors are kept in pasty to creamy condition, except Yellow, Green, or colors, which are intended to be diluted or used for shading purposes.

Loading the Brush

At the beginning of each subject, I will show you what color, how strong (weak, medium, strong, and thick) that color is, and how deep the color (1/2, 1/3...length of the bristle from the tip) is to be loaded into the brush. We usually load the weaker color first and allow it to go into the bristle at the deepest length. The successive colors are thicker and shorter on the bristle.

The spontaneous blending of contrasting colors within one stroke is one of the most exciting features of Chinese brush painting. It makes every petal vital with velvety shine. Even when the colors dry, they still seem to be in perpetual motion.

Let us use the Large Flow brush, wet Vermillion and Red colors, and do a loading exercise on a piece of Double Shuen paper.

When I say: "load 1/3 medium Vermillion + 1/6 thick Red..." I expect you to do the following:

1. Wet and dry the brush, then touch the tip of the brush with water 2 to 3 times, and stroke off the excess moisture.

2. Load Vermillion onto the tip of the brush, up to about 1/3 of the length of the bristle.

The fractions such as 1/3, 1/6, etc...are very loose measurements of the length of the brush bristle from the tip upward in relation to the total length of the bristle. Please do not use a ruler to measure these things. On occasion, you shall find something like "1/32" kind of fraction. Take that, Sir Newton; it simply means the very tip point. I failed my math in school terribly; that is why I am an artist.

3. Get rid of the excess moisture by stroking the bristle at the edge of the color dish (do this after every loading).

A

B

C

D

Fig. 2-6 Color Loading

I'd like you to work a stroke on a piece of Double Shuen paper now. Do the same stroke after each of the loading steps to study the result.

Hold the brush at a 45 degree angle with the tip pointing to the left (9 o'clock). Set the brush tip down on the paper with pressure, and do a shape by using the side of the bristle to move from the top down with same pressure. You see that the Vermillion is on the left and water on the right side of the stroke. There is a sharp division between the two. See Fig. 2-6 A.

4. After loading the color, press the tip of the brush on a saucer and stir a little to mix the color with the moisture on the brush. I call this "blending the tip." Consider water is the lady, color is the gentleman; the blending is their marriage ceremony.

Although Vermillion is of medium strength, we still will load the color strong at the tip. As you blend the tip on a saucer, the moisture on the tip will soften the intensity of the color.

During the blending, you will find the color has moved up and faded into the upper portion of the bristle. This is what we want, a man and a woman in love. Now do a stroke. You see the transition between the color and moisture is smoother. The shape division has disappeared. See Fig. 2-6 B.

5. Reload strong Vermillion into about 1/6 length of the bristle (1/2 of the first loading).

After the blending, the color is no longer strong. It is like after the marriage, the guy has lost his personality somewhat. In painting, this is easily correctable by reloading the guy to boost up the color at the tip.

6. Blend the tip again. At this time, I usually go around the classroom and check on the students' saucers. I need to find two Vermillion patches. One larger (the first blending), and one smaller (the second blending). In other words, you should not press the tip as much as on the first blending. The tip color stays stronger than the color that has worked into the body. This way, the variation can occur within one color. Try one stroke. See Fig. 2-6 C.

7. Load the brush tip with thick Red up to 1/6 the length of the bristle. The Red is in a pasty condition.

8. Blend the tip. Reload the thick Red up to 1/12 the length of the bristle, and blend the small area of the tip again on the saucer. Now do a stroke to see how wonderful is the result. See Fig. 2-6 D.

When you blend the tip on the saucer, you should make sure the Red is softened. The tip should feel smooth, rather than feeling like it is stuck in the mud. When colors are not softened, they merely stay on the surface of the rice paper, not absorbing into the paper. When you mount your painting, the thick color will bleed.

In summary, load each color according to the suggested length of the bristle from the brush tip (such as 1/3, 1/6, 1/8 etc.); get rid of the excess moisture by stroking the bristle at the edge of the plate (do this after every loading). Mix the colors by pressing the tip on a saucer and blending a little after each loading. Each color can be loaded 2 to 3 times, each time stronger and at a shorter length on the tip. Add tip colors when needed after each stroke.

BASIC EXERCISES

Brush painting is made up of lines, shapes, and dots (which are actually small shapes), all working with the space.

Let us wet the Indigo, Vermillion, and Red chips, prepare the Yellow, pour some Yellow out, and mix a little Indigo into the Yellow to make a dishful of Green.

I'd like you to use a sheet of Double or Best Shuen Paper, and work a few strokes with me.

Sharp Lines (Hard Brushes)
We do line work by relying on the tip of the brush. We usually hold the brush vertically. When drawing, we try to keep the tip of the brush traveling in the middle of a stroke.

Orchid Leaves
Load the Happy Dot (or one of the Orchid Bamboos for larger blades) brush 1/2 length with ample Green to the point that the bristle body expands a little. Load the tip 1/4 with thick Indigo, blend the tip.

We can begin a stroke with no pressure, add a little pressure as we move along, then taper into a fine point at the end of the stroke. Use your arm to move the brush, maintaining the vertical position of the brush. Do a few more, reload Indigo at the tip each time, and enjoy the beautiful color changes within each stroke. These are the Grass Orchid leaves. See Fig. 2-7 A.

Orchid Flower (Demo)
Load the Happy Dot Brush with 1/3 medium Green + 1/16 thick Red; blend the tip. Do the petals of a grass orchid. Add the stem. Then reload the brush with 1/4 thick Red; add a couple "Happy Dots." See Fig 2-7 B.

Bamboo Leaves (Demo)
Let us use one of the Orchid Bamboo Brushes. Use the same colors as the orchid leaves to do this exercise. We can land the stroke with pressure and lift the pressure off as we end the stroke. Let us do a few more. Keep the brush tip in the middle of the strokes. These are the Bamboo leaves. See Fig. 2-7 C.

The orchid and bamboo studies are not to be taken this lightly. For extensive lessons on these subjects, see <u>Chinese Brush Painting: An Instructional Guide</u>, by Ning Yeh., pp. 12-57.

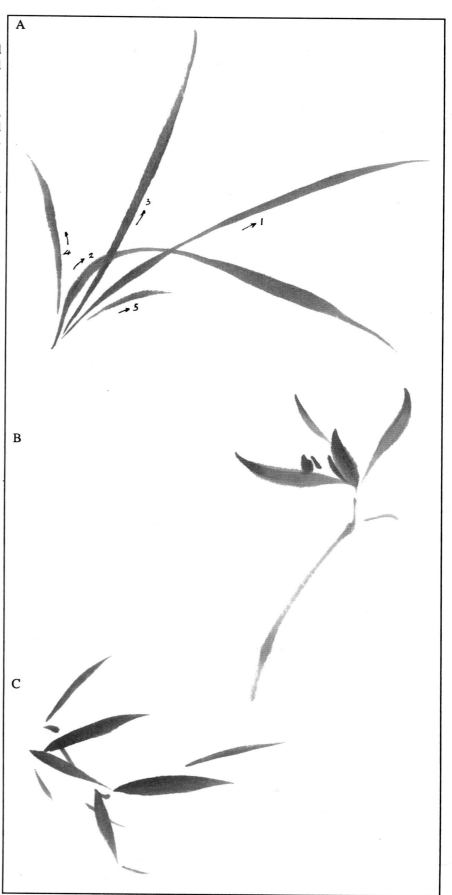

Fig. 2-7 Basic Line Work, Orchid and Bamboo with Hard Brush

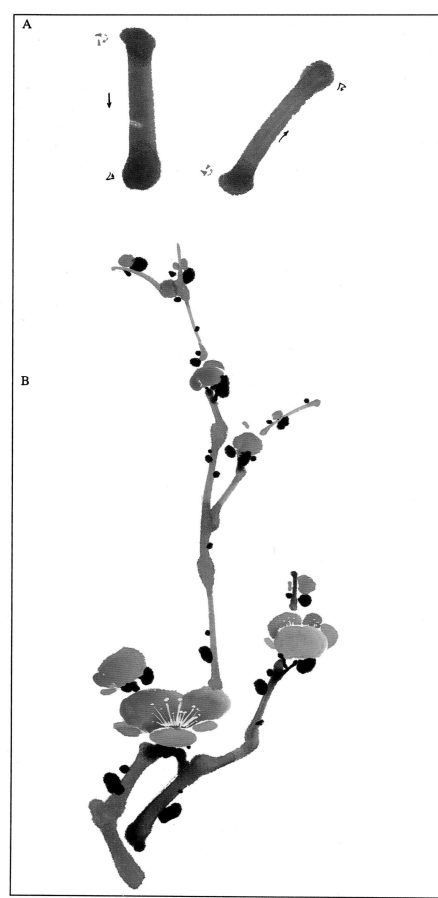

Fig. 2-8 Bone Strokes and Dots, Flow Brush

Bones & Dots (Flow Brush)

Bone Strokes

Dilute Vermillion into a medium puddle, add a drop of Ink, blend the mixture into a transparent and Dark Brown.

Using the Flow Brush, let us practice a couple of "Bone" strokes. You'll notice we've changed the brush. For sharp blades and fine lines, we use the Hard Brush (Happy Dot or Orchid Bamboo), but for full body strokes, we use the Combination Brush (Flow).

In a downward movement, point the brush tip at 9 o'clock and settle the pressure. While keeping the pressure, swing the direction of the tip a 1/4 clockwise turn (the tip should split open and bend upward). Let go of the pressure slightly and forcefully move the stroke down with even pressure. End the stroke by exerting a little more pressure and allowing the brush tip to travel along the base of the stroke from left to right, then lift upward. See Fig. 2-8 A.

The tip placement at the beginning and the tip traveling at the end of the stroke are done to square the ends. The initial 1/4 turn is done to allow the tip to be spread evenly in the center of the stroke rather than staying along one side. Simply put, all the line work must be done by allowing the brush tip to travel in the middle of the stroke. The reverse lifting at the end gives added strength.

Now, move the bone stroke upward. After settling the tip, swing it 1/4 counter-clockwise. Move the stroke up; settle the pressure, allowing the tip to travel along the top side; and then lift the tip with a downward motion. See Fig. 2-8 A.

We can use a series of interconnecting bone strokes to do branches, accenting them with "Happy Dots." See Fig. 2-8 B.

Plum Blossom (Demo)

Flower Petals: Use Flow Brush
with Vermillion, Red, and Crimson;
Stamen: Happy Dot Brush
with Bleed-proof White;
Pollen: Happy Dot Brush
Bleed-proof White with Yellow;
Branches: Flow Brush
Vermillion mixed with Ink;
Calyx and Dots: Flow Brush
Crimson with Ink.

Shapes (Large Flow Brush)

When we work on a large shape, we rely on the body of the brush much more. We frequently have the brush handle tilted to allow more body contact with the paper. A Combination Brush does shapes best.

As we load various colors, we concentrate the colors mostly at the tip area of the brush. Rarely do we push the colors more than 1/3 into the length of the brush bristle. Therefore, if we press the brush bristle down more than 1/3 of the way when we paint, the moisture, after the colors, will show at the end of a shape. This is the key to developing transparency and variation within a shape.

A Leaf

Let us use the Large Flow Brush. Dip the tip in the water a couple of times and stroke off the excess along the water bowl. Load 1/3 medium Green + 1/4 strong Indigo; blend the tip.

Hold the brush at 45 degrees with the tip pointing to 10 o'clock (the little triangle shows the angled direction of your brush tip). Begin with no pressure. Work the stroke by gradually lowering the pressure while pushing the tip to travel sideways in a small curve (like ﹖), increase the pressure then lift by scooping the tip to the right in a larger curve (like ↘).

When pressure is fully exerted, more than half the length of the bristle body is in contact with the paper. Lift the tip upward to the right, allowing the tip to complete the lower portion of the "S" curve. But do not let the tip travel too far to disturb the right (top) side. The top side remains a smooth curve.

This is the key stroke in flower painting. If you do it right, you can do hundreds of other flowers successfully (Relax, if you cannot get it, settle with what you've got; it will come to you in a big way. At worst, you still can do landscapes later).

Hold the brush vertically. Wrap the existing stroke with another smaller stroke, we now have a leaf. See Fig. 2-9 A.

Iris (Demo)

Using the Large Flow Brush, work the key stroke in different directions. Using 1/3 medium Vermillion + 1/6 strong Red as dark shade, and 1/3 diluted Pelikan White + 1/6 strong Vermillion as light shade; now we can do an iris. See Fig. 2-9 B.

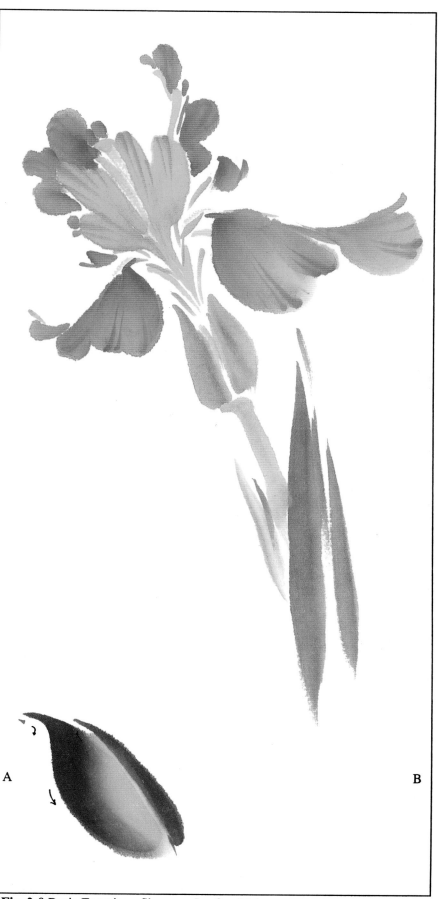

A B

Fig. 2-9 Basic Exercises: Shapes, a Leaf and Iris

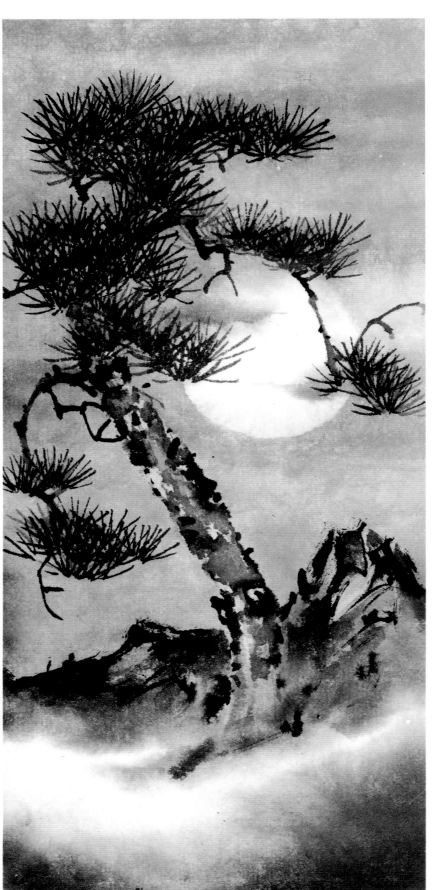

Landscape and Shading : Pine in the Moon (Demo)

Material
Paper: Ma
Brushes:
Happy Dot: Needles
Mt. Horse: Trunk, Branch, Rock
Large Flow: Mountain, Area Shading
Wash: Background
Colors
Chinese
Vermillion
Winsor Newton
Prussian Green, Charcoal Gray, Winsor Emerald, Winsor Violet, Cobalt Blue
OAS
Ink (OAS Best Bottle)

Preparation
1. Vermillion---Wet the chips, soften the chips with water, and keep the color strong.
2. Dark Green---Use 1/3 Prussian Green to 2/3 Charcoal Gray; develop a thick, pasty dark green.
3. Light Green---Dilute Winsor Emerald to a medium consistency and add a little Dark Green.
4. Purple---Mix Vermillion with Winsor Violet. Dilute to a medium wash. Keep in a separate saucer.
5. Cobalt Blue---Dilute to a medium wash. Keep in a separate saucer.
6. Ink---A tablespoon, in a saucer.
7. Dark Brown Mixture---Mix Vermillion with Ink; keep the mixture strong.

Steps
Needle Cluster
Happy Dot Brush
Dark Green for the main clusters, Light Green for lighter clusters, Ink for shadow clusters.

Branch & Trunk
Mt. Horse Brush
Medium Dark Brown first; add ink to accent.

Rock &Mountain Slope
Mt. Horse Brush (Rock), Wash Brush (large area) with Large Flow Brush (area near the trunk)
Light Green + Dark Green + Ink

Background
Wash Brush
Cobalt Blue, Winsor Violet, Dark Green and Ink

Fig. 2-10 Pine with Moon, Mt. Horse & Wash Brush, on Ma Paper

LESSON 3
IRIS (BEARDED)
Blue Butterfly

ART WORK
Fig. 3-1 Bearded Iris

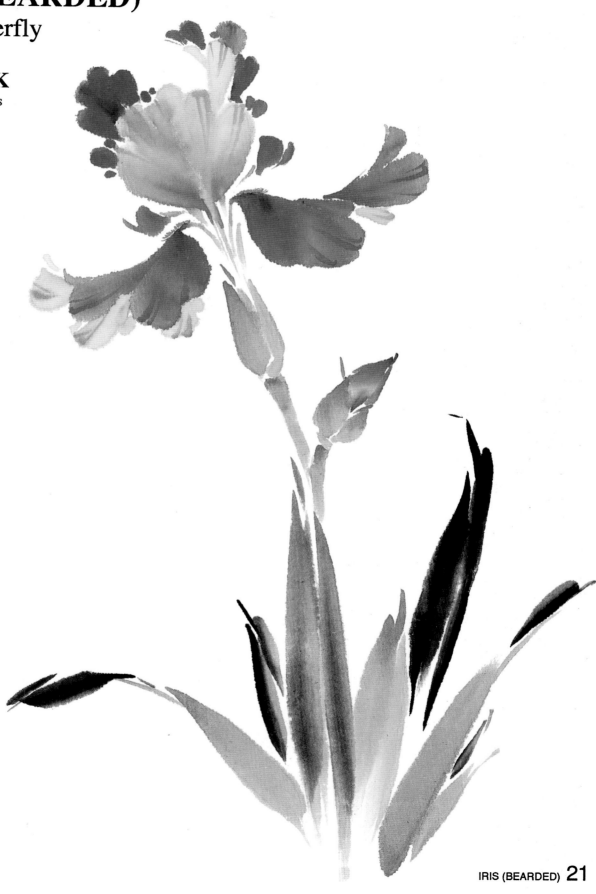

Fig. 3-2 Material Setup

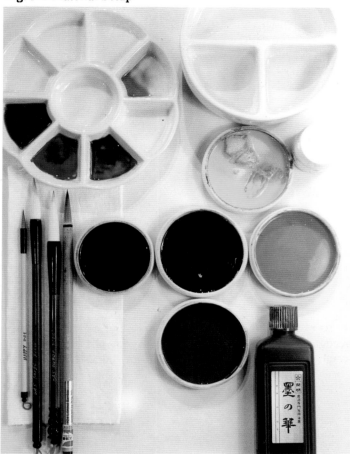

Fig. 3-3 Material ID

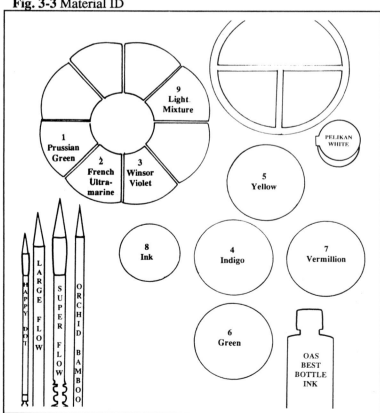

MATERIALS

For best results, use the following recommended materials (available at OAS)

See Fig. 3-2 and follow the preparation steps.

Rice Paper
Best Shuen or **Double Shuen**

Best Shuen offers more lively, vivid color variation. When using Best Shuen, colors should be thicker, we need to use less moisture on the brush, and move the stroke faster. Double Shuen is safer, and trouble free.

Brushes
Happy Dot: Veins, Beard Dots, Trumpets
Large Flow: Petals, Calyx, Bud
Orchid Bamboo: Tongues, Center Dots, Stems
Super Flow or **Dragon**: Leaves
(**Super Flow** and **Dragon** are the ultimate brushes for large leaves. If you do not have them, use Large Flow or the largest brush you have).

Colors
Chinese
Yellow
Indigo
Vermillion

OAS
Ink (OAS Best Bottle)

Winsor Newton
Prussian Green
French Ultramarine
Winsor Violet

Pelikan
White

See Fig. 3-3 to identify the materials.

Treasure your OAS brushes; they are the finest for brush painting, especially for these lessons. Each of the brushes is specially made and labelled. Some students seem to carry a lot of brushes for status or sentimental reasons and find themselves in perpetual confusion. Bundle up the unnecessary brushes. Put them in respectable but hard to reach places. When you get your pearl mixed up with a bunch of fish eyeballs, it is tough to find it in time for the party.

PREPARATION

Rice Paper
Best Shuen or Double Shuen, about 18" x 27"

Colors
Test prepared colors on Double Shuen to match Color Dots Chart (Fig.3-4).

Fig. 3-4 Color Dots: (On Double Shuen)

1 Pru. Green		6 Green	
2 F. Ultramarine		7 Vermillion	
3 Winsor Violet		8 Ink	
4 Indigo		9 Light Mixture	
5 Yellow			

Use an inexpensive brush (like OAS Basic Hard Brush) to prepare colors.

1. Prussian Green (P. Green)
Squeeze about 1/4" inch long, fresh from the tube (If unspecified, the amount of watercolors squeezed out from the tube each time is about 1/4"), into one pocket of the Flower Plate. Dilute it into a transparent, weak puddle (very light). Make about two tablespoons.

*Color name abbreviating is used in this lesson: Prussian Green is P. Green. French Ultramarine is Ultramarine, etc.

2. French Ultramarine (Ultramarine)
Use fresh (about 1/2" long), and place the color next to P. Green in one section of the flower plate. Soften it with one drop of water and a slightly wet brush. Keep it strong. I use my finger to blend my watercolor to keep its thickness.

3. Winsor Violet (Violet)
Put it next to the Ultramarine. Also put the same amount in the opposite side of the Flower plate to be used with Green for leaves. Soften them with one drop of water. Keep the color strong.

4. Indigo
Wet the chips (use a spray bottle or brush) with 2-3 drops of water; keep it thick.

5. Yellow
Soak Yellow chunks with 3-4 tablespoons of water for at least 10 minutes; blend softened Yellow into water, keeping the mixture strong. Pour the liquid into another saucer to drain out particles.

6. Green
Pour about 3 tablespoons of Yellow into a saucer. Add a little Indigo into Yellow, and blend into Green. Keep the mixture (Green) strong.

7. Vermillion
Wet the chips; keep it thick (moist, but no puddles).

8. Ink
Fresh; pour about 1 tablespoon into a saucer.

9. Light Mixture
Mix diluted Pelikan White with Violet. Soften the mixture into a light wash.

IDEA OF IRIS

The bearded Iris is the hero among Irises. Its blossom extends up to 6 inches across with the stem up to 4 feet in height. It is very important to project height to show the elegance of the plant.

Blessed with the colors of the rainbow, the Iris has long been recognized as the dancing spirit of spring. Its soft, fluttering petals remind the Chinese people of butterfly wings and swallows swinging in the spring breeze.

The flower is linked to one of the great romantic love stories in Chinese folk culture: The Butterfly Lovers (Please see my Red Book---An Album of Chinese Brush Painting: 80 Paintings and Ideas, pp. 88-89).

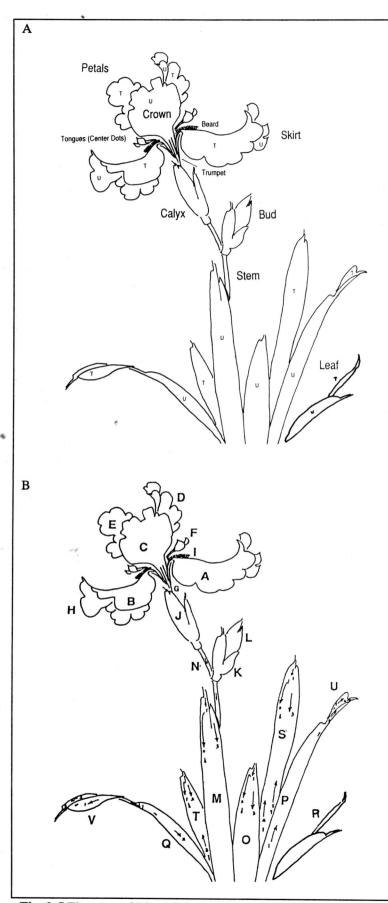

ELEMENTS OF IRIS

See Fig. 3-5 A.

Petals

Petals are soft with ruffled edges and noticeable veins. The topside (T) is darker, and the underside (U) is lighter.

Skirt: Three large shapes form a skirt drooping from the center (One is hidden in this composition).

Crown: Three shorter shapes arch back and upwards to form a crown on top.

Tongues (Center Dots)

Three females are hidden under light-colored tongues with their ends splitting upwards (center dots).

Beard

This consists of a prominent Vermillion-colored series of hairs with happy male dots, extending from the inside along the center line of the skirt petals. Cover about 1/5 of the total length of the petals, directly below the hidden females.

Trumpet

The joining root of the petal forms the trumpet.

Calyx

This is a sheath near the base of the flower, the bud, and the splitting joints along the stem.

Bud

The bud is large, sharply pointed and darker than the flower.

Stems

The stems are formed of thick, sturdy shoots from the center of the leaves to house the flower and the bud.

Leaves

Sheathing each other near the roots, the leaves are sword-blade shaped. The topsides (T) are darker and the underside (U) lighter.

STEPS

See Fig. 3-5 B.

The letters show composition steps in sequence. The full flower begins with petal A. The flower is tilted, above 1/4 length of the paper and off-center to the left. Do the bud next. Work Leaf M to establish the root, and lead the stem (N) into the leaf. Proceed to do the rest of the leaves.

Fig. 3-5 Elements of Iris and Composition Steps

Full Flower

Skirt Petals

Use the Large Flow Brush. Load 1/2 (length of the brush bristle) weak P. Green + 1/3 strong Ultramarine + 1/4 strong Violet + 1/8 strong Indigo; blend the tip.

Although each petal may be ruffled, its shape should not be fragmented. Arrange a dominant shape near the root, and taper and elongate at the tip. Present a continuous "S" curved center vein (bone) along the top edge of the petal. Do not let your flower suffer from arthritis.

Right Side Skirt Petal

See Fig. 3-6 A.
Stroke 1 develops the direction of the petal; its topside becomes the start of the center vein of the petal.

Hold the brush at 45 degrees with the tip pointing to the left about 10 o'clock (the little red triangle shows the angled direction of your brush tip). Begin with no pressure. Work the stroke by gradually lowering the pressure while pushing the tip to travel sideways in a small curve (like 〉), then lift the pressure by scooping the tip to the right in a larger curve (like ↘). Do not let the tip travel too far to disturb the right (top) side.

Ideally, the stroke should have a smooth, tilted curve on the topside, a reversed "S" curve on the lower side and a full body with smooth color transitions from dark to light.

Stroke 2 overlaps with stroke 1. Together, they form the dominant shape. Many antsy students tend to start the second stroke too high in relation to the first stroke and make the petal rigid. Just remember to slide down along the shoulder of the first stroke a bit, then start.

By now I trust that you have learned to study where each stroke begins.

Stroke 3 slides down further; it is short and serves as a liaison.

Stroke 4 is elongated. Do Stroke 5 to end the shape and extend Stroke 6 to show the tip of the petal. They form the guest shape.

Add Stroke 7 to show a handle, to lead the petal into the trumpet.

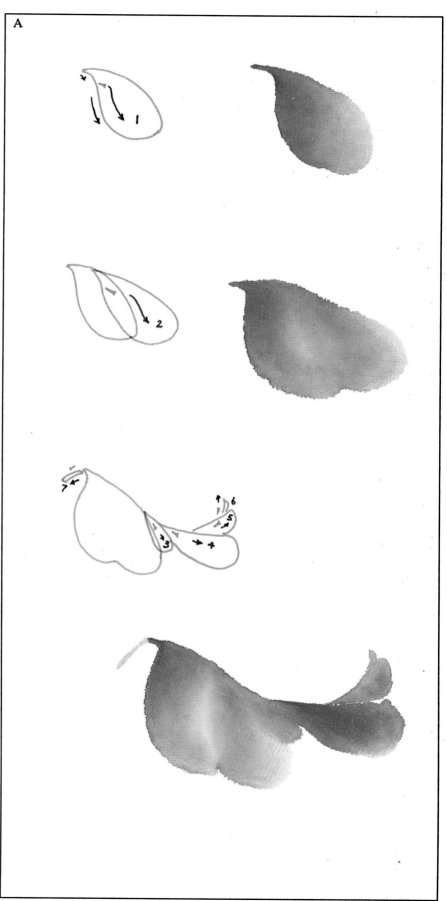

Fig. 3-6 Right Side Skirt Petal (A)

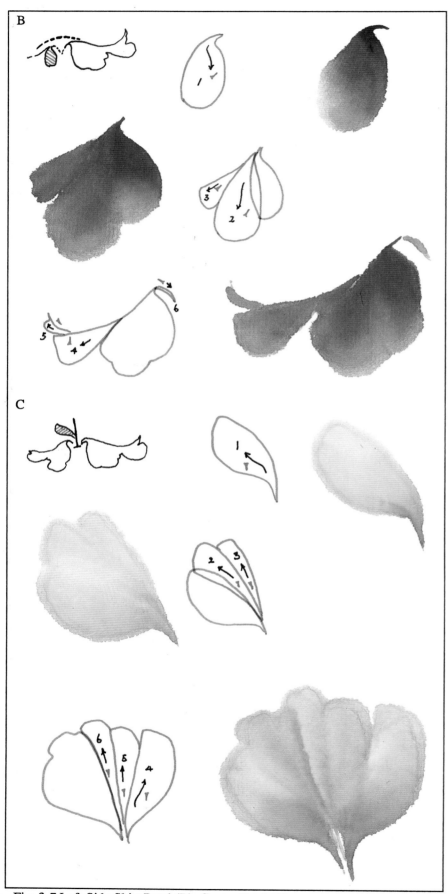

Left Side Skirt Petal
See Fig. 3-7 B.
Use your fingernail to project a nice arch following the first skirt petal. Often students tend to make the two petals too much into a straight line.

Leave ample space between the petals so you have room to show the turning of the petals as well as the trumpet.

Reverse the angle by slanting the brush handle to the left about 45 degrees; the brush tip is pointing at 2 o'clock. Let the tip travel along the right side of the stroke. Do Stroke 1, heading downward vertically. Proceed to work the rest of the strokes (2-5) by sliding down. Then lead the stem (6) downward.

Change size, angle, and shape so the two petals are not identical (host and guest).

Since I am a right-handed painter, usually my left side elements are the designated guest.

Crown Petals
See Fig 3-7 C, Fig. 3-8 D, E..

Be sure the direction of the crown is centered and anchored vertically in relation to the horizontal span of the skirt petals.

Center Petal
See Fig 3-7 C. The petal resembles a fully extended peacock tail. It is facing inward with its backside showing. We do this petal with light colors.

Rinse the Large Flow Brush. Load 1/3 weak Light Mixture (Diluted White + Violet), tip 1/8 medium Ultramarine and Violet; blend the tip.

Tilt the brush handle about 45 degrees to let the tip point at the artist (you). When pushing outward, the tip travels along the lower edge of the stroke.

Start from the lower left, with a series of overlapping strokes; line the starting points of each stroke straight vertically to form the center vein. Reload the brush and do the other side, starting from the lower right. Vary the width to show variation.

Fig. 3-7 Left Side Skirt Petal (B), Center Petal (C)

Right Side Crown Petal

Right Side Crown Petal
See Fig. 3-8 (D).
The petal is folded with its body arched back; both the underside and the topside are showing.

The Underside
Load the brush the same as above (C); show the petal root (Stroke 1) to the right of the center petal. Use a couple of strokes (2, 3) above the right side of the center petal, and link their left sides to form an arch.

The Topside
Load the brush the same as (A), with each color at a shorter length on the tip of the bristle (Since the petal is short, loading colors too deeply into the brush will prevent variation).

Work groups of dots (4-13) to show a ruffle-edged petal. They work best when the brush tip is slightly split open. Begin these dots by edging along the painted underside; leaving a hairline space between the two sides to prevent colors from bleeding into each other.

Push the dots outward by aiming the brush tip always to the root of the petal, so that all the dots are coming from the same source (fishes-looking-for-the-same-food rule).

Left Side Crown Petal
See Fig. 3-8 E.
Use a group of dots (1-10) to show a full petal facing us. Bring the petal almost as high as the petal on the right side. Load the brush the same as the topside of the crown petal on the left. Work the dots with the brush tip slightly open (nip the tip of the bristles a little bit). Settle the brush along the edge of the center petal. Exert pressure at the start of each dot to make the base fatter. Push the dot outward following the "fish" Rule, lowering the pressure as they go out.

Check whether your dot is done right: follow both sides of the dot and visualize the meeting spot. If the spot does not reach the root area of the petal, add a couple of strokes on both sides of the dot to fatten the root of the dot (see shaded areas 2 and 3 on both sides of dot 1). If you do not correct the width of the root now, the additional dots will be farther off. Some of us let the brush tip travel all the way up. The petal has no variation, since only the tip color is shown. Remember to lower the boom.

Add the stem (11) of the petal on the left side near the root of the center petal.

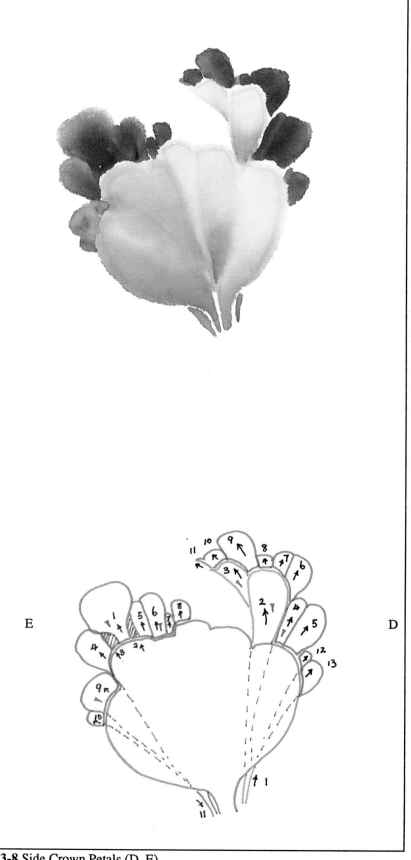

Fig. 3-8 Side Crown Petals (D, E)

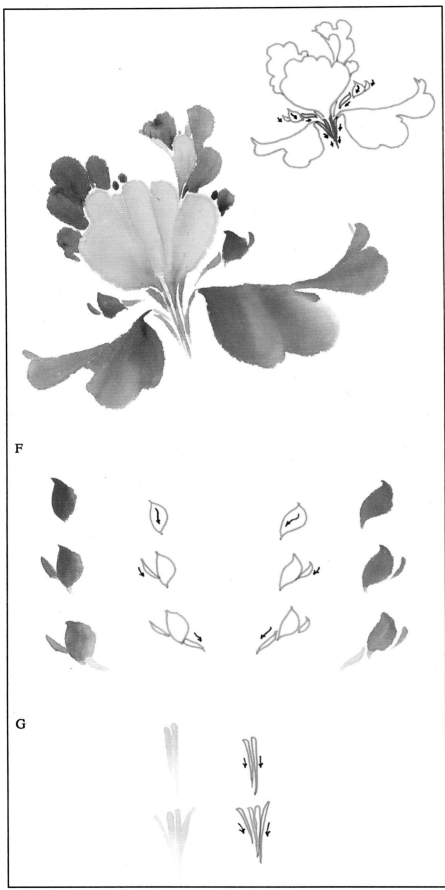

F

G

Fig. 3-9 Tongues, Center Dots (F), Trumpet (G)

Tongues or Center Dots
See Fig. 3-9 F.
A pair of dots represents the splitting ends of the tongue, are located above the beard. Use the Orchid Bamboo Brush. Load 1/4 P. Green + 1/8 strong Ultramarine + 1/8 strong Violet; work a set of parallel dots on each side.

Do leave a little space above the skirt petal for the beard. Move the dots outward a little so there will be room for the tongue. (Notice the "V" space between the Crown and the Skirt; put the dots on the top side of the "V").

The motion of the larger dots is similar to that of making quotation marks. A little scoop, then release the pressure by showing the tail of the dots leading to the root area of the petals. The hard brush has better bounce; it produces a cuter tail. The Orchid Bamboo Brush is the best hard brush. Do the larger dot, then pair it with a smaller, moon-shaped dot. Let the smaller dot end into the larger one.

Rinse the tip of the brush, but keep the tip dry. Load a little Light Mixture (diluted White + Violet); add the tongue line above the tail of the dot. Lead the dots into the root of the flower.

It is best not to completely tuck the line into the root. Have the line fade earlier with the suggestion that it continues into the root.

Trumpet
See Fig. 3-9 G.
Use the Happy Dot Brush and keep the tip dry. Load a little Light Mixture (diluted White + Violet); work two strokes following the roots of the center crown petal. Taper the pressure and allow the strokes to join at one point at the end. It is best to let one go longer, and let the others end into it.

Add two more strokes, underneath the stem of the skirt petals on both sides. Make them end into the center lines.

The trumpet is necessary but insignificant. Do not let it become too important. It should carry the weight of the flower in a balanced way.

Veins

See Fig 3-10 H.

Veins are optional. They can easily ruin your petals if they are not done right. Veins must be done under the following conditions: when the petal is still wet, use a dry Happy Dot Brush and load the same colors you used for doing the petals (only stronger or slightly darker). Do them selectively, grouping them into clusters showing host and guest; follow the pattern of the strokes. Lead them toward the root of the petal.

Start them along the edges of the petals. Land heavier, then lift the pressure as you move the brush swiftly to show energy.

If the petal is dried, veins can be done a little wet. Otherwise, keep the brush dry and the colors strong. The best result is a slight blending of veins into the wet petals. Timing is important. Sometimes you need to add veins after each petal is drawn to take advantage of the wet condition.

Underside of the Skirt Petals

See Fig. 3-10 H.

Use the Large Flow, load 1/2 with the Light Mixture (diluted White + Violet), tip 1/8 medium Ultramarine and Violet, and blend the tip. Keep the tip split; add some clusters of dots underneath the skirt petals to show an occasional underside (In the spirit of Marilyn in "Some Like It Hot").

A third skirt petal may be added behind the trumpet, showing in light underside colors. In this composition, however, the implication is that it is hiding behind one of the skirt petals. Should it be visible, it should be done after the calyx of the flower is drawn.

Beard

See Fig. 3-10 I.

Use the Flow Brush (or the Best Detail, or the ultimate--Happy Dot Brush). Wet the bristle; towel dry to form a fine tip. Dip the very tip into water. Then, load strong Vermillion at the tip; blend the tip.

Draw the fine lines from the top downward. Start from the middle of the cluster; notice they become shorter as they move inward toward the center and become gradually tilted as they reach outward. After the front layer is formed, add a few in the back to form the suggestion of a second layer.

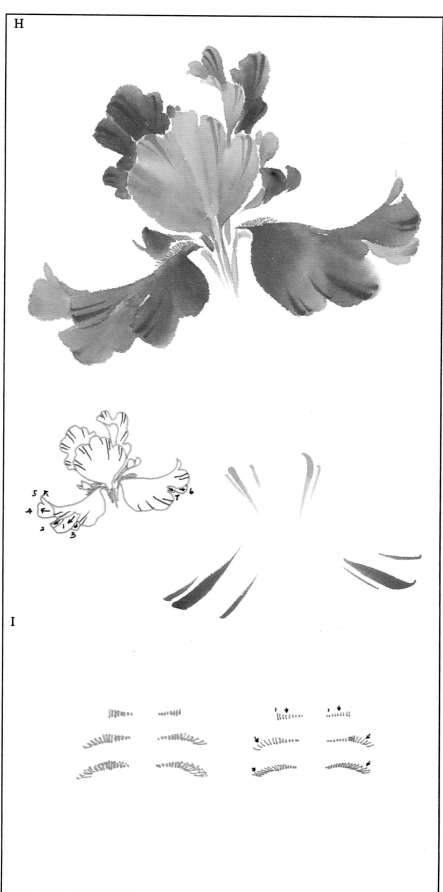

Fig. 3-10 Veins, Underside Skirt Petals, Beard

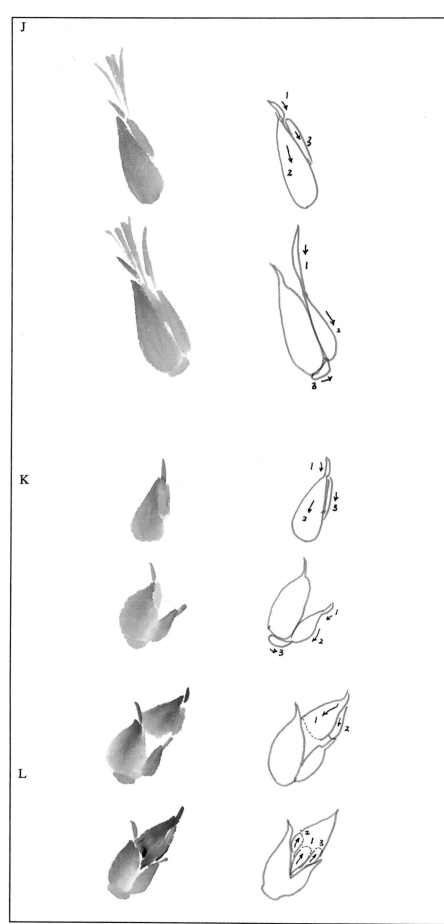

Calyx

See Fig. 3-11 J, K.

Use the Large Flow Brush. Load 1/3 medium Green + 1/8 strong Vermillion + 1/8 strong Violet; blend the tip. Make the Green transparent; the calyx has an onion skin appearance.

Calyx for the Flower

See fig. 3-11 J.

The calyx should start near the root of the trumpet and share the direction of the trumpet. Try not to stuff the base of the flower by not leaving any space. A taller calyx makes the flower more elegant (think of the reasons for ladies wearing high-heeled shoes).

Work the left side of the calyx with wrapping strokes downward. Slightly tilting the brush with the tip pointing to the left, do Stroke 1 to show the tip of the calyx. Work Stroke 2 to show the left side. Maintain pressure to the end. Work Stroke 3 on the right to form a host shape.

Reload the Violet at the tip. Work the right side stroke by wrapping the trumpet with Stroke 1. Work Stroke 2 to wrap along the edge of the left side, to form the guest shape. Tie the bottoms of the two sides together with a horizontal shape (3).

Calyx for the Bud

See Fig. 3-11 K.

Do not do the stem yet. Instead, use your fingernail to estimate the course of the stem. Then, place the calyx of the bud (K), and allow the base of the calyx for the bud along the course of the stem. Draw the calyx of the bud. Hold off the stem until you have drawn the first leaf. Tuck the stem into the leaf at that time.

Bud

See Fig. 3-11 L.

After the calyx is drawn, rinse the Large Flow Brush. Load the brush the same as for the skirt petal (A), with each color at a shorter length on the tip of the bristle. Stroke downward from the bud tip. Do one stroke on the left to develop the tip point. One stroke on the right completes the top side of the bud.

Again, it is important not to let the brush tip travel down with the body of the bristle; lower the boom (press down) instead.

Reload the tip with strong Ultramarine and Violet. Work strokes with upward pressure from the gap of the calyx to seal off the middle area.

Fig. 3-11 Calyx and Bud

Front (Underside) Leaves

See Fig. 3-12 M, O, P, Q, and No Name.
Leaves should come together like a group of fishes attracted by the same food (plant root). Arrange the leaves according to host and guest--- at varying height, length, interval, and angle.

Use a fingernail to draw the stem down from the root of the flower to decide the root point of the leaves. Lead the first leaf down to the root. Do the rest of the leaves to join the first leaf near its root.

The height is crucial to the elegance of the iris. If the paper is short, lead the leaves off the base of the paper to be joined at a distant point below.

These leaves are showing their backs. Wet the tip of the Super Flow Brush. Load 1/2 with ample Green + 1/8 strong Violet and blend the tip.

The first leaf (M) sets the root of the whole plant. It runs parallel to the flower stem, so the stem can sheath into the leaf. Do the leaf from the top down. Show the tip of the blade (1); then work the left side with a decisive stroke (2). Add a parallel stroke (3) on its right. Then add one more stroke (4) to show the right side of the leaf. Do a guest leaf (O) on the right of the first leaf the same way, but end it higher.

Work a larger leaf (P) on the right, tilting the brush handle to allow the tip to point at you slightly for the stroke. Develop a curve and taper at the end. Then, follow the baseline to extend the tip. Do another smaller leaf to the right of Leaf P the same way, but start higher (This leaf is an afterthought to soften the stiff edge on the right; it was too late to assign him a letter. The leaf is young; fame does not matter to him yet.)

Work a smaller leaf (Q) from the top down. Show the tip of the leaf, then add a wider stroke. End it higher than the center leaves.

Stems

See Fig. 3-12 N.
Use the Orchid Bamboo (or Flow) Brush. Load 1/3 strong Green + 1/8 strong Violet; blend the tip. Hold the brush vertically. Settle the brush tip along the center base of the bud calyx, with the tip pointing to the left. Shift the brush 1/4 of a circle clockwise, to allow the brush tip to point upward to the bud. After shifting the brush tip, move with even pressure. Lead the stem to the center of the leaf cluster (root). Tuck the stem into the first leaf. Add the stem of the flower, letting it join the stem of the bud.

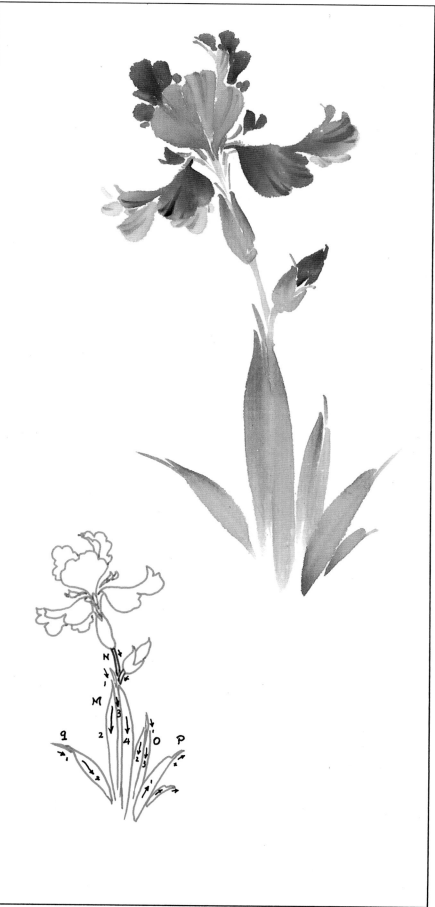

Fig. 3-12 Front Leaves and Stems

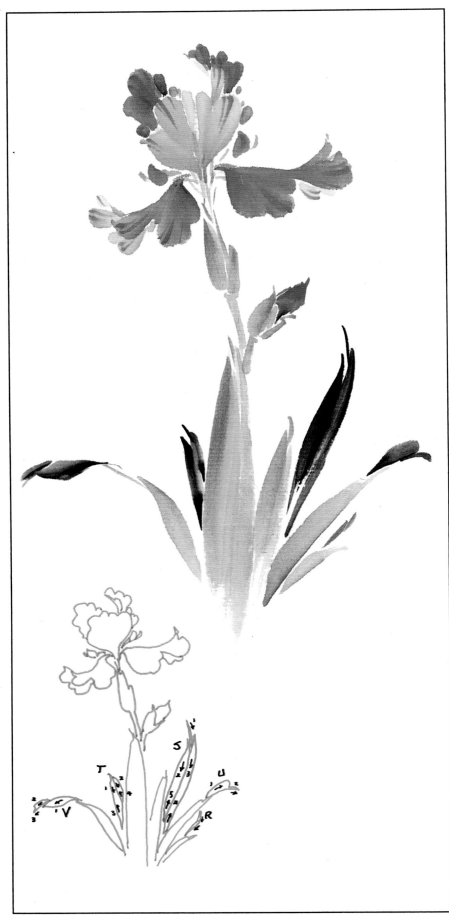

Fig. 3-13 Back (Topside) Leaves

Back (Topside) Leaves

See Fig. 3-13 R, S, T, U, V.

Use Super Flow. Load 1/2 with ample Green + 1/4 strong Indigo; blend the tip, then add 1/6 thick Indigo + 1/8 ink. Again, blend the tip.

Work the leaf (R) with two strokes from the top down. Work leaf (S) and leaf (T) from the top down first. Show their tips, and work each with two strokes, leading them into the existing leaf cluster but stopping short of actually joining the other leaves. Reload the colors and work a couple of strokes upward from the root to join the downward strokes to complete the shapes.

When working the strokes upward, try to reach as far down as possible into the gap of the existing leaves. Try to avoid bleeding by working along the edge of the existing neighboring leaf and leaving a hairline space. Set the root point of the strokes apart to show width, to ensure that the leaf does not appear to end right there.

Folding Leaf (U)

When a leaf is folding, the center vein travels along the baseline, the lower shape shows the underside, and the top shape shows the topside of the leaf. Load the colors as with the other topside leaves, only make each color shorter on the tip. Move the brush in the same way to paint the top shape (U) as you did for the lower shape (P).

Turning Leaf (V)

The turning leaf (V) marks the finale of this composition. It is the most graceful leaf. Load the brush the same way as for the topside of the folding leaf. Do the right side stroke first. Move the stroke from right to left. Begin the stroke on top of the tip of the underside (Q). It is important not to overlap the tip area of the underside too much. The transition between the two sides needs to be fine---one point tapers, fades...another point reveals softly, gently.

Tilt the brush handle more than 45 degrees with the brush tip pointing to the right; begin the right side with a little pressure. Allow the brush tip to travel along the right side of the stroke. Increase the pressure a little, then taper.

The second stroke (the left side) begins halfway over to the left of the right side stroke. This will ensure the leaf's turning posture. Extend from the middle of the two strokes to lead the tip of the leaf outward to the left.

A beautiful iris is created. Isn't it a piece of cake? Let us learn more flowers together.

LESSON 4
TULIP
Peach Bulbs

ART WORK
Fig. 4-1 Tulip

Fig. 4-2 Material Setup

Fig. 4-3 Material ID

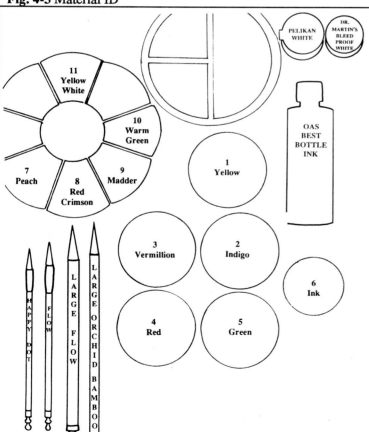

MATERIALS

For best results, use the following recommended materials (available at OAS)

See Fig.4-2 and follow the preparation steps.

Rice Paper
Best Shuen or **Double Shuen**

Brushes
Large Orchid Bamboo: Petals
Flow: Stem, center
Happy Dot: Vein, Stamen
Large Flow: Leaf
(**Super Flow** or **Dragon** is the ultimate brush for large leaves).

Colors
Chinese
Yellow
Indigo
Vermillion
Red

Pelikan
White (or OAS White)

Winsor Newton
Crimson Lake
Purple Madder

OAS
Ink (OAS Best Bottle)

Dr. Martin's
Bleed-proof White

See Fig. 4-3 to identify the materials.

PREPARATION

Rice Paper

Best Shuen or Double Shuen, about 18" x 27"

Colors

Test prepared colors on Double Shuen to match Color Dots Chart (Fig.4-4).

Fig. 4-4 Color Dots: (On Double Shuen)

1 Yellow		7 Peach	
2 Indigo		8 Red Crimson	
3 Vermillion		9 Madder	
4 Red		10 Warm Green	
5 Green		11 Yellow White	
6 Ink			

Use an inexpensive brush (like OAS Basic Hard Brush) to prepare the colors.

1. Yellow

Soak the Yellow chunks with 2-3 tablespoons of water for at least 10 minutes; blend softened Yellow into water, keeping the mixture strong. Pour the liquid into another saucer to drain out particles.

2. Indigo

Wet the chips (use a spray bottle or brush) with 2-3 drops of water; keep it thick.

3. Vermillion

Wet the chips; keep it thick.

4. Red

Wet the chips; keep it thick.

5. Green

Pour about 3 tablespoons of Yellow into a saucer. Add a little Indigo into the Yellow and blend into green. Keep it strong.

6. Ink

Fresh, pour about 1 tablespoon into a saucer.

7. Peach

Put one brush load of pasty Pelikan White into a section of the flower plate. Add water to make it transparent. I refer to the condition of the White as "Grecian Formula." When you load this White on the brush, you should still see the natural color of the bristle. If the brush turns white, the color is too opaque. Mix a drop of Vermillion into the white. The color turns into a beautiful Peach.

8. Red-Crimson

Soften Crimson Lake with a slightly wet brush (I use a finger to blend my watercolor to keep its thickness). Mix strong Red with thick Crimson Lake. The mixture should still be thick.

9. Purple Madder

Use Purple Madder fresh from the tube (about 1/6") into one pocket of the Flower Plate.

10. Warm Green

Bring 1 tablespoon of Green into one section of the Flower Plate, add a little Vermillion and Crimson Lake, and develop the mixture into a Warm Green.

11. Yellow White

Take a generous portion of the Bleed-proof White from the jar with a wet brush. Smooth the White onto a section of the Flower Plate, and mix in a small portion of Yellow. The mixture should stay in a creamy condition---not too pasty or too runny---smooth.

If you use Best Shuen, you should make all the colors stronger than if you use Double Shuen.

IDEA OF TULIP

Yu Chin Shiang (鬱金香) is the Chinese name for tulip. The word "Yu" is intriguing. On the one hand, it means cheerful, abundant growth; on the other hand, it means feeling pent-up, despondent. "Chin" is gold, and "Shiang" is fragrance. The golden fragrance of the tulip can be cheerful or despondent, depending on how it is treated by the sun.

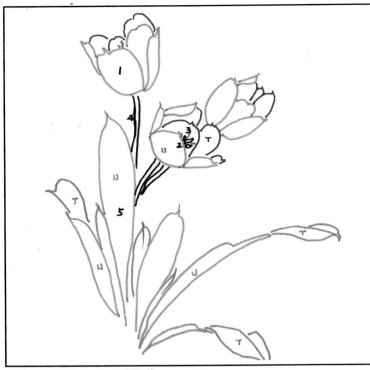

Fig. 4-5 Elements of Tulip
Fig. 4-6 Steps

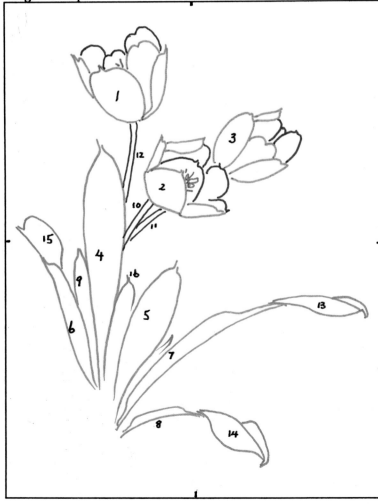

ELEMENTS OF THE TULIP

See Fig. 4-5.

Petal (1)
The petals (a total of six) are hard, pointed at the top and wide at the base. The petal has a prominent center vein. The topside (T) is darker than the underside (U).

Pistil (2) and Stamen (3)
The pistil is bright yellow-white, with three "happy dots" on top. The stamen are three skinny, dark guys.

Stalk (4)
Long and sturdy, it rises from the center of the leaves to house the flower.

Leaf (5)
Wrap the root of the flower stalk with leaves. The topsides (T) are darker and the undersides (U) lighter

STEPS

See Fig. 4-6.

Flower 1 is the high point of our composition. It leans slightly to the left.

Flower 2 is the host and focus. Plant Flower 3 behind Flower 2. Set the flowers high to add more elegance. Keep the flowers close together to avoid a top-heavy composition.

Project the stalks all the way to the root of the plant. Make the exposed part short. Long stalks can be rigid. Avoid "Chicken Foot" (Y): do not show stalks joining at one point. All elements come together near the root like fishes looking for the same food.

Penny has been in the class for years, she finally got enough courage to ask me a question which has been bothering her for some time: "What is this host and guest thing?"

The host plays a dominating role. He (She) invites a guest to his (her) party, even though he may not be the first one at the party. The guest is supportive to the host. Together, they may form a host group and invite other guest.

In this composition, Flower 2 is the host, Flower 3 is the guest. Together, they play host to Flower 1. Leaf 4 is the host leaf, Leaf 5 is his guest. Together, they play host to Leaf 6 and 7. I work most compositions with this dynamic interaction between the host and guest until all the ingredients of the party reach a optimum equilibrium.

"Ning, you have ruined my life," one husband told me. "Now she has to have two of everything. We go out looking for a sofa, we have to have a host sofa and a guest sofa." The host and guest need not be the same item; otherwise, the lady would want to have two husbands too.

Flower 1

Front Petals

See Fig. 4-7 (The small triangle shows the angle of brush tip placement for each stroke).
Brush: Large Orchid Bamboo
Colors: 1/3 transparent Peach + 1/16 strong Vermillion; blend the tip (I always blend the tip, whenever I load the colors).

Middle Host Petal

Show the petal tip with one small stroke (1); it is like saying: "Gentle persons, start your engine."

Holding the brush vertically, work the left side with the brush tip, making an arch turn (the small triangles show the directions of the tip). After the turn, lower the boom (2).

Work a couple of strokes to smooth the right side (3, 4). The right side is the center vein of the petal. Always ask yourself: Where am I in relation to the center vein?

Hold the brush at a 45-degree angle, with tip pointing to 9 O'clock (Chinese time, that is between 9-10). Work Stroke 5 with the side of the brush. Make the right side of the petal fuller than the left side.

Reload the tip with Vermillion, and work a couple of strokes to round off the base of the petal (6, 7). Use the "lowering the boom" method. Match the contour of the petal.

Side Petals

Reload the tip with Vermillion, blend. Do the right side petal with two downward strokes (8, 9) to show the tip and the shoulder of the petal. Reload the tip, connect Stroke 10 to the right side of the center petal, and lead it into the root of Stroke 9. Again, use "lowering the boom" method. Project a smooth contour on the right side of the side petal. Do the left side petal the same way (Strokes 11, 12, 13).

Project a balanced "U" shape. If the "U" is turning into a "V," move the left side petal more to the left and allow the root to come down further to widen the base.

Middle Guest Petal (Top End)

Reload the tip with Vermillion, do Stroke 14 with an arch turn, then add Stroke 15 to complete the top left side. Roll the tip, and do the right side (16, 17). Do all the strokes with "lowering the boom" method.

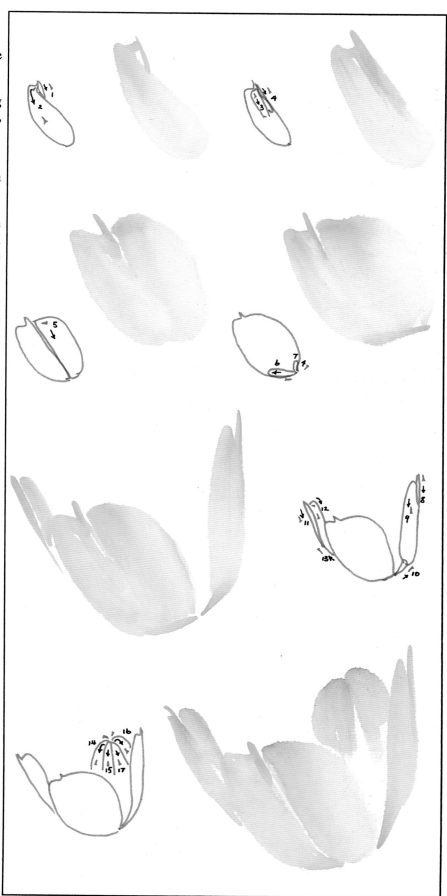

Fig. 4-7 Front Petals

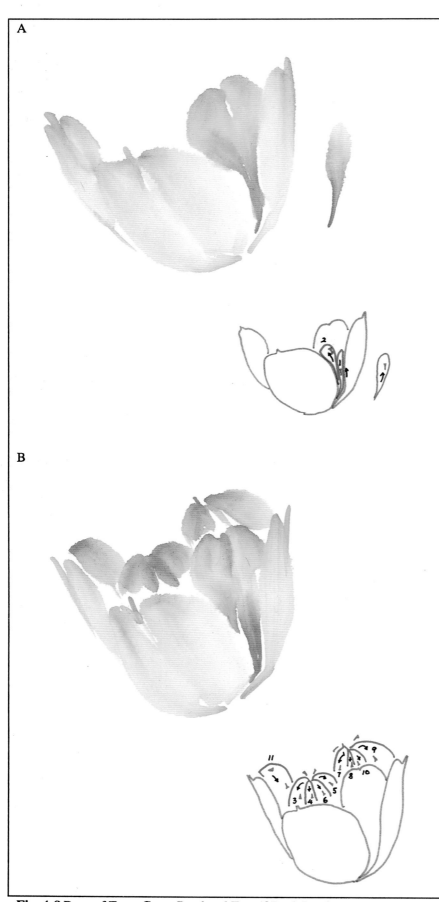

Fig. 4-8 Root of Front Guest Petal and Top of Back Petals

Middle Guest Petal (Root)
See Fig. 4-8 A.
Rinse the very tip of the brush (1/16"), and dry it on the paper towel. This is to ensure that there is no more Peach color left on the tip.

Load 1/16" strong Vermillion + 1/32" strong Red. Blend the tip (These measurement only serve as a reminder for you to think small).

Americans think big. We do a painting 8" x 12" and call it a miniature. In China, people carve 360 words on a single rice. That is a miniature piece of art (kind of like the opposite of the "This is a knife" thing in "Crocodile Dundee").

Do Stroke 1 from the base, and lower the boom as you move upward, until it blends into the top shape. Try to fill the gap between the front petals.

Leave a hairline space between this stroke and the front petals to prevent colors from running into each other.

Do another stroke if needed (2).

Back Petals
Topside
See Fig. 4-8 B.
Do the middle petal first.

Do Stroke 3 with an arch turn, then add Stroke 4 to complete the top left side. Reload the tip, and do the right side (5, 6). Do all the strokes with the "lowering the boom" method.

Keep a little space open between the top and lower petals.

Note: It may be wise to work the lower part of each petal individually after you finish the top part, especially if you are not painting in rapid motion. Doing each lower part separately right after the top part is done also makes each petal more distinct. The only drawback is that you need to clean the brush, keep it dry, and load the darker colors each time.

Add another petal with the same method (7, 8, 9, 10). Make the right side of the petal wider. It helps to bend the petal toward the center.

Reload the tip. Hold the brush diagonally, and do Stroke 10 to complete the backside of the left petal. Leave the root area open.

Root Area of Back Petals

See Fig. 4-9 A.

The center area is the darkest. After completing the top shapes, do not reload the brush with moisture. Keep the bristle dry. Load the tip 1/8" with strong Vermillion and 1/16" thick red. Blend the brush tip.

We need to use the thick colors to seal the root area of the top petals to show depth and contrast. Do the root of the petals one at a time. Reach into the gap between the front petal first. Then, seal both sides of the petal, and seal the middle.

Work the root of the middle petal first. Hold the brush tilted with tip pointing at 6 O'clock. Insert the tip at the gap between the front petals and lower the pressure. This "lowering the boom" method allows the thick tip colors to blend into the strokes on top without a trace (1). Define the root of the right side with another stroke (2).

Reload the brush. Do the same on the left side (3). Use the remaining colors on the brush to seal the middle of the petal (3, 4). Seal the other top petal roots the same way (5, 6, 7, 8, 9, 10).

Leave a hairline of space between these strokes and the front petals to prevent colors from running into each other.

There is no need to make every part of the root area with the same dark colors. Emphasize the crevice area and the edges of the petal more.

Veins and Stamen

See Fig. 4-9 B.

The top edge of the petal has veins coming to the center. Do the veins while the petals are still wet.

Use a dry Happy Dot Brush. Load the tip 1/4 with thick Vermillion + Red.

Work all the strokes from the outside edge of the petals inward. Begin the lines with pressure, then lift the pressure by bouncing off the paper.

Do veins selectively, grouping them into clusters to show host and guest. Vary the size, length, and interval.

Do the darker petals first, then dilute the colors a little (keep the brush dry) to do the lighter ones.

Using the Happy Dot Brush, load strong Purple Madder and add a couple of stamen.

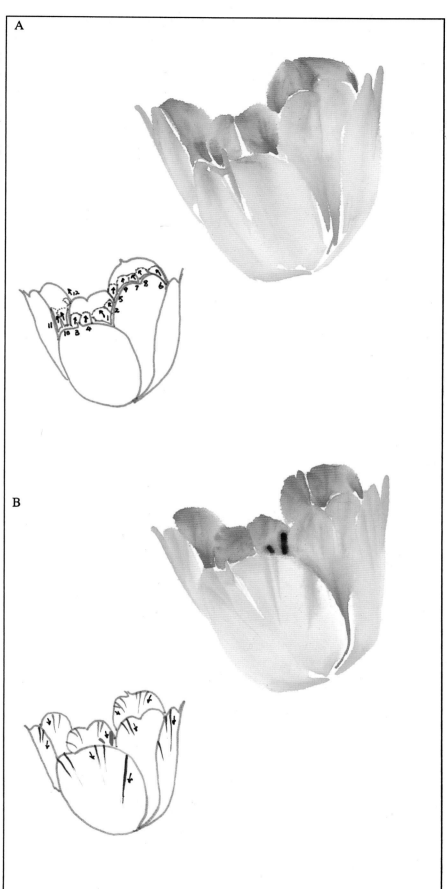

Fig. 4-9 Center Area, Veins, and Stamen

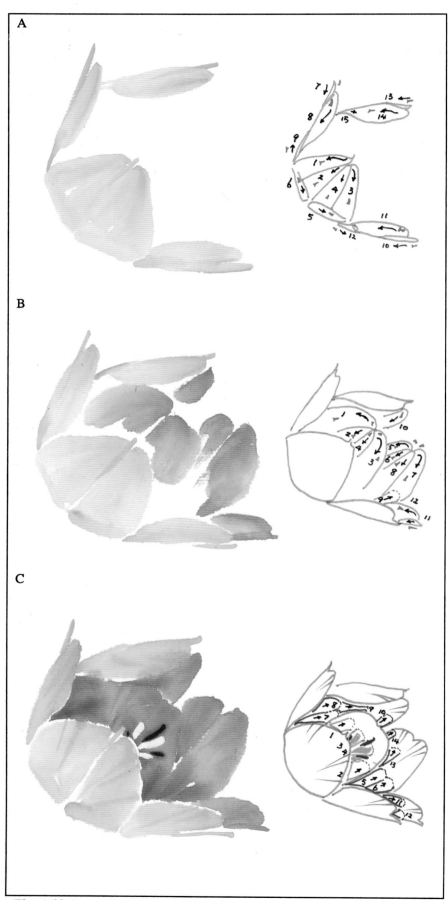

Fig. 4-10 Flower 2

Flower 2

This is a fully opened flower. The front petals are foreshortened and the "U" cup extended. It shows pistil and stamen.

Front Petals
See top diagram, Fig. 4-10 A.

Middle Host Petal
Using the same brush and colors as for Flower 1, hold the brush vertically. Do Stroke 1 with a slight curve; add Stroke 2 to complete the top left side. Reload the tip, and do the right side (3, 4). Reload the tip with Vermillion, and work a couple of strokes to round off the base of the petal (5, 6). Match the contour of the petal. Use "lowering the boom" method on all strokes.

Additional Petals
Do the two side petals the same way as Flower 1. Add another spoon-shape petal on the upper left of the "U" shape. Try to project the root of the petal reaching to the base of the center petal.

Topside
See middle diagram, Figure 4-10 B.
Reload 1/16" Vermillion + 1/32" Red.
Do the middle petals first, then the side ones, using the same method discussed in Flower 1.
Pay special attention to Stroke 9. We do it to connect the topside to the front petal. It helps to seal the center area.
Keep a little space open between the top and lower petals.

Center Area
See lower diagram, Figure 4-10 C.
This is the darkest area of all the flowers. After completing the top shapes, do not reload the brush with moisture. Keep the bristle dry.
Load the tip 1/8" with strong Vermillion + 1/16" thick red + 1/16" thick Red Crimson. Blend the brush tip. Use the same method discussed in Flower 1 to seal the center area of the flower.

Veins, Pistil, and Stamen
Do the veins while the petals are still wet. Use a dry Happy Dot Brush. Load the tip 1/4 with thick Vermillion + Red.

Using the Flow Brush, load 1/3 brush tip with rich, creamy pre-mixed Yellowish white; blend the tip. Add three dots of varied sizes to show the top of the pistil.
Use the Happy Dot Brush; load strong Purple Madder, and add stamen next to their favorite subject---the pistil.

Flower 3

See Fig. 4-11.

For better composition (and to make your life a little easier), hide the base of Flower 3 behind Flower 2. Project the course of the stalk to decide its placement.

We have covered every detail of the petal strokes. I trust you can study the Nitty Gritty diagram and do the flower on your own.

"What brush should I use?" Margo asked.

Margo is a sweet girl who has been in my class for 15 years. Like a prompter in a Shakespeare play, she never fails to remind me that I have missed a cue.

It is not that Margo stands for Mother of AiR GO nuts. She is intelligent and has been a teacher all her life. She just wants me to be a better teacher.

Margo is 92. Who could argue with someone who won the Civil War?

I took a sabbatical leave this year. While writing this book, Margo is always on my mind.

OK, Margo, you win:

Petals: Use Large Orchid Bamboo Brush.
Colors: 1/3 transparent Peach + 1/16 strong Vermillion (front petals, 1-11); reload 1/16 Vermillion (12), reload 1/16" Vermillion + 1/32" Red (topside, 13-15), and 1/8" with strong Vermillion and 1/16" thick red (center area).
Veins: Use the Happy Dot Brush. Load 1/4 thick Vermillion + Red.

Leaves Showing Underside

See Fig. 4-12.
Visualize the course of the flower stems to decide the root point of the plant. Lead the first leaf down to establish the root. Do the rest of the leaves to join the first leaf near its root.

Use the Super Flow or Dragon Brush (the largest brush). Load 1/2 ample medium Green + 1/4 medium Indigo. Blend the tip.

First Leaf
See Fig 4-12 A.
The first leaf runs parallel to the flower stalks and anchors the flowers. Do it from the top down. Develop the left edge first. If the shape is too narrow, add more parallel strokes (1, 2, 3, 4). Hold the brush vertical; reload as needed.

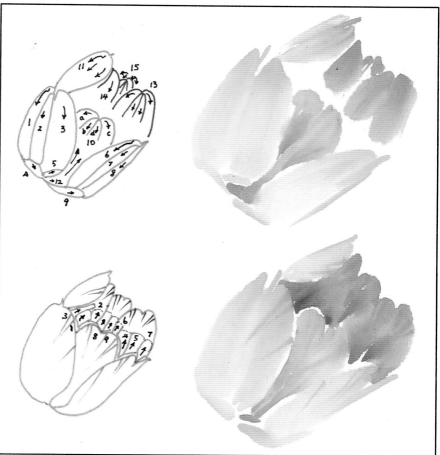

Fig. 4-11 Flower 3
Fig. 4-12 Leaves Showing Underside

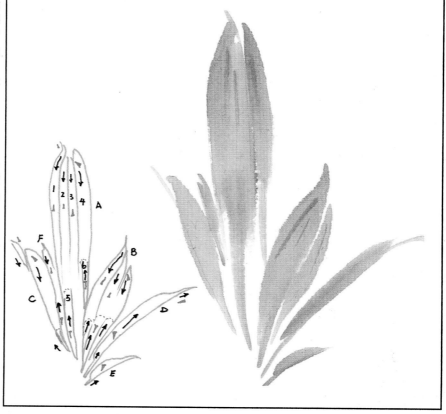

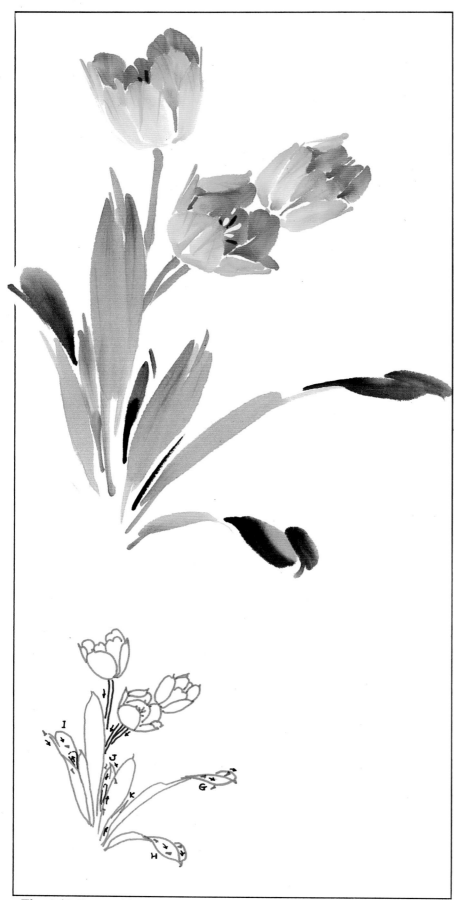

Fig. 4-13 Composition

First Leaf (Continued)
See Fig. 4-12 A.
Reload the brush, and do two strokes from the base up (5, 6). Use the "lowering the boom" method. Match them with the outside edges of the top strokes.

If spontaneous streaks of spaces occur between or within the strokes, treasure them. In China, the streak of space occurred naturally within a stroke is called "the Flying White." It adds energy, variation, and texture to a leaf. Like a window, it allows the shape to breathe.

Other Leaves Showing Underside
See Fig. 4-12 B-F.
Do a guest leaf (B) on the right of the first leaf the same way. Work a spoon shape leaf on the left (C).

Reload the brush with 1/3 green, with tip 1/8 strong Vermillion; do a couple of folding leaves (D, E). Tilt the brush handle to allow the tip to point at you slightly for the stroke. Develop a slight curve and taper at the end. Then, follow the baseline of the shape with a thinner stroke to extend the tip. Load the same colors; do a small leaf (F) on the left side to balance (See Fig. 4-12).

Stalks
See Fig. 4-13.
Use the Flow Brush. Load 1/3 strong Warm Green. Plant the stalk for each flower below the center of the "U" cup. Do Flower 2 first (As a rule, always do the lower flower first, because it is closer to us). Make the stalk of Flower 3 join into the stalk of Flower 2. Do not force it; God knows where your flower may be now. Tuck Flower 1 in last.

Leaves Showing Topside
See Fig. 4-13.
Use the Large Flow (Super Flow, Dragon) Brush; wet the tip. Load 1/2 with a generous amount of Green + 1/4 strong Indigo; blend the tip, then add 1/6 strong Indigo again + 1/8 ink at the tip.

Turning Leaves (G, H)
Do two strokes on each leaf to show the topside; tilting the brush tip to the right.

Folding Leaf (I)
Do a bold stroke to show the topside; hold the brush at an angle, tilting the tip to the right.

Add a couple smaller leaves (J, K).
The composition is done.

LESSON 5
POPPY 1
Flowers

ART WORK
Fig. 5-1 Poppy

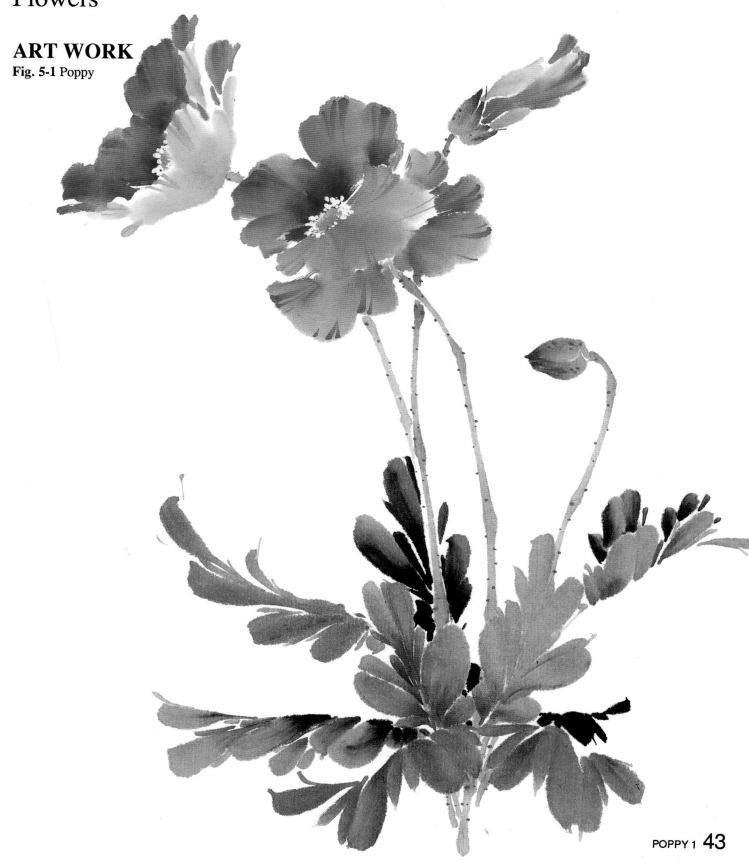

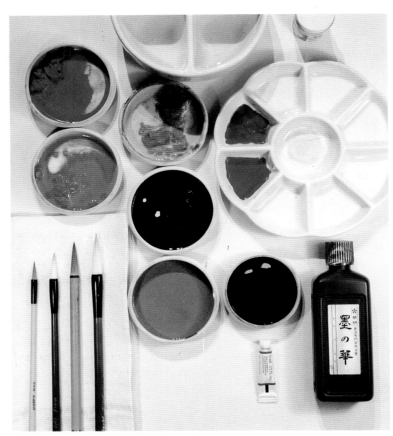

MATERIALS

For best results, use the following recommended materials (available at OAS)

See Fig. 5-2 and follow the preparation steps.

Rice Paper
Best Shuen or **Double Shuen**

Brushes
Large Flow: Petals
Flow: Seed Pod, Pollen, Stems, Stalks, Calyx, Bud
Large Orchid Bamboo: Leaves
Happy Dot: Veins

Colors
Chinese
Yellow
Indigo
Vermillion
Red

Winsor Newton
Crimson Lake

OAS
Ink (OAS Best Bottle)

Dr. Martin's
Bleed-proof White

See Fig. 5-3 to identify the materials.

Fig. 5-3 Material ID

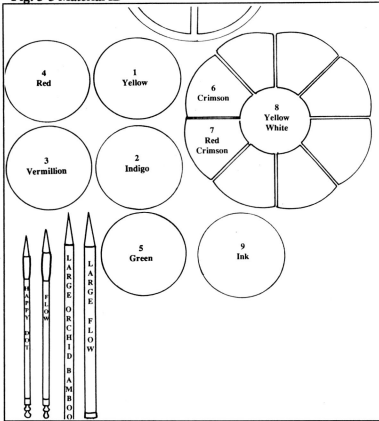

PREPARATION

Rice Paper
Best Shuen or Double Shuen, about 18" x 27"

Colors
Test prepared colors on Double Shuen to match Color Dots Chart (Fig. 5-4).

Fig. 5-4 Color Dots: Show colors on Double Shuen.

1 Yellow		6 Crimson	
2 Indigo		7 Red Crimson	
3 Vermillion		8 Yellow White	
4 Red		9 Ink	
5 Green			

Use an inexpensive brush (like OAS Basic Hard Brush) to prepare the colors.

1. Yellow
Soak Yellow chunks with 3-4 tablespoons of water for at least 10 minutes, blend softened Yellow into water, keeping the mixture strong. Pour the liquid into another saucer to drain out particles.

2. Indigo
Wet the chips (use a spray bottle or brush) with 2-3 drops of water; keep it thick.

3. Vermillion
Wet the chips; keep it thick.

4. Red
Wet the chips; keep it thick.

5. Green
Pour about 3 tablespoons of Yellow into a saucer. Add a little Indigo into the Yellow, and blend into green. Keep it strong.

6. Crimson Lake
Use fresh from the tube (about 1/4") into one pocket of the Flower Plate. Soften the color with a slightly wet brush (I use finger to blend my watercolor to keep its thickness). The color should stay pasty.

7. Red-Crimson
Mix strong Red with thick Crimson. The mixture should still be thick.

8. Yellow White
Take a generous portion of the Bleed-proof White from the jar with a wet brush. Smooth the White onto a section of the Flower Plate; mix in a small portion of Yellow. The mixture should stay in a creamy condition---not too pasty, or too runny---smooth.

9. Ink
Fresh, pour about 1 tablespoon into a saucer.

Use saucers for mixing and blending.

IDEA OF POPPY

The enchantment of Chinese brush painting is intertwined with the entire sphere of Chinese culture. Each flower has its legends, romantic stories, volumes of poetry, and symbolic spirituality.

The poppy is the spirit of Lady Yee, a devoted wife who danced with a sword to cheer her husband in times of desperate battles. The flower represents loyalty and faith. (For the enchanting legend of the flowers. Please see An Album of Chinese Brush Painting: 80 Paintings and Ideas, by Ning Yeh, pp. 48-49).

We will study the poppy with a two-parts lesson. In Lesson 5, we will enjoy the different growing stages of this remarkable flower. In Lesson 6, we will unite the flowers with stalks and leaves, and complete an elaborate composition.

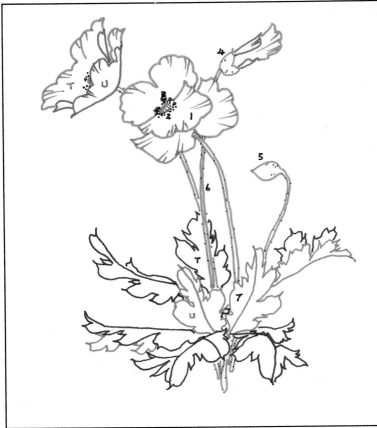

Fig. 5-5 Elements of Poppy
Fig. 5-6 Steps

ELEMENTS OF POPPY

See Fig. 5-5.

Petals (1)
The petals (a total of four) are soft with ruffled edges and noticeable veins. The topside (T) is darker, and the underside (U) is lighter.

Seed Pod (2)
A green ball sits at the center of the flower.

Pollen (3)
A bright yellow cluster of dots encircles the seed pod.

Calyx (4)
It wraps the bud and usually falls off when the flower opens.

Bud (5)
The bud is egg-shaped, hairy, and it droops downward.

Stem (6)
Long and sturdy, it rises from the center of the leaves to house the flower. The stem is covered with fine hair.

Leaves (7)
Clustering one another near the root of the flower stem, the leaves are ruffled. The topsides (T) are darker and the undersides (U) lighter.

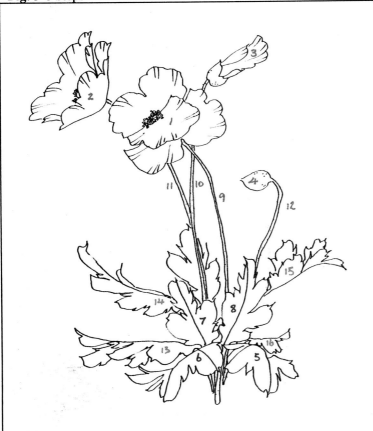

STEPS

See Fig. 5-6.
Let us follow the steps to study the different elements.

Height is essential for the elegance of this plant.

Run the orientation at a tilted angle; avoid moving straight up and down.

Cluster the flowers into a host group. Set the bud aside as a guest.

Leave a little space under each flower to show the stalk. Group the stalks to show a slender waistline for the composition, crossing them to develop more depth and interest.

The large, showy flowers can easily make the composition top heavy. Be sure to develop a significant spread of leaves to anchor the flowers.

Full Flower

Seed Pod

See Fig. 5-7.

Brush: Happy Dot

Color: Green

The oval-shaped seed pod resembles a pumpkin, with the base hidden. Move the strokes from the center outward. Start with the lower strokes. Do the middle one first. Begin lightly; lower the pressure to widen the stroke as it moves down. Allow a hair line space between the strokes. Curve the side ones to allow their ends to come back to the center.

The top strokes are much shorter, with the side ones curving down.

Fig. 5-7 Seed Pod

Lower Center Petal

See Fig. 5-8.

Brush: Large Flow Brush

Colors: 1/3 medium Vermillion + 1/4 strong Red; blend.

Basic Stroke

See Fig. 5-8 A.

Hold the brush at a 45-degree angle. Use the brush sideways, with the tip pointing to the left and travelling along the left side of the shape. Start with a little pressure, and increase pressure to widen the shape as the stroke moves down.

Right Side

See Fig. 5-8 B.

Overlap the first stroke with Stroke 2 to blend the two strokes into one shape. Work Stroke 3 and Stroke 4 with the brush held vertically. Stroke 4 can be done both from inside out or from outside in. Study the different placement of the brush tip in executing the strokes (the small triangles in each diagram).

Left Side

See Fig. 5-8 C.

Reload the colors to match the intensity of Stroke 1. Work the left side of the petal from inside out. For the right-handed artist, it is best to hold the brush vertically for better control of the tip (When the triangle on the diagram runs opposite to the direction arrow, it usually suggests that the brush is held vertically).

Split the brush tip to give the starting point more width. Increase pressure as the strokes move out. When a shape begins with some width, while the diagram calls for vertically holding the brush, the shape is done by having the tip splitting open. You may want to nip the brush tip a little to spread the bristle a little before doing the stroke.

Fig. 5-8 Lower Center Petal

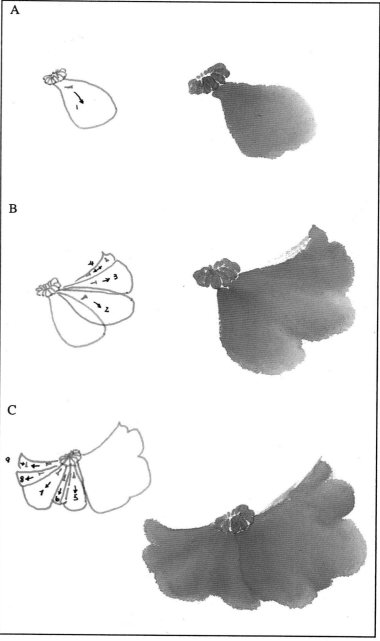

A

B

C

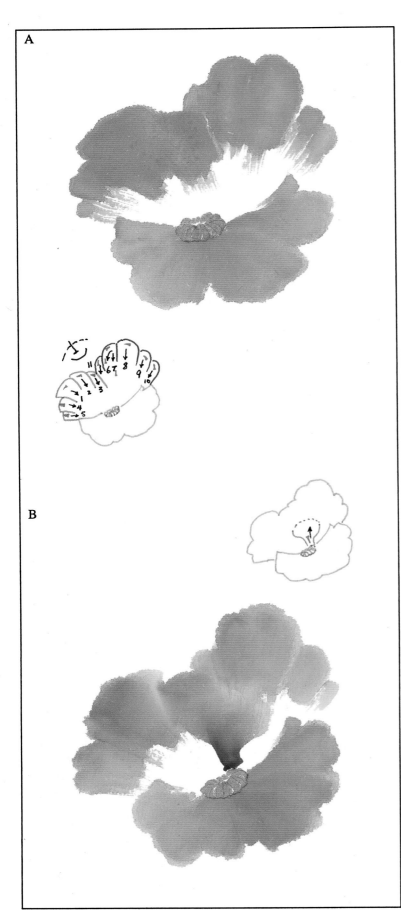

Top Center Petal
See Fig. 5-9.
Brush: Large Flow
Colors: 1/3 medium Vermillion + 1/4 strong Red.

Topside
See Fig. 5-9 A.
Do strokes from outside into the center. Overlap the strokes to connect the shape. Strokes are heading toward the base of the seed pod. The petal may be ruffled.

Start from the left side. Hold the brush diagonally to work Stroke 1, 2, and 3 with the side of the brush. Visualize the oval perimeter. Stay on the left side of the seed pod.

When I use the side of the brush, I usually pivot the brush upon landing on the paper (turning the tip from pointing left to pointing upward). This movement allows the dark color to stay on the topside, rather than on the left side of the stroke.

Hold the brush vertical and work Stroke 4 and 5 with the tip splitting. Allow the left corner of the top petal to connect to the lower petal. Add more strokes if needed.

Reload the brush; work the right side. Do Stroke 6 with the brush held vertically to develop a soft shoulder; add Stroke 7 to fill the shape. Turn the brush more obliquely, with the tip pointing to the left, and work a few more strokes (8, 9, 10) to complete the shape. Round off the left end with a shorter stroke (11).

The diagram is merely a snapshot of a dynamic movement. The brush tip may not be always pointing in the same direction during a stroke. These subtle moves are tough to write about, but if you could see my TV lesson, they would become easy to learn. Now you know where to look.

Lift the strokes early enough to keep the center area of the petal open. If a stroke ends solidly, extend its root with a couple of dry strokes (hold the brush vertically, split the tip, and use the colors left on the brush) to prevent the solid end from forming water marks.

Center Area
See Fig. 5-9 B.
After completing the top shapes, do not reload the brush with moisture. Keep the bristle dry. Load the tip 1/3 with strong Vermillion and thick red, then add 1/4 length of the tip with thick Crimson Lake. Blend the brush tip.

Split the bristle tip a little; hold the brush vertically. Set the pressure along the top edge of the seed pod, and push the stroke upward while lowering the pressure. This "lowering the boom" method allows the thick Crimson Lake to blend into the strokes on top without a trace (See Fig. 5-9 B).

Fig. 5-9 Topside of the Top Center Petal

Center Area (Continued)
See Fig. 5-10.

Overlap and radiate a few more strokes outward and fill the whole center area. Carve around the seed pod and line along the top edge of the lower petal, then move upward or outward.

Leave a hair line space between the petals, to avoid bleeding and to set the top petal apart from the lower petal.

The green seed pod is now surrounded by red, like a cavalry officer in a frontier outpost, looking lonely and out of place. Use the Flow brush, wet with water then wipe the brush dry. Brush over the seed pod with the moisture left on the brush to marry the seed pod with the red. Now the cavalry officer does not need to dance with the wolf.

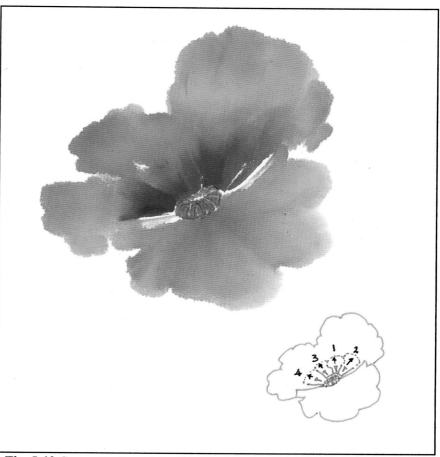

Fig. 5-10 Center Strokes of the Top Petal

Fig. 5-11Outside Petals

Outside Petals
See Fig. 5-11.

Work two additional petals, using the Large Flow Brush, load tip 1/3 strong Vermillion and 1/4 strong Red. Compared to the center petals, the colors of these petals may be a little lighter.

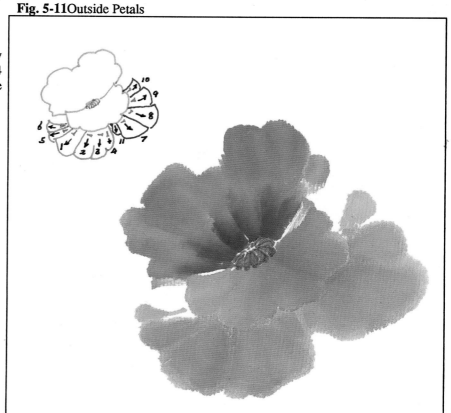

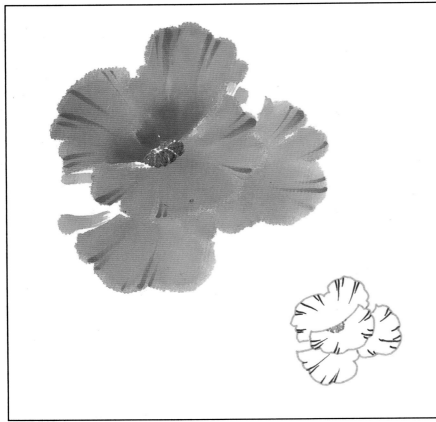

Fig. 5-12 Veins

Veins
See Fig. 5-12.
Do the veins while the petals are still wet.

Use a dry Happy Dot Brush. Load 1/4 thick Red Crimson mixture (or load the same colors used for doing the petals only stronger or slightly darker).

Work all the strokes from the outside edge of the petals inward with a curve. Move the brush swiftly to show energy.

Begin the lines with pressure, then lift the pressure by bouncing off the paper.

Do the veins selectively, grouping them into clusters to show host and guest. Follow the pattern of the strokes. Vary the size, length, and interval of these veins.

Do not overdo them. In many cases, it is better not to do them if you have very nice petals.

If the petal is dry, veins can be done a little wet. Otherwise, keep the brush dry and the color strong. The best result is a slight blending of veins into the wet petals.

Fig. 5-13 Pollen Dots

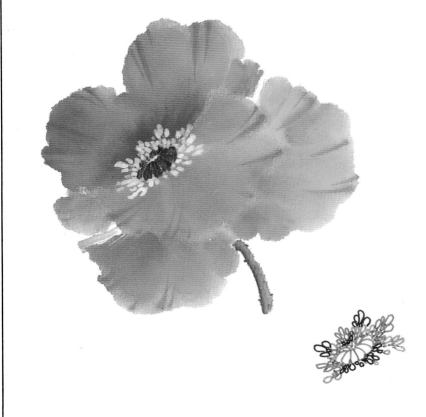

Pollen Dots
See Fig. 5-13.
Use the Flow Brush (I like to use the Flow than Happy Dot Brush for fuller-shaped dots). Load 1/3 brush tip with rich creamy pre-mixed Yellowish white; and blend the tip.

Place the dots in clusters and in radiating patterns so that the roots of the dots are heading toward the base of the seed pod.

Follow the oval shape with the side dots extending more, and the ones in front of the seed pod foreshortened.

Connect the dots in one group into a continuous shape. Reduce unnecessary spaces or gaps between the dots and between the pollen and the seed pod.

Profile Flower

The profile flower is shown as a cup.

The front petal shows its backside and the back petal shows its topside. The side petals extend like tilted spoons, with both sides showing.

The underside is lighter than the topside (Although the underside may be in the shadow, the Chinese artist goes with the true colors of the subject in nature).

Front Petal
See Fig. 5-14.
Brush: Large Flow
Colors:
Load 1/3 light Vermillion; add 1/4 medium Vermillion at the tip of the brush. Blend the tip.

Hold the brush at a 45-degree angle. Work Stroke 1 (see Fig. 5-14 A) upward to the right; add Stroke 2 by starting higher, to project the base of the strokes into half a "U" curve (see Fig. 5-14 B).

Reload the tip with strong Vermillion, and work Stroke 3 (see Fig. 5-14 B) with the brush held more vertically. The stroke is neutral in its orientation. It serves as a transition point between moving to the right side of the "U"--- and moving to the left side.

Show Stroke 3 with a fuller base.

Sometimes we need to make the stroke go left and "U" turn back with the side of the brush to make the shape fatter. God has made sure that we have balanced, round, nicely cushioned seat. Do not let our flower suffer from hip pointer.

Do Stroke 4 with the brush tip pointing to the right, and move left to complete the other side of the "U" shape. Extend the "U" with a skinnier stroke if you desire (See Fig. 5-14 C).

Side Petals
See Fig. 5-15.
Continue to develop the underside of the side petals.

Begin the stroke with no pressure, and increase the pressure as the stroke moves up (Stroke 5, 7). Continue from the baseline of the stroke with an extension (Stroke 6, 8).

The two sides need not to be identical; vary the width and height.

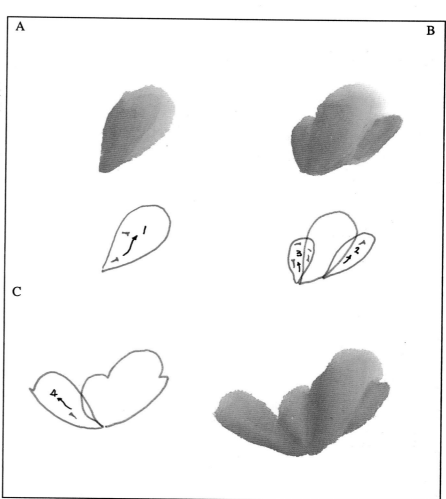

Fig. 5-14 Front Petal, Profile Flower
Fig. 5-15 Side Petals, Underside

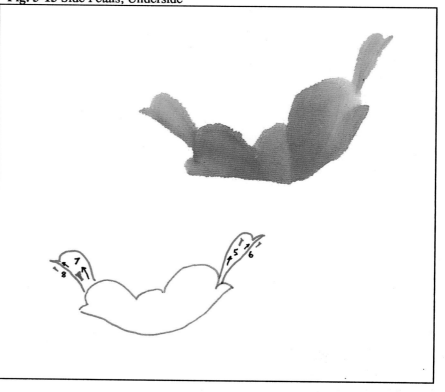

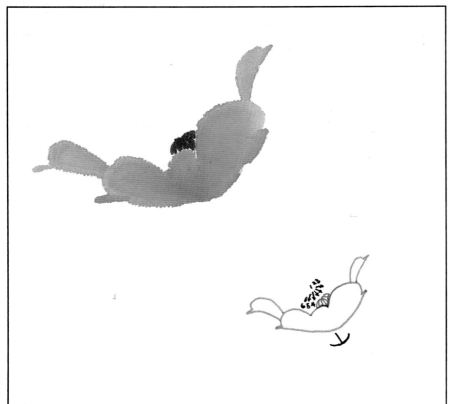

Fig. 5-16 Seed Pod, Profile Flower
Fig. 5-17 Back Petal, Topside

Seed Pod
See Fig 5-16.
Plant the seed pod at the center of the "U" curve.

Use the Happy Dot Brush, load 1/3 strong Green, and place the seed pod above the edge of the underside petal. The seed pod may only show partially.

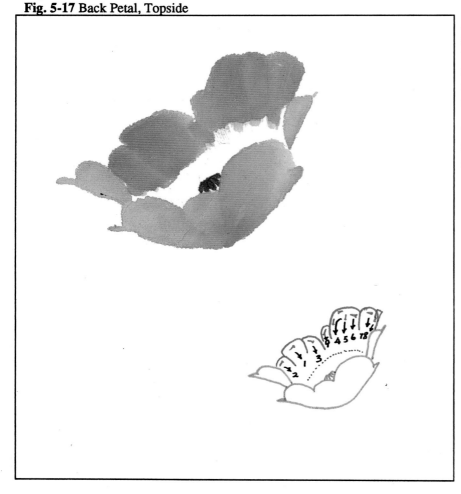

Back Petal
See. Fig. 5-17.
Use a method similar to the top petal of the full flower. Work with the Large Flow Brush, load 1/3 medium Vermillion + 1/4 strong Red, and blend the tip.

Work strokes from top down, fill the area between the two side petals, and keep the center area near the seed pod open.

Center Area
See Fig. 5-18.

Do the center Area of the profile flower the same way as the full flower.

It is important to keep an eye on the shapes of the front petal while working the dark strokes. Keep the borderline smooth. Reach into the gaps. Leave a hairline of space between the dark and the light petals.

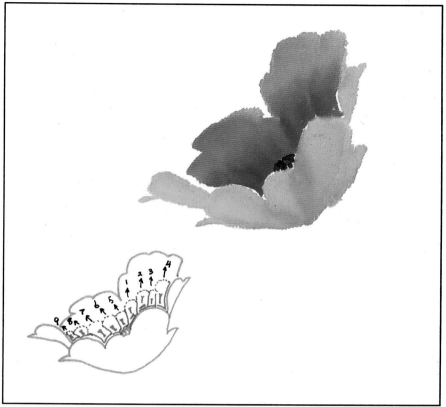

Fig. 5-18 Center Area of the Profile Flower
Fig. 5-19 Veins and Pollen Dot of the Profile Flower

Folding Side Petals, Veins and Pollen
See Fig. 5-19.

Use the Large Flow Brush, load 1/3 medium Vermillion + 1/4 strong Red, and extend from the spoon shapes a few strokes. Elevate both sides by moving the strokes outward while lowering the boom. Do the base strokes in line with the light-colored spoon tips. Make sure the direction of each stroke radiates from the base of the seed pod.

Add the veins and the pollen dots.

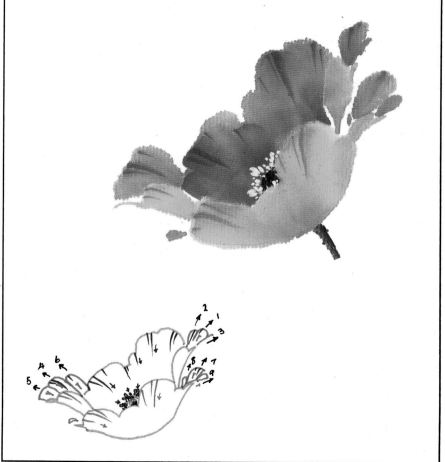

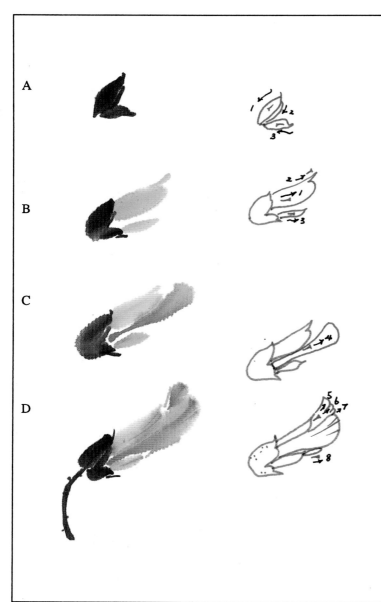

Teenager
See Fig. 5-20.

Calyx
See Fig. 5-20 A.
Brush: Flow
Colors: 1/3 Green + 1/16 Crimson, blend the tip.

Unlike teens in the United States, the teenager of the poppy flower is shy with head bending. Making the topside larger helps the drooping tendency. Use two strokes and work the shape from its tip down to the base.

Reload the tip with Crimson. Do the lower side with one stroke. Make the two shapes connect to form a "U" base (A).

While the calyx is still wet, use a relatively dry Happy Dot Brush with tip loaded with strong Red-Crimson; add a few dots to suggest hairs. Allow the tip land onto the wet calyx lightly so the dots stay fine. Group the dots into clusters of host and guest.

Petals
See Fig. 5-20 B, C, D.
Brush: Large Flow
Colors: 1/3 light vermillion + 1/4 strong Vermillion. Blend.

Work a larger petal on the topside, and continue its top edge with a little extension (Stroke 1, 2). Open a little space, then work a smaller petal (Stroke 3) below the large one (B).

Load the tip with 1/4 medium Vermillion + Red; insert Stroke 4 between the space, and gradually increase the pressure as it moves outward (C).

Load the tip with more Red; work a few strokes to show the topside petals (D). Add vein lines with the Happy Dot Brush on the wet petals

Fig. 5-20 Teenager
Fig. 5-21 Bud

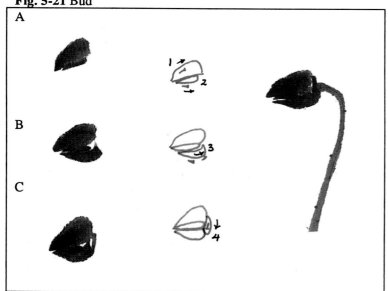

Bud
See Fig. 5-21.
Brush: Flow
Colors: 1/3 Green + 1/16 thick Crimson, blend the tip.

The bud droops its head downward; making the topside larger helps the drooping tendency. Use two strokes to work the topside from its tip down to the base (A). Work a smaller stroke on the lower side (B). Add another stroke to round off the base (C).

Use the Happy Dot Brush, loaded with strong Red-Crimson; add a few dots to suggest hairs the same way as you did on the calyx.

Our ladies are waiting for their escorts. In our next lesson, the stalks and the leaves will take the ladies to a grand ballroom dance.

LESSON 6
POPPY 2
Composition

STEPS

Let us arrange our flowers with style, and bring in the supporting casts to compose our masterpiece. See Fig. 6-1.

Do the full flower below the top 1/4 mark of the paper, off center to the left, and leaning toward 11 o'clock (1). Do the profile flower, with a little space open to the upper left of the full flower; head it toward 10 o'clock (2). Work the teenager to the upper right of the full flower. Establish a "V" space above the flowers to lead the viewer into the painting (3). Do a bud just above the middle to the right of the composition (4).

Lightly draw the stalks with your fingernails to project their course. Tilt them a little so the composition is not rigid. Lead them in as fishes looking for the same food. Paint them after you have done the front leaves.

Do the front drooping (A, B) and raising (C, D) leaves. Project them coming from the root area of the stalks.

Work the stalks in; begin with the host group-the full flower, the teenager, and the profile flower. Then, lead the stalk for the bud from the side as a guest.

Add additional leaves to the sides (E, F, G) and to the back of the stalks (H, I).

We have mastered the flowers. Go ahead, make your day, put the flowers in. Let us talk leaf now.

Idea of the Poppy Leaf
See Fig. 6-2.
To draw a human figure, one needs to know the complicated bone structure. To do a leaf, one only needs to know the center vein. The center vein divides a leaf into two halves.

Most leaves have smooth edges. The poppy leaf, however, is very serrated. I divide the poppy leaf into 3 parts---the tip, the shoulder, and the rear. To show the serrated edges, I develop each part with two fuller strokes wrapping each other in the middle, and add one smaller stroke on each side.

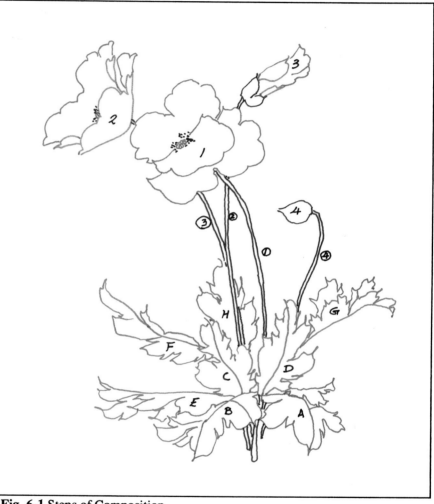

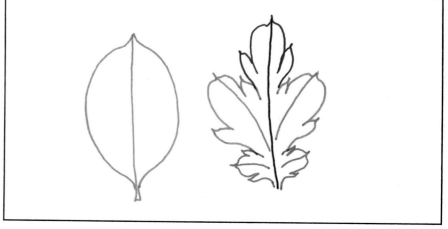

Fig. 6-1 Steps of Composition
Fig. 6-2 Idea of the Poppy Leaf

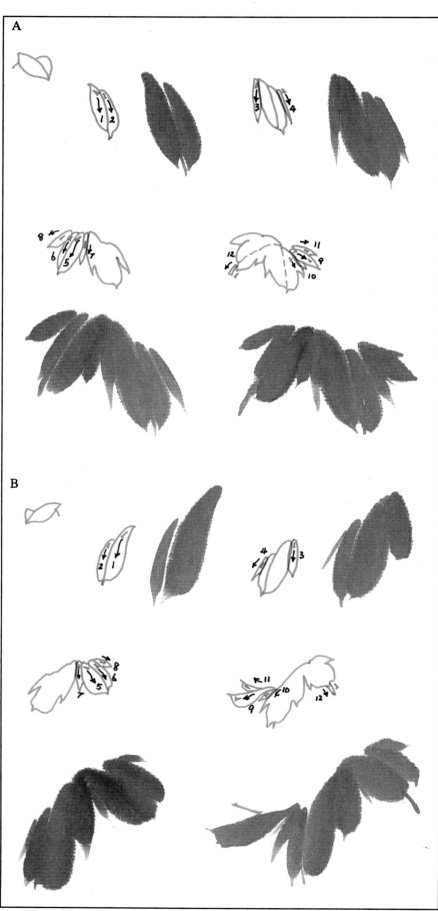

The idea of each of the leaves is shown in a green colored diagram.

Front Drooping Leaves
Brush: L. Orchid Bamboo
Color: 1/3 generous medium Green + 1/6 strong Indigo; blend the tip.

Leaf Facing the Right Side (A)
See Fig. 6-3 A.
This is a foreshortened leaf coming toward us. Only the tip half is showing. Hold the brush diagonally, with the tip pointing to 10 o'clock. Do Stroke 1 with the side of the brush. Begin Stroke 2 a little lower, with the brush held vertically. Add two smaller strokes to show the serrated points. Do Stroke 3 higher and fuller, and Stroke 4 lower and skinnier.

Turn the handle of the brush, with the tip pointing to 2 o'clock. Do Stroke 5 a little higher than the existing strokes. Complete the left side of the leaf (6, 7, 8).

Make the right side of the leaf smaller. Begin Stroke 9 with a slight arch. Complete the right side (10, 11). Show a "V" space above the center of the leaf. Add the stem (12) by projecting the turn of the center vein from the tip of the leaf.

Leaf Facing the Left Side
See Fig. 6-3 B.
Hold the brush diagonally, with the tip pointing to 2 o'clock. Do Stroke 1 with the side of the brush. Begin Stroke 2 a little lower, with the brush held vertically. Add two strokes (3, 4) to show the serrated points.

Turn the handle of the brush, with the tip pointing to 9 o'clock. Do Stroke 5 a little higher than the existing strokes. Complete the right side of the leaf (6, 7, 8).

Make the left side (9, 10, 11) of the leaf extend outward. Show a "V" space above the center of the leaf. Add the stem (12).

Fig. 6-3 Front Drooping Leaves

Front Raising Leaves

Brush: L. Orchid Bamboo
Color: 1/3 generous medium Green + 1/8 strong
Crimson; blend the tip.

Leaf Reaching to the Left Side (C)

See Fig. 6-4 C.

Hold the brush diagonally, with the tip pointing to
5 o'clock. Do Stroke 1 with the side of the brush.
Begin Stroke 2 a little higher and Stroke 3 still
higher. The continuation of the right side of these
strokes shows the course of the center vein.
Reload the tip with Crimson, do Stroke 4 at the
base, and make it fuller.

Pointing the brush tip to 6 o'clock, work Stroke 5
with its right side continuing the course of the
center vein. Complete the top portion of the leaf
with additional strokes (6, 7, 8).

Work the right side of the leaf smaller and higher
than the left side (9, 10, 11, 12).

Leaf Reaching to the Right Side

See Fig. 6-4 D.

Hold the brush diagonally, with the tip pointing to
6 o'clock. Do Stroke 1 with the side of the brush.
Begin Stroke 2 a little higher and Stroke 3 still
higher. The continuation of the left side of these
strokes shows the course of the center vein.
Reload the tip with crimson, do Stroke 4 at the
base, and make it fuller.

Pointing the brush tip to 6 o'clock, work Stroke 5
with its left side continuing the course of the
center vein. Complete the top portion of the leaf
with additional strokes (6, 7, 8).

Work the left side of the leaf smaller and higher
than the right side (9, 10, 11, 12).

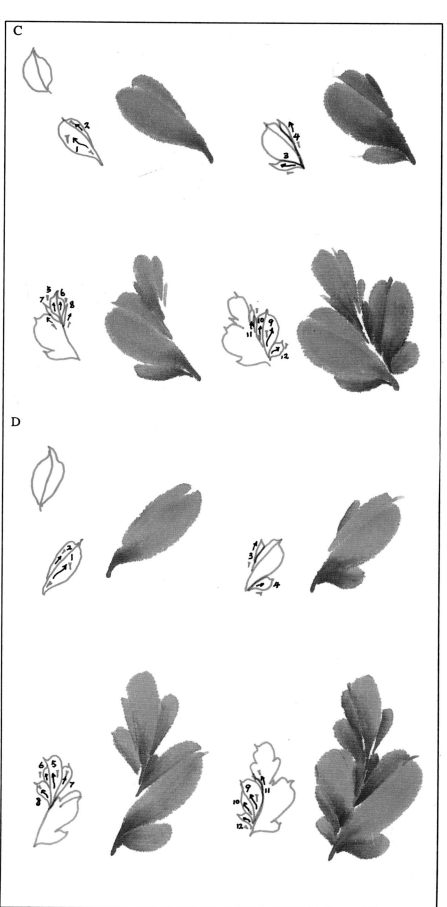

Fig. 6-4 Front Raising Leaves

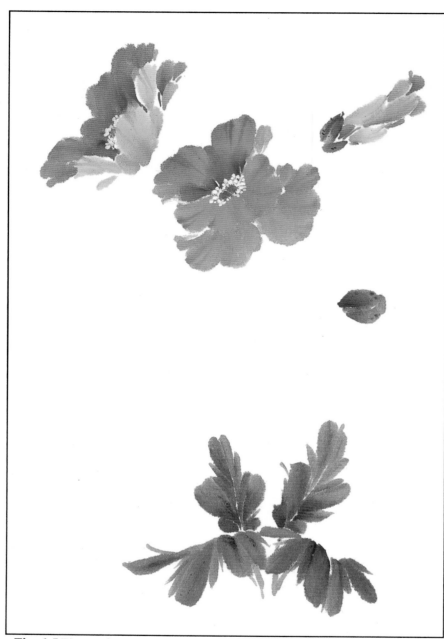

Fig. 6-5 Flower Groupings and Front Leaves

Projection of the Stalks
See Fig. 6-5, 6.

Project the stalks from the center base of the flowers. Show each one with a graceful curve. Avoid parallel formation. Group 3 stalks into a tight cluster to form a host, and set one stalk off as the guest.

Crossing the stalks is a good way to project depth and divide spaces. However, it is important not to show a confrontational "X." It is like saying "This is wrong." Try to ease one stalk into the other with a soothing angle.

Fig. 6-6 Projection of the Stalks

Stalks

See Fig. 6-7.
Brush: Flow
Colors: 1/3 medium Green + 1/8 strong Crimson, Blend.

Work the stalks in; begin with the lower elements--the bud, the full flower, then the teenager and the profile flower.

Do the stalks from the top downward. Maintain an even pressure, and move with a steady pace. Pause to adjust the brush tip if necessary, but try to avoid the "bamboo syndrome (pausing at the identical length)."

It is important to keep the brush tip travelling at the center of the stalk throughout the whole length.

The stalk of the bud needs to make a "U" turn; and do the turn gently. Aim the stalk of the full flower perpendicular to the base of the seed pod. Do the stalk of the teenager; let it cross the stalk of the full flower early to avoid an obvious "X" in the middle of the composition. Work the stalk of the profile flower last. Be careful not to run it parallel to the stalk of the full flower.

Thread the flower stalks through the front leaves. Show their roots like fishes looking for the same food, with the center ones lower than the side ones.

While the stalks are still wet, use the Happy Dot Brush, and load 1/3 strong Crimson; add fine dots along the stalks. Make these dots unevenly distributed. Show some along the sides, and some inside the stalks.

We have a tendency to get overly excited about adding dots. In reality, there are a cast of thousands of fine hair along the stalk. We cannot do them all. Get hold of yourself, enough is enough.

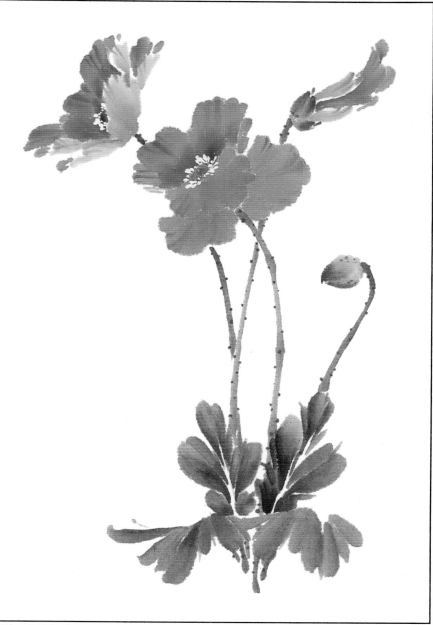

Fig. 6-7 Stalks

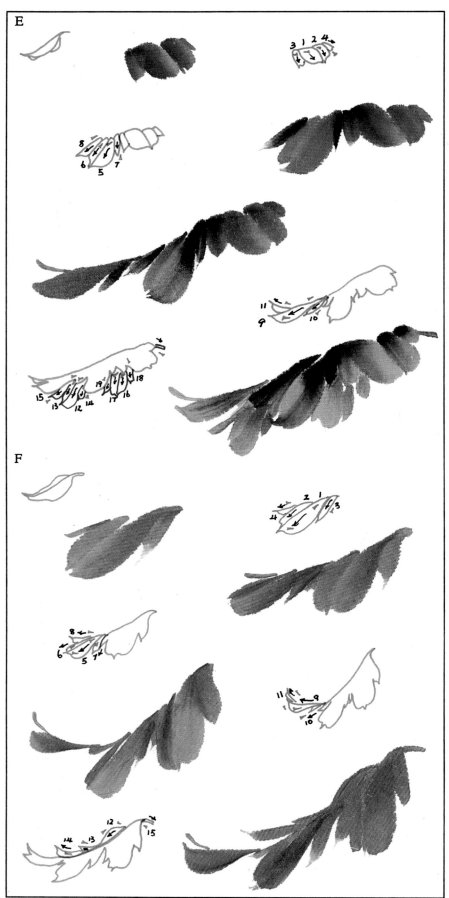

Leaves Reaching to the Left Side

Brush: L. Orchid Bamboo
Color: 1/3 medium Green + 1/6 strong Indigo + 1/8 Ink; blend the tip.

Marilyn's Skirt

See Fig. 6-8 E.
Hold the brush diagonally, with the tip pointing to 9 o'clock. Do Stroke 1 and 2 with the side of the brush. Begin the strokes with some width; make them fat and short to suggest they are only half showing. Add two smaller strokes (3, 4). Line their top to show the center vein.

Turn the handle of the brush, with the tip pointing to 2 o'clock. Do Stroke 5 a little longer. Complete the center portion of the leaf (6, 7, 8), keeping the beginning of these strokes still in line.

Begin Stroke 9 by sliding down further. Do Stroke 10, then let Stroke 11 extend with a cheerful, uplifting curve.

Load the brush with 1/3 medium Green + 1/6 strong Crimson, then do two groups of strokes to reveal the underside (12-19). Allow them to extend longer than the top side, so the overall shape of the leaf shows more in-and-out contour. The strokes are done mostly with the side of the brush to suggest that they are half way showing.

Use the colors left on the brush to do the stem after the leaf; it can be dark or light. We may not need any stem if the leaves are overlapping. But, then, some of us may need a long stem to bring the leaves home. At this stage of our adventure, I may still be your guide, but the Lord only knows where you are. Just remember, all fishes are looking for the same food (the root of the center stalk), and may the Lord be with you.

Eagle's Wing

See Fig. 6-8 F.
Hold the brush diagonally, with the tip pointing to 2 o'clock. Do Stroke 1 with the side of the brush. Begin Stroke 2 a little lower, with the brush held vertically. Add two strokes (3, 4) to show the serrated points. Line the beginning of these strokes to show the center vein. Do another group of strokes (5, 6, 7, 8) the same way, but tilt further to the left and skinnier. Extend the tip of the wing with Strokes 9, 10, and 11. Add Strokes 12, 13, and 14 to show the other side of the leaf if needed. The top strokes are added to make the leaf fuller and to break the monotony of the top edge.

Fig. 6-8 Leaves Reaching to the Left

Leaf Reaching to the Right Side

See Fig. 6-9 G.

When a leaf is folding upward, its underside is showing in the front. We do the underside first.

Brush: L. Orchid Bamboo
Color: 1/3 medium Green + 1/8 strong Crimson; blend the tip.

Hold the brush diagonally, with the tip pointing to 8 o'clock. Do the first group of strokes (1, 2, 3, 4) with the side of the brush. The base line of these strokes shows the course of the center vein. All the strokes begin with some width to show the folding nature of this portion of the leaf.

Pointing the brush tip to 8 o'clock, work Stroke 5 with its right side continuing the course of the center vein. Complete this portion of the leaf with additional strokes (6, 7, 8).

Extending the tip portion of the leaf with Strokes 9 and 10; project a graceful curve along the lower side.

Reload the brush with 1/3 medium Green + 1/6 strong Indigo + 1/8 Ink. Do the top side of the leaf (11-19). Show hills and valleys. The strokes are done mostly with the side of the brush to suggest that they are only showing half of their bodies.

Leaf Reaching to the Back

See Fig. 6-9 H.
Brush: L. Orchid Bamboo
Color: 1/3 medium Green + 1/6 strong Indigo + 1/8 Ink; blend the tip.

Do the strokes the same way as the raising leaves in the front. But, because the leaf is placed behind the stalks, the strokes begin in line with the edge of the stalk. A hairline space is kept between the stalk and the leaf strokes.

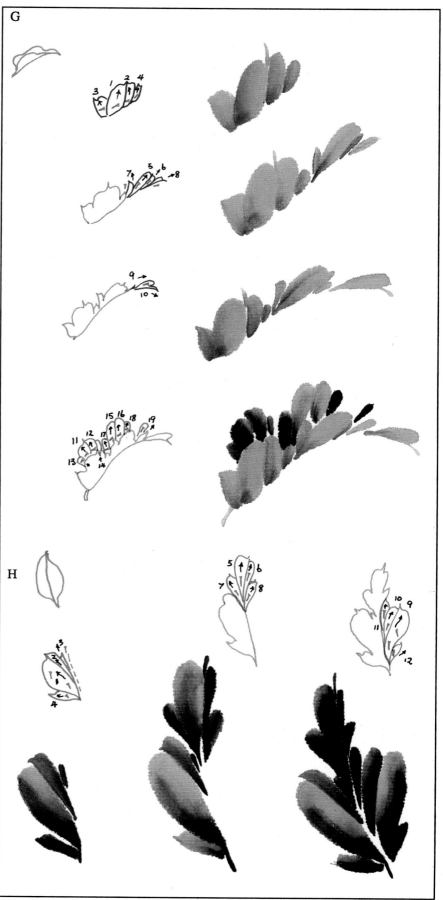

Fig. 6-9 Folding Leaf and Leaf Reaching to the Back

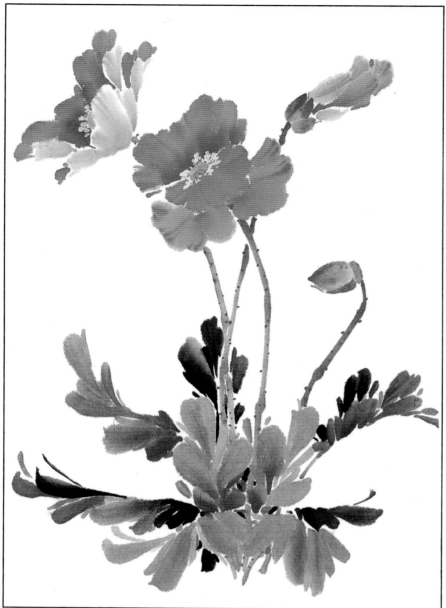

Fig. 6-10 Poppy Final

Shadow Leaves

See Fig. 6-10.
Brush: L. Orchid Bamboo
Color: 1/3 medium Green + 1/4 strong Indigo + 1/6 Ink, blend the tip.

To complete the composition, a couple of dark leaves (or suggestion of leaves) are added. These leaves are done with more Indigo and Ink. They add depth and seal off unnecessary spaces.

Another masterpiece is created!

Undoubtedly, we have seen an example of a beautiful poppy on Page 5 (Fig. 1-7, Lesson 2). I call the flower "Drunken Poppy," because of its rich wine colors.

Some of us may have already suffered an anxiety attack after our Tulip Lesson, for the lesson did not cover any information on the Purple Tulip (on Page 5, next to the Drunken Poppy).

Weep no more, my dear ones, allow me to present these well-guarded secrets to you now.

BONUSES
Colors for the Drunken Poppy
Chinese
Vermillion, Burnt Sienna, Yellow, Indigo
Winsor Newton
Purple Madder, Neutral Tint, Crimson Lake
Pelikan
White
OAS
Ink

Colors for the Purple Tulip
(Fig. 1-6, on Page 5)
Chinese Vermillion
Pelikan White
Winsor Newton
Permanent Magenta, Winsor Violet
Purple Madder, Neutral Tint
Petals:
Topside: Medium Purple Madder
+ strong Winsor Violet
Underside: Diluted White + medium
Vermillion + medium Magenta +
Strong Winsor Violet at the tip
Center: Thick Neutral Tint
Veins: Thick Winsor Violet
Stamen: Thick Vermillion

Preparation for the Drunken Poppy
Seed Pod: Happy Dot Brush
Topside: Strong Purple Madder
Base: Mix White with Green (Yellow + Indigo)
Dark Patches: Flow Brush
Medium Crimson Lake + strong Purple Madder +
thick Neutral Tint
Petals: Large Flow Brush
Underside: Diluted White + medium Vermillion
+ medium Burnt Sienna
Topside: Load colors for the underside, rinse the
brush tip, add strong Vermillion + Crimson Lake
+ a little Purple Madder
Veins: Happy Dot Brush
Strong Crimson Lake + Purple Madder
Pollen: Flow Brush
Strong Neutral Tint + thick Ink

LESSON 7
LOTUS
Flower

ART WORK
Fig. 7-1 Lotus

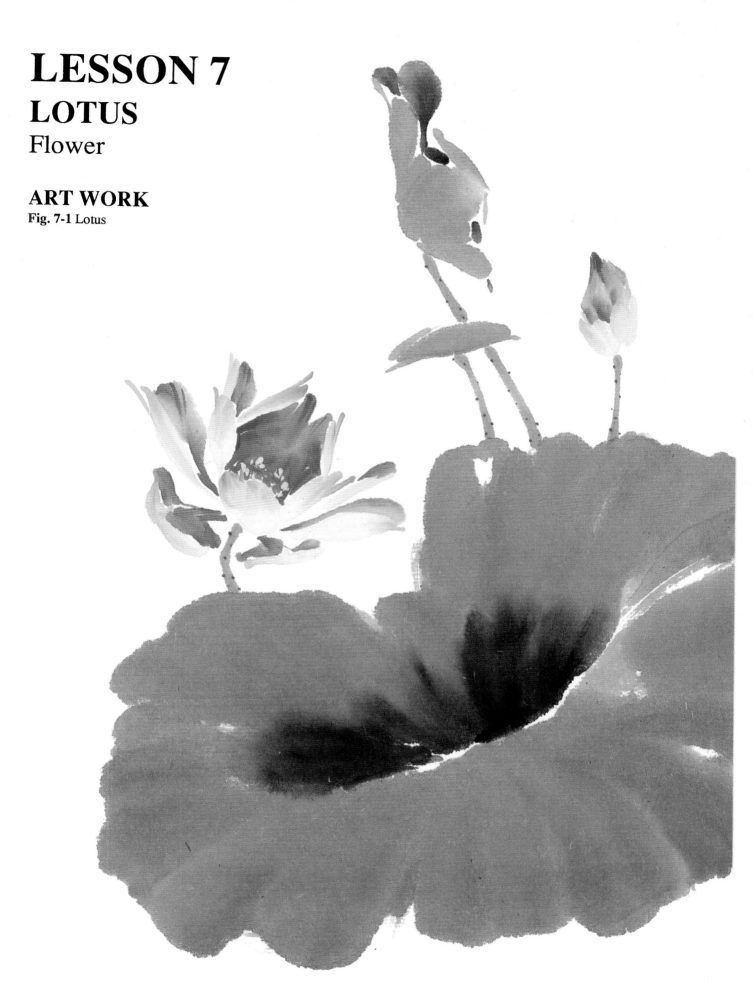

Fig. 7-2 Material Setup

MATERIALS

For best results, use the following recommended materials (available at OAS)

See Fig. 7-2 and follow the preparation steps.

Rice Paper
Best Shuen or **Double Shuen**

Brushes
Large Orchid Bamboo (or **Orchid Bamboo**): Petal
Flow: Petal, seed pod, stem
Happy Dot: Pollen, dots
Large Flow: Leaf
(**Super Flow** or **Dragon** is the ultimate brush for large leaves).

Colors
Chinese
Yellow
Indigo
Vermillion

Pelikan
White (or OAS White)

Winsor Newton
Permanent Magenta
Crimson Lake
Charcoal Gray

Dr. Martin's
Bleed-proof White

See Fig. 7-3 to identify the materials.

Fig. 7-3 Material ID

PREPARATION

Rice Paper

Best Shuen or Double Shuen, about 18" x 27"

Colors

Test prepared colors on Double Shuen to match Color Dots Chart (Fig. 7-4).

Fig. 7-4 Color Dots: (On Double Shuen)

1 Magenta		6 Indigo	
2 Pink		7 Warm Green	
3 Crimson		8 Yellow White	
4 Light Green		9 Charcoal	
5 Dark Green			

Use an inexpensive brush (like OAS Basic Hard Brush) to prepare the colors.

1. Magenta

Put Permanent Magenta (1/2" long) into one section of the Flower Plate. Soften it with a slightly wet brush (I use a finger to blend to keep the thickness of my color). Mix a little Crimson Lake (1/6"). The mixture should still be thick (for petals).

2. Pink

Put one brush load of Pelikan White into a section of the flower plate. Add water to make it transparent (Grecian Formula). When you load this White on the brush, you should still see the natural color of the bristle. Mix a little Magenta (1) into the White to turn the mixture into a weak pink (mostly white).

3. Crimson

Put Crimson Lake (1/4") into one section of the Flower Plate. Soften it with a slightly wet brush. Keep the color thick (for the center of the flower).

4. Light Green

Soak Yellow chunks with 3-4 tablespoons of water for at least 10 minutes; blend softened Yellow into water, keeping the mixture strong. Pour about 3 tablespoons of Yellow into a saucer. Add a little Indigo into the Yellow, and blend into Light Green. Keep it medium (for the undersides of the leaves).

5. Dark Green

Pour about 3 tablespoons of Yellow into a saucer. Add a little Indigo into the Yellow, and blend into Dark Green. Keep it medium (for leaves the topsides of the leaves).

6. Indigo

Wet the chips (use a spray bottle or brush) with 2-3 drops of water; keep it thick.

7. Warm Green

Bring 1 tablespoon of Green into one section of the Flower Plate; add a little Vermillion and Crimson Lake, developing the mixture into a Warm Green (for stalks).

8. Yellow White

Take a generous portion of the Bleed-proof White from the jar with a wet brush. Smooth the White onto a section of the Flower Plate; mix in a small portion of Yellow. The mixture should stay in a creamy condition---not too pasty or too runny---smooth (for pollen).

9. Charcoal (Ink often gets too dark, Charcoal Gray is better)

Use Charcoal Gray fresh from the tube (about 1/6") into one pocket of the Flower Plate; add a little Indigo and Dark Green, keeping the mixture thick (for the center of the leaf).

IDEA OF THE LOTUS

At dawn, rows of children ride on their bicycles passing the arch bridges across the West Lake in Hangzhou, South China. Under the bridge, each bud of lotus opens after a night of embracing.

In the heat of summer afternoon, the sizzling sun is baking everything in sight. Even the tireless cicadas stop humming. The air is dreadfully thick and still; every willow leaf droops its head.

A gentle breeze starts. All the flowers in the pond begin to nod, and the leaves do their Marilyn Monroe act with raising skirts. Fragrance traces miles away. Soon the dark cloud grows thick. Bean size drops land. Like a million pearls let loose from heaven, they dance on every leaf, accompanied by the music they create. Some jump up and down, others do the motor drum around. They roll to the center of the leaf. Quickly, hundreds of little round pools appear. The playful leaf buckles and sends the first batch into the pond with a cheer, then starts greeting the newcomers. Heat sweeps away with the smell of dust. Rain ends as fast as it starts. Cool.

Young girls roll their wooden buckets, cutting the fresh seed pod, singing. You hear them near, you hear them far.

What an incredible beauty---lotus, or Ho Hwa (荷花)---as the Chinese call them. It has enchanted artists and poets for thousands of years.

"I know the lotus, it is like a water lily..." I get irritated when I hear this. It is like comparing a court lady to a street walker. The lotus is regal. It rises above the water a foot high. Its large, showy shape is illuminated with transparency. Each petal offers inspiration in an artist's dream. Its color can only be imitated when a young maiden gets herself slightly drunk. Its fragrance has no equal. Every part of the lotus---from its root to its seeds---is treasured as a delicacy or medicine. The water lily is small and monotonous. It chooses to float and drift without a purpose. You will not learn the water lily from me. But, we will spend two lessons on the lotus.

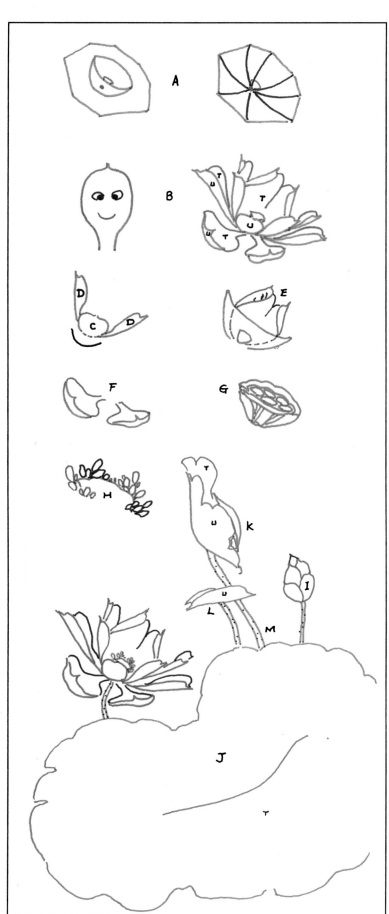

Fig. 7-5 Elements of Lotus

ELEMENTS OF LOTUS
See Fig. 7-5.

Flower

Idea
See Fig. 7-5 A. The lotus petal forms a cup shape in the middle and extend outward like an octagon. The root of the petals come to the center (base of the seed pod).

Petal
See Fig. 7-5 B. The petal resembles the head of a Kewpie doll. It has a pointed tip, wide shoulders and a slender root. The topside (T) is darker, and the underside (U) is lighter.

Petals in the Front of the Cup
See Fig. 7-5 C, D. They show their backside (underside). The center petal (C) is foreshortened, with the base rounded off. Side Petals (D) reach taller. They are spoon shaped, folded in half, with roots ending into the shoulder of the center petal. Together, they form a "U" curve.

Petals at the Back of the Cup
See Fig. 7-5 E. They show a parenthesis formation (with the lower half hidden). Their Heads bend like a pair of Japanese business men greeting each other.

Bending Petals
See Fig. 7-5 F. The spoon tip turns upward, with uneven shoulders (inside wider).

Seed Pod
Shaped like a shower head, the seed pod is light green colored and sits at the center of the flower.

Pollen
See Fig. 7-5 H. Creamy light Yellow dots, form clusters surrounding the seed pod.

Bud
See Fig. 7-5 I. Three layers of petals form the bud.

Leaf
The topside (T) is darker and the underside (U) lighter.

Full Leaf
See Fig. 7-5 J. A large circle with center indented forms the full leaf.

Teenager
See Fig. 7-5 K. Wrap from both sides like a clam shell, with the center strip showing occasionally.

Baby
See Fig. 7-5 L. Both sides are wrapped tightly together.

Stalk
See Fig. 7-5 M. Long and sturdy, the stalk has little red dots all over. Each flower and leaf have its own stalk.

STEPS

Flower

Cup

Brush: Large Orchid Bamboo; Colors: 1/4 transparent Pink + 1/16 strong Magenta.

Front Middle Petal

See Fig. 7-6 A.

Do the petal tip with one small stroke. Hold the brush vertically; work the left side with the brush tip making an arch turn (the small triangle shows the placement direction of the tip). After the turn, lower the boom (1). The stroke looks like a duck swimming sideways (all my flowers are made of ducks in hiding).

Work a couple of strokes to smooth the right side (2, 3). The right side is the center vein of the petal. Hold the brush at a 45-degree angle, with the tip pointing to the left; work Stroke 4 with the side of the brush.

Front Side Petals and Top Petals

See Fig. 7-6 B. Reload the tip with Magenta, blend. Do the left side petal with two downward strokes (1, 2) to show the tip and the shoulder of the petal. Reload the tip, and do the right side petal (Strokes 3, 4). End the petals higher than the center petal to project a balanced "U" shape.

Do the top petals the same as the side petals above. Show the top half as a parenthesis or a pair of Japanese business men greeting each other. Project the roots of the petals reaching to the center of the flower (The center is hidden behind the middle petal). Do not bend the petals' roots inward; let them go out and attach to the upper part of the lower petals (5, 6, 7, 8).

Seed Pod

See Fig. 7-6 C. The seed pod is shaped like a shower head; the top oval shape is slightly ruffled, like a jello mold. The base section is divided. Use the Happy Dot or Flow brush, and load strong Light Green. Work the top half the oval first, varying pressure to show ruffles (1). Do a few dots below it. Make the spaces among the dots and line into very fine lines (2). Add the lower half of the oval (3), and develop the base with heavier lines (4).

For this flower, we need only the top half of the oval with a couple of dots. Do them in the center of the "U" and have them closely attached to the top of the middle petal below (See Fig. 7-6 D).

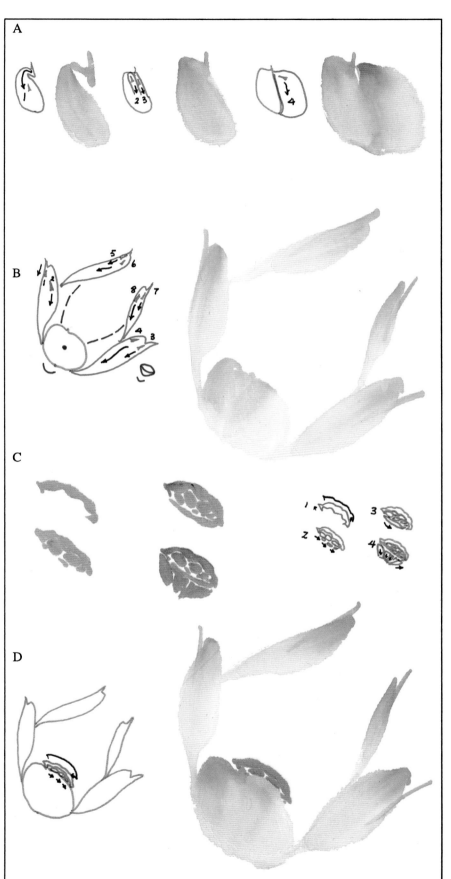

Fig. 7-6 Cup and Seed Pod

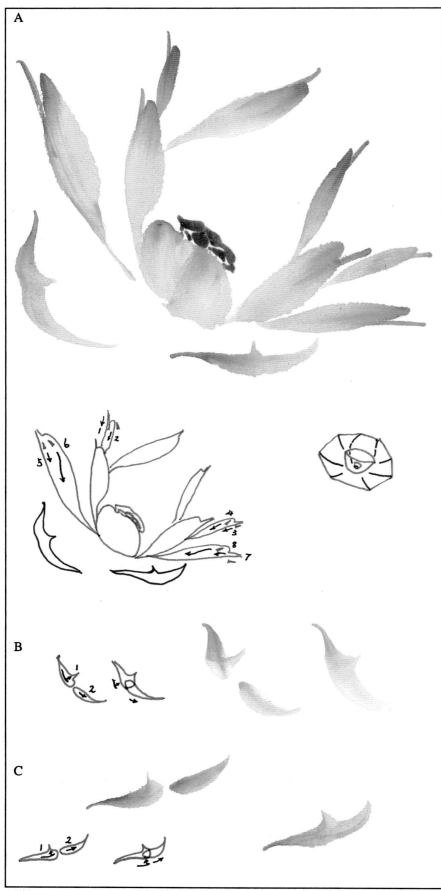

A

B

C

Fig. 7-7 Perimeter Octagon

Perimeter Octagon
See Fig. 7-7.

Side Wings
See Fig. 7-7 A.
Add four spoon-shaped petals (Strokes 1-8). Make the left side ones longer and wider, with intervals between them. The right side ones are shorter and closer. This is the way to make the flower tilt to the right. Lead these petals to the base of the seed pod.

The side petals need to end higher than the cup petals to show that they are behind the cup.

Birds
See Fig. 7-7 B, C.
Add two "birds" below the cup. These are the tip portions of two bending petals. Spread them apart; do not let them come close to each other. Do let them stay close to the base of the cup, but do not drop them too low. Allow their baseline to reflect the lower half of an oval.

Each bird shape is made up of two strokes. Stroke 1 begins with no pressure; lower the boom as it moves to the right. Then lift the pressure to regroup the tip (The tip still keeps contact with the paper, only not so pressed down). This lift moves the tip back a little. At this time, change direction 90-degrees and do a sidekick, and release pressure to show the petal point.

Stroke 2 begins inside the heavy area of Stroke 1. It begins with pressure to match the width of Stroke 1, lift the pressure as the stroke moves to the right.

Fig. 7-7 B, and C show the strokes first as separate units, then the overlapping version. The bird on the left shows a longer right side (B), while the bird on the right shows a longer left side (C).

With two Japanese gentlemen greeting each other, four wings on the side, and two birds below, we come up with the eight points of our octagon.

Top Petals (Inside)

See Fig. 7-8 A.

Rinse the very tip of the brush (1/16"); dry it on the paper towel. This is to ensure that there is no more Pink color left on the tip. The Pink is still on the brush above the tip, and should be kept there throughout the flower. Occasionally, we need to rinse the whole brush and reload the pink, if it gets too weak.

Load 1/8" strong Magenta. Blend the tip.
Do Stroke 1 with an arched turn; then add Stroke 2 to complete the top left side. Reload the tip, and do the right side (3). Do all the strokes with the "lowering the boom" method. Leave the center area of the flower open.

Leave a hair line space between these strokes and the outside petals to prevent the colors from running into each other.

Center Area Strokes

See Fig. 7-8 B.
Seal the center area with a series of strokes moving upwards to join the shapes above.

Load 1/6" strong Magenta and 1/8" thick Crimson. Stroke 1 begins with no pressure from the base; lower the boom as you move upward, until it blends into the top shape. Tilt the brush to allow the tip to point to the base of the stroke when you start.

Stroke 2 shows a spread root. Begin with the brush tip set sideways (a), then pivot the brush a quarter turn counter-clockwise. The tip is turned pointing downward with this move (b). Move upwards to join the shapes above with the lowering the boom method (c).

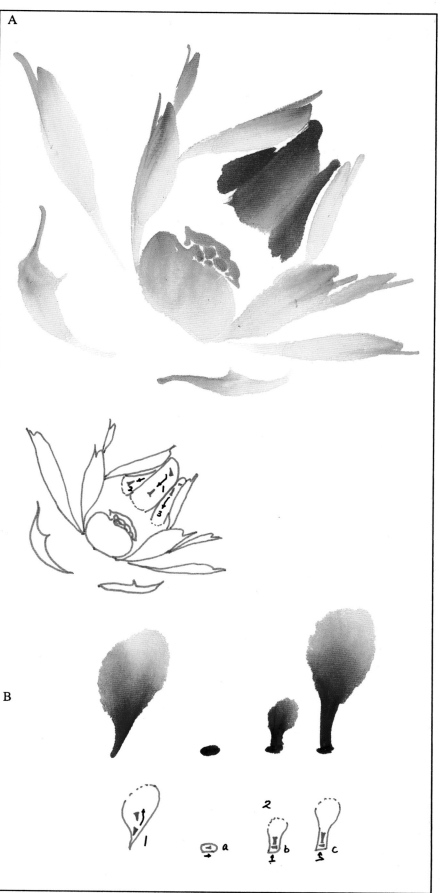

Fig. 7-8 Top Petals (Inside) and Center Area Strokes

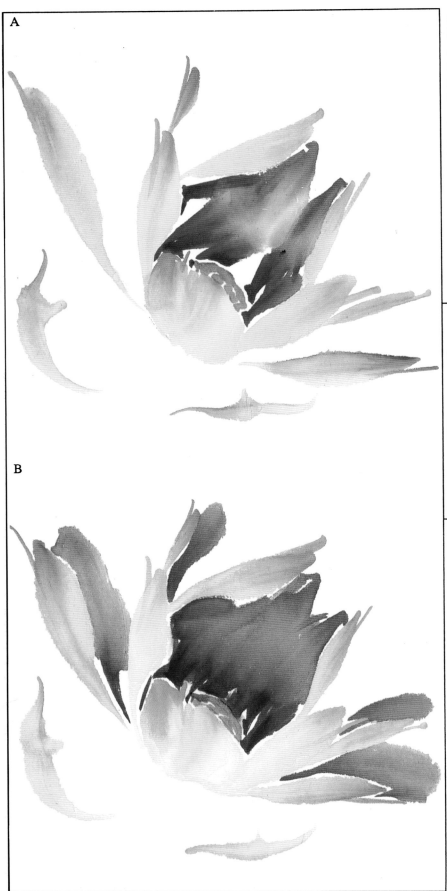

A

B

Fig. 7-9 Center Area and Wing Petals (Inside)

Center Area
See Fig. 7-9 A.
Apply the center area strokes. Use the pointed ones to reach into the gap between the front petals. Use the square root ones to do the open areas.

Work the strokes to complete the roots of the top shape respectively. Keep a hairline space open between the top and lower petals. Eventually, seal the center area completely (B).

At this time, use the Flow brush; wet it slightly in the water, then dry the tip. Brush on top of the seed pod with this "dry" moisture. This method helps to marry the odd looking green seed pod (Dances with Wolves) with the red roots of the petals all around (Indians).

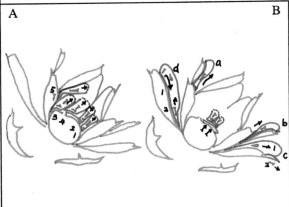

Wing Petals (Inside)
See Fig. 7-9 B.
Load 1/8" strong Magenta and 1/16" thick Crimson. Tilt the brush to allow the tip to point to the base of the stroke. Lead the strokes out by lowering the boom. Use this method on the right side petals or small petals.

Some petals are rooted high. We need to make the base a little wider to suggest the petal is continuing down into the center (a). Some petals need more than one stroke at the root (b). Some petals need more than one stroke at the top (c).

The large petal on the left side (d) is done with a different method.

Load 1/8" strong Magenta. Move a stroke from outside in, first with an arch turn; then lower the boom (1). Stop the stroke about 2/3 the length of the petal. Reload the tip with 1/16" thick Crimson. Remember always to blend the tip. Move a stroke (2) up to join the top shape, with the lowering the boom method.

Bending Petals (Inside)

See Fig. 7-10.

These are tough cookies. We want to show the spontaneity and transparency of the strokes. We want the shape to suggest the location of the petal. We do not want the shape too rigid.

The bending petals are foreshortened spoons. They need to be rooted apart to show that they are going in further and to allow room for the stalk. The roots should be wide (See Fig. 7-10 A).

Load 1/8" strong Magenta and 1/16" thick Crimson.

Left Spoon

See Fig 7-10 B.

Lead a line out to show the root of the petal; then make a "U" turn while lowering the boom (1).

Add the width of the root with another stroke and come down to fill the right side of the spoon (2). Still widening the root (3), move left (up) and lower the boom (4), smooth the edge if necessary (5).

Right Spoon

See Fig 7-10 C.

The right spoon is the reverse of the left spoon. Do two strokes to show the root (1, 2). Work a third stroke sideways to finish the left side (3). Add the right side with another stroke (4).

It is here I find the students engaging in extensive repair work. Show the spontaneity of the strokes and let them be. If you do too much fix up, these two spoons can be renamed "Terminator 1" and "Terminator 2."

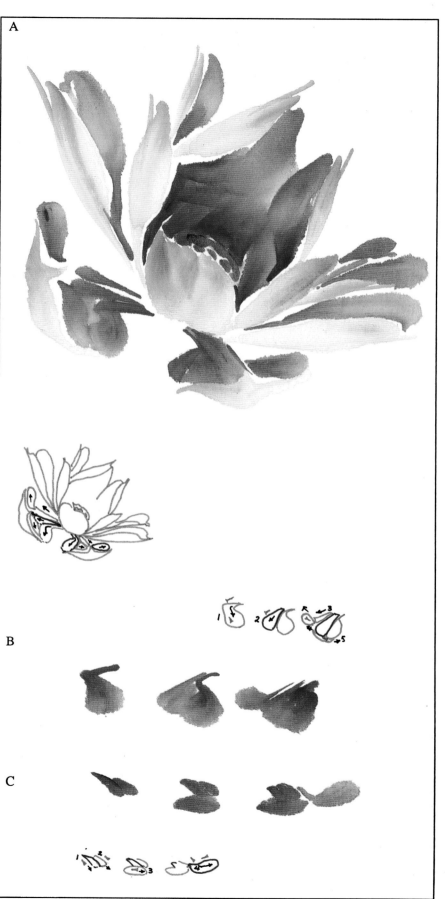

Fig. 7-10 Bending Petals

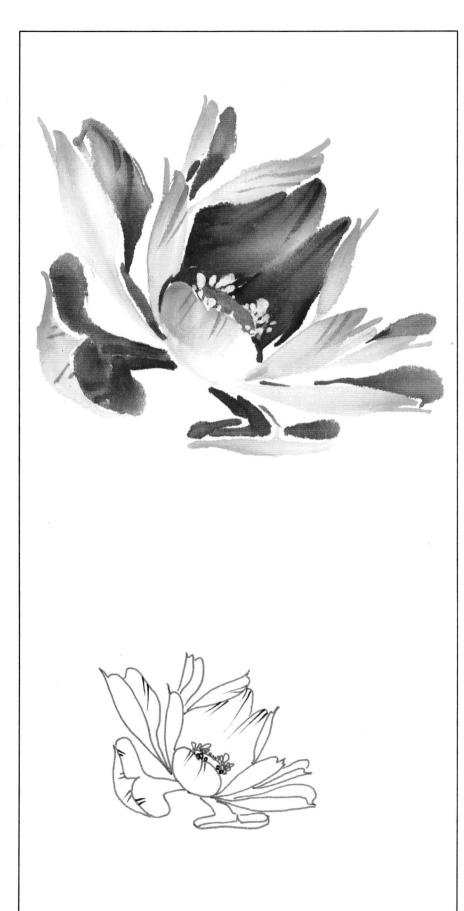

Fig. 7-11 Pollen and Veins

Pollen

See Fig. 7-11.
Brush: Flow
Color: Load 1/3 creamy rich Yellow White

Surround the seed pod with pollen dots in happy clusters of two or three. Show a host and guest relationship. Allow the pattern of the dots to agree with the petal formation: The top ones greeting each other, the side ones extending outward, and the front ones foreshortened.

Pollen dots are fully shaped. Scoop the tip of the brush when you do them, hum a happy tune, nod your head as you move along. But get hold of yourself; do not overdo them.

Veins

See Fig. 7-11.
You have come this far with beautiful petals showing wonderful transparent fluidity. Do you really want to ruin your flower with bad veins? Stop; there is no need to put veins.

I have occasionally run into students who use veins to cover up boo-boos. Like a criminal's need to return to the scene of the crime, it only makes the boo-boos more pronounced.

We do veins to add a bone element to our flowers. They should be a fully integrated feature, done while the petals are still wet. They should be bold, decisive, and selective.

Brush: Happy Dot
Colors: 1/4 strong Magenta + 1/6 thick Crimson; blend the tip.
Do the darker petals first; use up the dark colors on the tip, then move to the lighter petals.

Work all the strokes from the outside edge of the petals inward with a curve. Arrange the groupings of veins into a host and guest relationship, varying interval, length, and size.

It takes a life long effort to capture the intangible quality which makes the lotus one of the most elegant spirits among flowers. Practice this flower 20-30 times. Eventually, we begin to develop a rhythm. We become so confident that each petal just flows out of the tip of our brush. Or, we become so frustrated that we no longer care. In either case, good things will come. Our lotus will blossom into something spectacular.

Now that we have experienced the lotus flower, let us study the rest of the elements of the lotus in our next lesson.

LESSON 8
LOTUS 2
Composition

With great care, we have explored the exquisite petal patterns of the lotus flower in our last lesson. In this lesson, we need to turn ourselves loose. The lotus leaf is one of the most dynamic subjects in brush painting. We must be bold and free.

STEPS
See Fig. 8-1.
Let us study the steps toward our masterpiece.

1. Work a full leaf leaning to the left to anchor the composition. The leaf takes up half the painting.

2. Do a host flower on the left side, carrying the flow of the leaf. Then turn to 1 o'clock, to bring the attention back to the center. The flower rises above the leaf and creates a "V" space in the middle.

3. Do a baby leaf off center to the right, as a stepping stone to link the various elements of the composition. It is well protected, very happy to be in the middle.

4. Pair the baby leaf with a teenager leaf. Keep the two leaves close to form a vertical formation. The spaces among the three leaves should be varied.

5. Add a bud on the right side of the composition as a guest element. The bud is higher than the flower. Group the bud with the two small leaves to form a pleasing triangle.

6. Run the stalks for each of the elements above the full leaf. Tuck them behind the full leaf. Begin with the baby leaf (6). Work the stalk in relation to the leaf like a tilted "T."

Do the stalk for the teenager next (7). Let it grow from the fatter half of the shell shape. Ideally, it should come out from the middle of the "U" curve. However, that would involve too much of a "U" turn, so do a short cut. Avoid parallel movement with the baby stalk. Proceed to bring the stalks for the bud (8) and the flower (9) down.

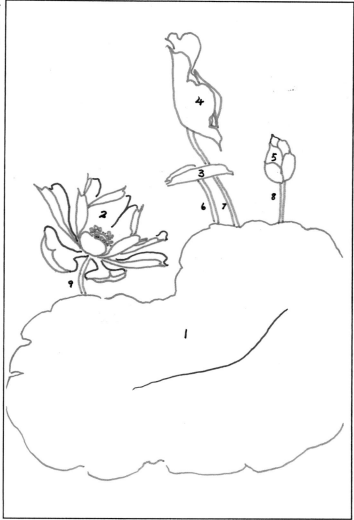

Fig. 8-1 Composition Steps

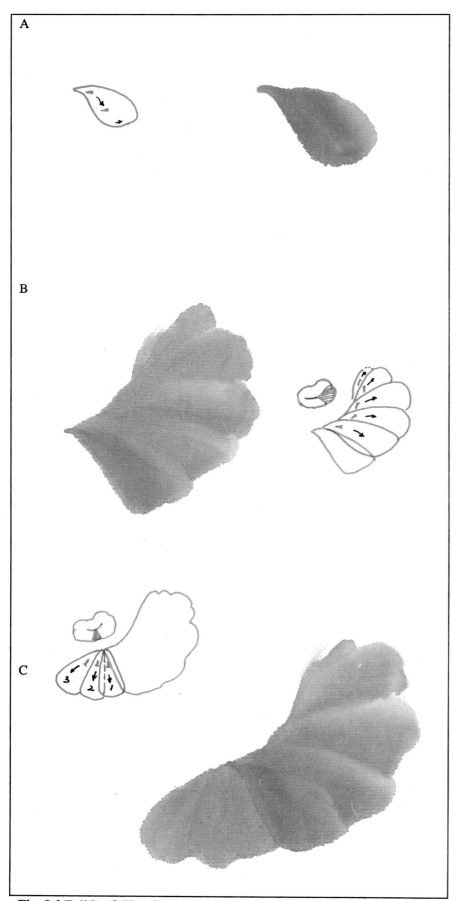

Full Leaf

Brush: Large Flow or Super Flow
Color: 1/3 generous medium Dark Green

A very exciting collection of strokes are used in the formation of this spectacular leaf. Study the placement of the brush tip for each stroke (the small triangle). I encourage you to do this leaf many times to learn how to handle the brush strokes from different directions.

Basic Stroke

See Fig. 8-2 A.
Hold the brush diagonally, with the tip pointing to the left. Work the stroke with the side of the brush. Begin with no pressure, and gradually increase the pressure as the stroke moves down. Lift the stroke by rounding off the baseline with the tip.

Lower Right Side

See Fig. 8-2 B.
Overlap a series of basic strokes to build the shape with a continuous skirt. Begin the strokes shorter, and elongate them as you move to the right so that the shape shall eventually turn into an oval. Allow the top edge to show half of a "U" curve.

The shape of each stroke is a curved triangle, not a square. Do not begin the stroke with too much pressure. Turn the angle of each stroke; avoid running them parallel. Imagine you are slicing a round cake. If you keep slicing the same direction, you never get to go around. The guests are waiting.

Overlap the strokes; do not leave an opening gap between the strokes. Notice each of the latter strokes begins from the shoulder of the former stroke. Blend the colors into a consistent tone.

End the right side with a dry stroke, to prevent the edge from forming a water mark. Eventually, the topside strokes need to blend into this area to complete a full circle.

Lower Center

See Figure 8-2 C.
Hold the brush vertically. Load the brush to match the color of the first stroke. Work a few overlapping strokes to develop a transitional area.

Fig. 8-2 Full Leaf: First Stroke, Lower Right Side, Lower Center

Lower Left Side

See Fig. 8-3 A.

Reload the brush, and tilt the handle to let the tip point to the right. Overlap a series of strokes using the side of the brush to complete the lower left side.

Allow the top edge to continue the formation of the "U." Since the leaf is tilted, the "U" is heading more to the left. End the left side with a dry stroke, to prevent the edge from forming a water mark.

Top Side

See Fig. 8-3 B.

Reload the brush. Tilt it to let the tip point to 9 o'clock. Use the side of the brush to work a series of strokes from the top down.

Project the oval pattern of the full leaf. Begin the first stroke (1). Lead the stroke to the left side of the "U" space below. End the stroke early by lifting the pressure. Should the stroke root become solid, brush a couple of dry strokes to break the solid edge. This method should be applied to the root of all the top strokes. It helps to integrate the top strokes with the center dark strokes that come later.

Do a small stroke (2) on the right side of the first stroke to round off its edge. Then work a series of strokes (3, 4, 5) to complete the upper left side. Let the end stroke overlap into the lower skirt to connect the shape.

Do a couple of short strokes (6, 7) in the middle of the top area.

Reload the brush. Start on the top right side. Hold the brush vertically, do Stroke 8 with an arch turn, then add Stroke 9 to smooth the right side of Stroke 8.

Reload the brush. Tilt the handle to let the tip point to 10 o'clock. Do stroke 10 using the side of the brush (add more strokes that way if you feel comfortable).

Do a short stroke (11) to round off the edge of stroke 8 and ease the right side into the center.

Reload the brush. Tilt the handle to let the tip point to 7 o'clock. Do a couple of strokes (12, 13) from the inside out, to complete the top right side. Let the end stroke overlap into the lower skirt to connect the shape.

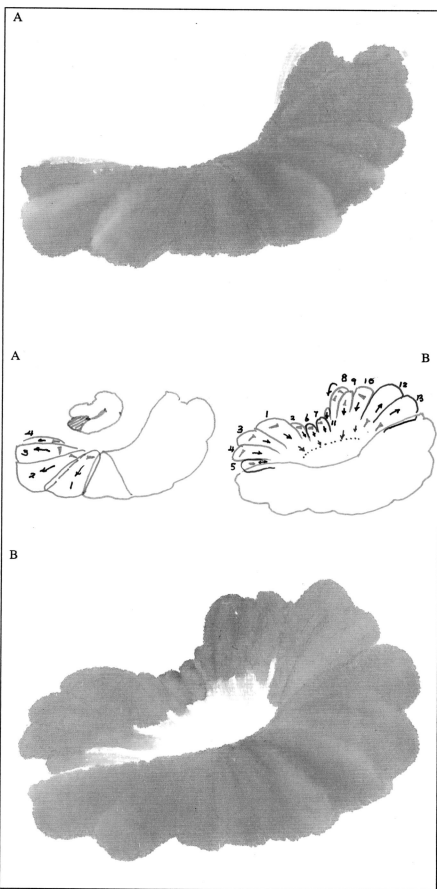

Fig. 8-3 Full Leaf: Lower Side and Top Side

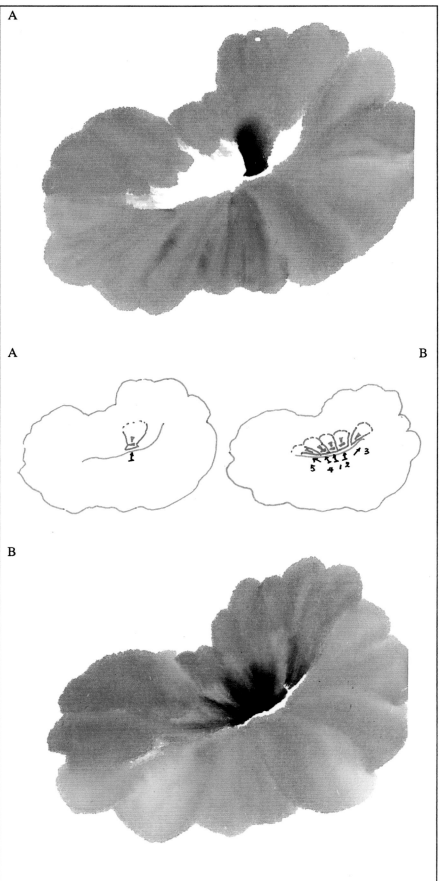

A

A

B

B

Fig. 8-4 Full Leaf: Center Area

Center Area

See Fig. 8-4.

The center area is the darkest. After completing the top shapes, do not reload the brush with moisture. Keep the bristle dry. Load the tip 1/8" with strong Indigo and 1/16" thick Charcoal. Blend the brush tip.

Start with the right side of the "U." Hold the brush tilted with tip pointing at 9 O'clock. Settle the brush tip along the edge of the lower shape, then pivot the brush with a quarter turn, so the tip is pointing to 6 o'clock. When the turn is complete, lower the pressure and move upward. This "lowering the boom" method allows the thick tip colors to blend into the strokes on top without a trace (Fig. 8-4 A).

Reload the tip. Do the same stroke on the left side a couple of times (Fig. 8-4 B, 1,2). Be sure that the strokes radiate slightly. Do not run them parallel to one another.

Reload the tip; add Stroke 3 and Stroke 4 on both sides of the dark shade to seal the corner areas. Use the "lowering the boom" method.

Leave a hairline space between the dark shade and the lower shape to prevent colors from running into each other. It also helps to show a streak of light and add depth to the leaf.

Teenager Leaf

The teenager is like a clam shell slightly opened.

Outside (Underside):

See Fig. 8-5 A.

Using the Large Flow, load 1/3 Light Green. Work the left side of the clam shell from the middle area. Hold the brush vertically. Do Stroke 1 by settling the tip down, pointing to 10 o'clock. Hold the pressure down while pivoting the tip a quarter turn (Here we go again). Move the stroke out and increase the pressure. The root of this stroke needs to be wide to suggest that the leaf is wrapping; only the top half is showing. Embrace the middle stroke with two strokes (2, 3). Tilt the handle, and place the tip according to the diagram. Begin the strokes a little higher to form a "U" curve with the first stroke.

Tilt the brush and point the tip to 6 o'clock; work Stroke 4 by lowering the boom. Favoring the pressure a little to the right. Extend Stroke 5 by following the edge of the left side of Stroke 4. Begin the strokes a little higher to continue the "U" curve. Come down to the lower end and do Stroke 6 and Stroke 7 the same way.

Do a couple of strokes (8, 9) to complete the other side of the clam shell. Certain areas of the two sides are close to each other. Be sensitive about the openings between the two sides. We do not want to open too wide.

Inside

See Fig. 8-5 B.

Reload the tip 1/3 Light Green + 1/6 strong Indigo + 1/16 thick Charcoal. Seal the open pocket between the two shells (1). Then use lowering the boom method to do the exposed inside shapes on both ends (2, 3, 4).

Baby

See Fig. 8-5 C.

The baby leaf looks like Washington's hat.

Use the Orchid Bamboo or L. Orchid Bamboo Brush; load 1/3 Light Green. Show the front tip of the hat with a stroke (1). Slightly tilt the handle to let the tip of the brush point to you; then do Stroke 2, carrying the stroke with a little pressure. Then follow the lower edge and extend the third stroke (3).

Tightly wrap the lower side with a stroke (4) to show the other side of the hat.

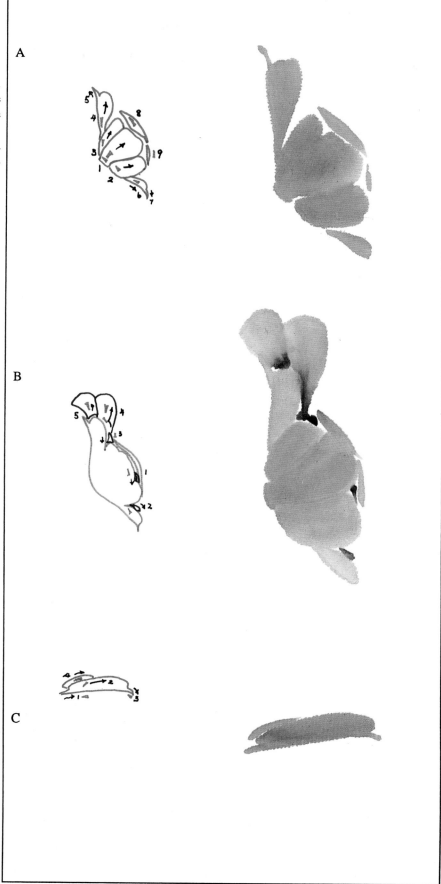

Fig. 8-5 Teenager and Baby Leaf

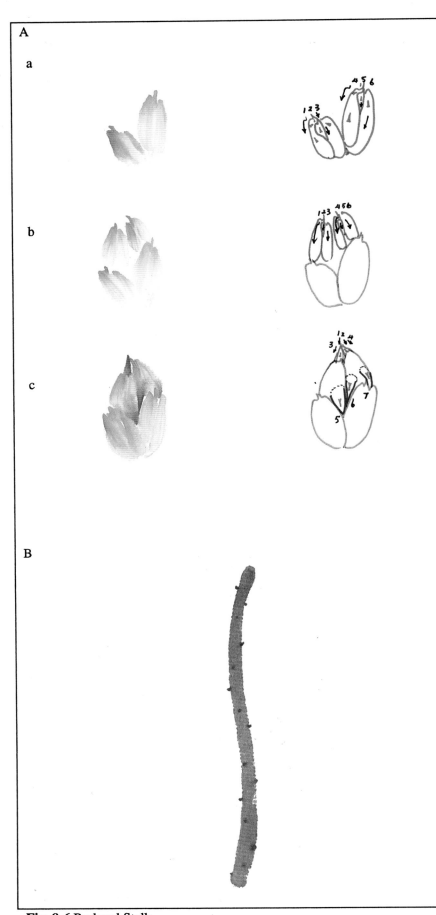

A

a

b

c

B

Fig. 8-6 Bud and Stalk

Bud

See Fig. 8-6 A.
Brush: Orchid Bamboo or L. Orchid Bamboo
Colors: 1/4 transparent pink + 1/16 thick Magenta
The bud shows three layers. Be aware of the size of the bud. The bud is a cute little thing. Get hold of yourself.

Base Layer

See Fig. 8-6 A, a.
The base layer has two petals spitting open and connected to form a "U" at the base. Do the left side petal first. Work a duck stroke on the left, a filler in the middle, and a stroke on the right (1, 2, 3). See instructions in Lesson 6. Reload the brush, and do the right side petal the same way. Make the right petal taller to prompt the bud to lean to the left.

Middle Layer

See Fig. 8-6 A, b.
The middle layer has two petals greeting each other. Load and work the brush the same way as the base layer petals. Leave a small area open between the two layers.

Top Layer

See Fig. 8-6 A, c.
Add 1/16 thick Crimson at the tip. Do the tip of the bud with strokes from the top down (1, 2, 3). Reload the very tip with Crimson. Tilt the brush to let the tip point down. Seal the opening between the layers with dark strokes (4, 5, 6) by lowering the boom.

Stalks

See Fig. 8-6 B.
Use the Flow Brush. Load 1/3 strong Warm Green. Plant the stalk for each element below the center of the "U" cup. Do the stalks from the base of each element downward. Show the spirit of fishes looking for the same food. Maintain the same pressure throughout the course of the stalk. Keep the brush tip travelling in the center of the stalk. Project each stalk with a curve.

Do the Full Flower first (As a rule, always do the lower flower first, because it is closer to us). Then work the stalks for the baby leaf, the teenager, and the bud. While the stalks are wet. Use the Happy Dot Brush. Load tip 1/4 with thick Crimson, and add fine dots throughout the stalks.

The Chinese name for the lotus is "Ho." It shares the sound with the words for joy, unity and harmony. Hang your lotus painting in your family room.

LESSON 9
HYDRANGEA 1
Flower

ART WORK
Fig. 9-1 Hydrangea

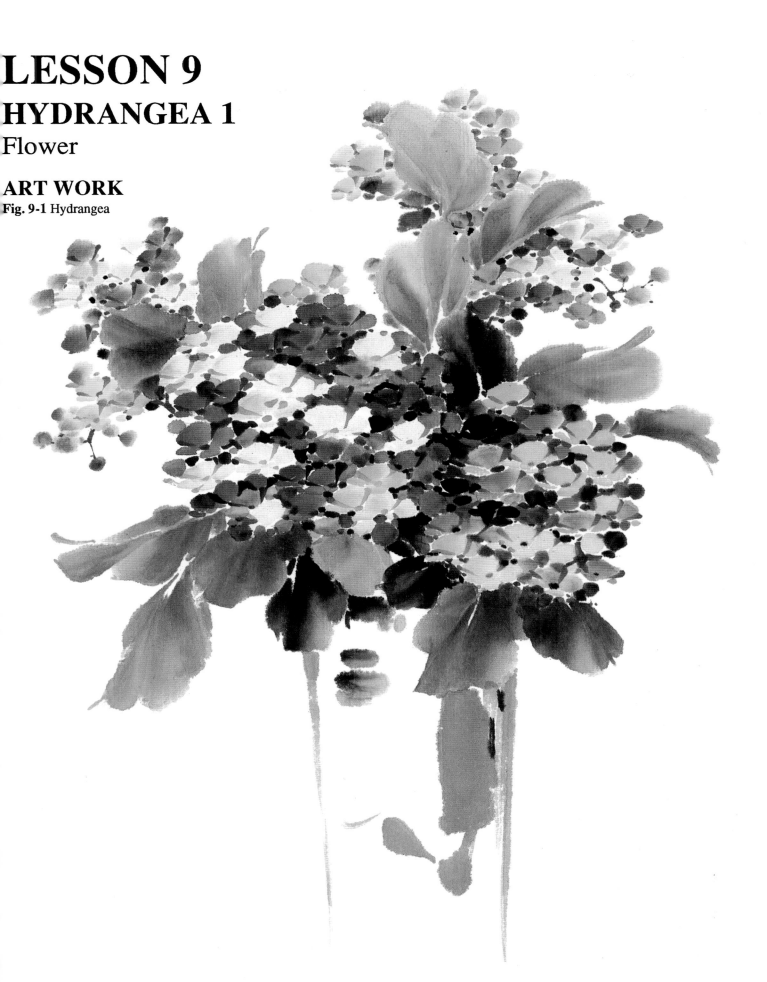

Fig. 9-2 Material Setup

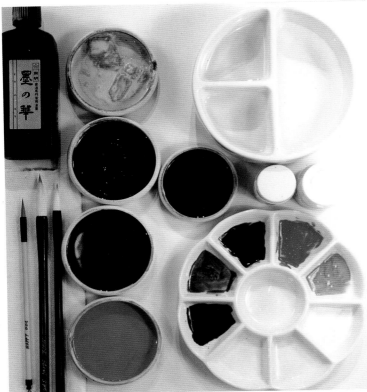

Fig. 9-3 Material ID

OAS BEST BOTTLE INK	
3 Yellow	
2 Indigo	5 Ink
4 Green	DR. MARTIN'S BLEED PROOF WHITE / PELIKAN WHITE
1 Vermillion	9 Dark Brown / 8 Warm Pink / 10 Winsor Violet / 7 Magenta Pink / 11 Deep Purple / 6 Pelikan White

HAPPY DOT / LARGE FLOW / FLOW

MATERIALS

For best results, use the following recommended materials (available at OAS)

See Fig. 9-2 and follow the preparation steps.

Rice Paper
Best Shuen or **Double Shuen**

Brushes
Flow: Flower petal, branch
Large Flow: Leaf, vase
Happy Dot: Stem, detail, dot

Colors
Chinese
Yellow
Indigo
Vermillion

Pelikan
White (or OAS White)

Winsor Newton
Permanent Magenta
Winsor Violet

OAS
Ink (OAS Best Bottle)

See Fig. 9-3 to identify the materials.

PREPARATION

Rice Paper
Best Shuen or Double Shuen, about 18" x 27"

Colors
Test prepared colors on Double Shuen to match Color Dots Chart (Fig. 9-4).

Fig. 9-4 Color Dots: (On Double Shuen)

1 Vermillion		7 Magenta Pink	
2 Indigo		8 Warm Pink	
3 Yellow		9 Dark Brown	
4 Green		10 Winsor Violet	
5 Ink		11 Deep Purple	
6 Pelikan White			

Use an inexpensive brush (like OAS Basic Hard Brush) to prepare colors.

1. Vermillion
Wet the chips (use a spray bottle or brush) with 2-3 drops of water; keep it thick.

2. Indigo
Wet the chips; keep it thick.

3. Yellow
Soak Yellow chunks with 3-4 tablespoons of water for at least 10 minutes; blend softened Yellow into water, keeping the mixture strong.

4. Green
Pour about 3 tablespoons of Yellow into a saucer. Add some Indigo into Yellow and blend into Green. Keep it medium (for leaves).

5. Ink
Fresh, pour about 1 tablespoon into a saucer.

6. Pelikan White
One brushful of pasty white; put it into the center of the flower plate. Add water to make it transparent.

7. P. Magenta (Pink)
Put Permanent Magenta into two sections of the Flower Plate (1/2" long each). Soften it with a slightly wet brush (I use a finger to blend my watercolor to keep its thickness). We use one Magenta for the flower, the other for the leaf.

8. Warm Pink
Mix Vermillion with P. Magenta. Keep the mixture strong (In the Flower plate).

9. Dark Brown
Mix Warm Pink with more Vermillion and a little ink. Keep the mixture strong (In the Flower plate).

10. Winsor Violet
Put Winsor Violet (1/2") into one section of the Flower Plate. Soften it with a slightly wet brush. Keep the color thick.

11. Deep Purple
Mix Dark Brown with Winsor Violet and add a little ink, keeping the mixture strong (In the Flower plate).

IDEA OF THE HYDRANGEA
Silky embroidery balls prepared by nature to celebrate the spring of life.

For years, I have tried unsuccessfully to bring this wonderful creation of nature to life in my painting. On July 4th, 1991, we watched the fireworks on the beach. As hundreds of shining dots formed spectacular multi-colored fireballs in a glorious burst in the deep purple sky, I regained my urge to paint the hydrangea.

Instead of using one color, I chose to mix various colors in each flower ball. I used light colors to show the bright areas of the ball, and highlighted the dimension by contrasting them with dark petals. I used cool colors (White, Magenta, Purple) and warm colors (Peach, Brown) together on one ball. I harmonized them by using some mixed elements (Warm Pink, Brown-Purple) as a matchmaker between the cool and warm.

The composition was done late at night. I was cleaning up the dishes with my brush as I finished the flowers. There were some dirty spots on the dishes where different colors got mixed up. They gave the missing link for my previously failed endeavor.

What a fitting way to celebrate July Fourth---a marvelous melting pot experiment which is the foundation of this great nation. What a wonderful subject to celebrate the conclusion of our flower studies. Let us bring out the wine, and let the fireworks begin.

The flower looks complicated, but it is a piece of cake. Everyone in my class did great.

Fig. 9-5 Elements of Hydrangea

ELEMENTS OF HYDRANGEA
See Fig. 9-5.

Flower
Multiple flowers form large balls. In this composition, two overlapping large flower balls serve as the focus. One is cool; the other is warm.

The cool colored clusters are made of Light Pink, Violet, and Deep Purple petals. The warm ones are light Vermillion, Warm Pink, and Dark Brown.

Two scattered clusters of flowers and buds are featured along the top perimeter, connected with small stems, to form a triangle with the balls.

Each flower has 4 fan-shaped petals, tightly connected to form an oval shape, with a center dot in the middle (See Fig. 9-6).

Leaves
The leaves are large, full at the base, and tapering to a point at the tip, with serrated edges. The topside of the leaves is green; the underside is warm green, with the leaves in the shadow darkened.

Vase
A tall vase holds the flower and leaves at the lower portion of the composition.

STEPS

Basic Petal Formation

See Fig. 9-6.
Brush: Flow.
Colors: 1/4 diluted White + 1/8 strong Magenta; blend the tip.

The individual full flower shows 4 petals. Work the top petal with the brush slightly tilting, pointing the tip at 8-9 o'clock. Lightly settle the pressure down, then move the tip, heading to 4 o'clock, while lifting the brush off the paper. See Fig. 9-6 A, 1.

Do the left petal (see Fig. 9-6 B, 2) by holding the brush vertically. Land with a little pressure; then move the stroke to the right while lifting. The petal is slightly tilted. The root should attach to the first petal.

The petal on the right can be done from outside in (see Fig. 9-6 B, 3), by landing pressure downward and scooping to the left in one motion. Or, it can be done from the inside out (see Fig. 9-6 C). Overlap its root to the lower part of the top petal.

The lower petal resembles Sophia Loren's lower lip (see Fig. 9-6 D). The top side is slightly indented. The lower side is fuller. Move the stroke from left to right, and keep the shape balanced. After forming the four petals, add a dot to seal the center area of the flower. See Fig. 9-6 E.

Using the Happy Dot Brush, load 1/4 strong Deep Purple, and add the division lines between petals. The lines are heavier where the gap between the petals is wider, and reduce to a fine point when coming to the flower center. Add a horizontal dot in the middle of the flower. See Fig. 9-6 F.

Practice basic petal strokes before working on the whole flower. The diagram of the basic petals is dark to show the strokes better. In reality, use more White and less Magenta for the light clusters.

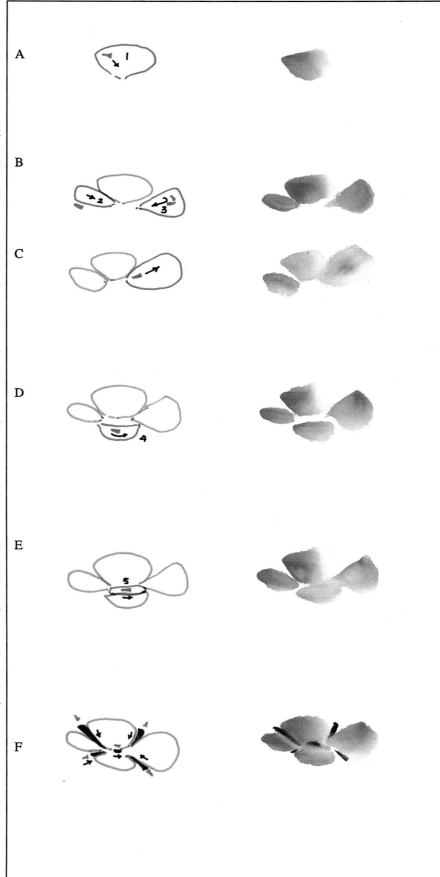

Fig. 9-6 Basic Petals Strokes

A

B

Fig. 9-7 Light and Medium Clusters

Host Flower

Draft a circle, the size of the flower ball (3 1/2" width more or less); place it under the rice paper. Line the base of the circle at the mid-length of the paper, off center to the left. It helps us to form our ball shape.

Light Clusters
See Fig. 9-7 A.
Brush: Flow.
Colors: 1/4 diluted White + 1/8 strong Magenta; blend the tip.

Develop light areas of the ball with clusters of flower groups. Tightly connect the flowers within each group to form a continuous shape.

The center area of the ball should be light to show the dimension or the roundness. Do a host group in the upper middle portion of the circle (1, 2, 3). Add a guest group (4, 5).

The upper portion shows a host lighter area on the left (6, 7, 8), and a guest (10) on the right. At times, light may show on parts of a flower; we need not to do all four petals. A half flower (9) is used as a liaison between the host and guest.

The lower right side of the circle borders another flower. By having this portion light and the overlapping area of the other ball very dark, the contrast will enhance the depth of our composition. Do a couple of flowers (11, 12), and extend the light area with a couple of half flowers (13, 14).

Medium Clusters
See Fig. 9-7 B.
Rinse and dry the brush tip. Add 1/8 strong W. Violet; develop a cluster of purple petals.

The purple flowers are connecting to and extending the existing light group. It is important to realize that the more we connect the flowers, the less gap or space will be left behind. Since eventually the whole circle will be filled, it makes good sense not to leave gaps that are hard to fill.

The perimeter circle, although incomplete, is recognizable now. The remaining spaces inside the circle should have an interesting contour, not be monotonous. Save some large areas so that the dark petals may form a host group; do not cut spaces into scattered little spots.

Dark Clusters

See Fig. 9-8 A.

Rinse the tip; add 1/4 Dark Brown (with occasional addition of Deep Purple and Ink). Use the petal strokes to form dark flowers in the open areas where the spaces are available first. Complete the ball shape, and seal the spaces inside with additional strokes or dots. We really do not want a perfect ball shape. A slightly serrated contour offers much more interest.

Accenting and Sealing

See Fig. 9-8 B.

Happy Dot Brush

Load 1/4 Dark Brown, Deep Purple, and Ink at the tip. Add occasional division lines and center dots to accent the dark and Violet flower clusters while the petals are still wet. Clean the brush, and load 1/4 strong Magenta for the lighter clusters.

Fig. 9-8 Host Flower: Dark Clusters, Accenting & Sealing

Guest Flower

Move the circle to the lower right side of the existing flower ball; overlap a small portion of the circle with the existing flower. Do make sure there are "V" gaps between the two balls.

Light Clusters
See Fig. 9-9 A.
Brush: Flow.
Colors: 1/4 diluted White + 1/8 strong Vermillion, blend the tip.

Develop light areas of the ball with clusters of petals showing host and guest. Connect the flowers into groups of continuous shapes. Stay away from the border to the other flower ball.

Medium Clusters
See Fig. 9-9 B.
Add 1/8 strong Warm Pink, and develop clusters of medium-colored petals.

Fig. 9-9 Guest Flower: Light, Medium Clusters

Dark Clusters

See Fig. 9-10.

Rinse the tip, and add 1/4 Dark Brown (with occasional addition of Deep Purple and Ink). Use the petal strokes to form dark flowers in the open areas where the spaces are available. Complete the ball shape and seal the spaces inside with additional strokes or dots. The shadow area overlapping the first flower is especially dark.

Accenting and Sealing

See Fig. 9-11.

Happy Dot Brush.

Load 1/4 Dark Brown, Deep Purple, Ink at the tip. Add occasional division lines and center dots to accent the dark and Warm Pink flower clusters.

Clean the brush, and load 1/4 strong Warm Pink for the lighter clusters .

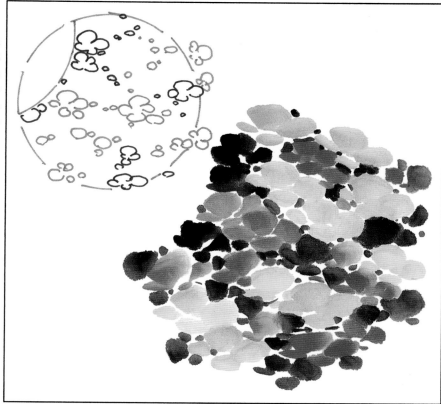

Fig. 9-10 Guest Flower: Dark Clusters

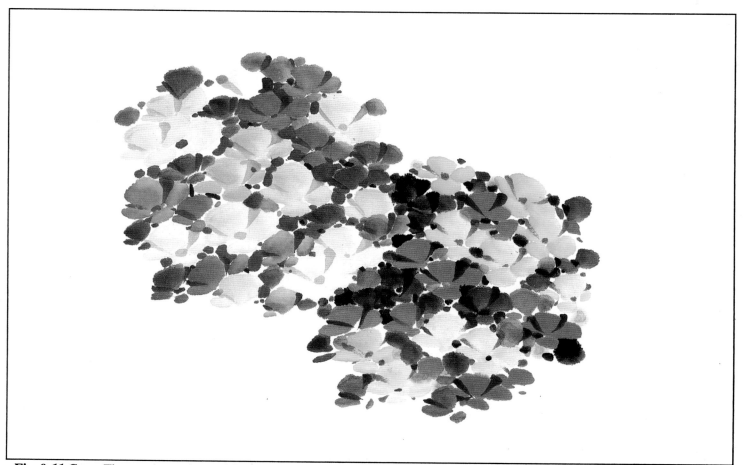

Fig. 9-11 Guest Flower, Accenting and Sealing

By now, we should have two beautiful flowers. In fact, none of my students' flowers come out looking like mine, or for that matter, looking like one another's. Each shows a different personality. Each is the result of meeting the challenge presented by a special series of accidents. Each student is engaged in his or her own crisis management. All of them are beautiful, in their own right.

Occasionally, students may become despondent because they have misplaced a dot or two. Relax; there really is no absolute right placement. Most of us should be able to live with some misplaced items in our lives, as long as they are not in biblical proportions.

Boo-don*

Chi-gu, a dear friend whom I have lost contact with for many years, once shared with me this story.

When he graduated first in his college class in 1964, he was given the honor to be in charge of the ancestral relic of the royal family in his native tribal kingdom.

He did explain to me how important these relics were. He told me about the method used back in the Middle Ages to ensure that the relic was collected intact. We do not wish to go into details. At any rate, he decided to do a thorough inventory and reorganization of these holy relics.

These relics were not big pieces. In fact, many of them were small chips or toothpick size. Through the centuries, many were dried and light as feathers.

In a large room upstairs, he carefully rested the thousands of tiny pieces of relic on cotton balls, with detailed ID information on pieces of paper next to each. He lined them in rows along large flat tables. He was very pleased with his efforts.

It was a hot, humid afternoon. An aging assistant, who was hard of hearing, decided to open the window while Chi-gu was working at the other end of the room. A gentle breeze swept through, and hundreds of cotton balls went flying; some even went out of the window and scattered in the palace lawn.

Today, the palace still has relics on display. Underneath many of them, the ID card reads "Boo-don." In his native language, it means something like "unable to attribute to." In other words, only the Lord knows.

Chi-gu has since left his native country; the story was told during a class break while he was chain smoking profusely. He was only a few years older, but his hair was all white. While he was sharing the story, I could see sweat gleaming in the evening light, although it was a cold winter night.

He told me this story because I made a boo-boo in the class and was unable to let go. He said the royal family did forgive him. He, however, was unable to face the family and felt that he had to leave the country.

Everything is true; only the name of the principal and place is changed to protect the innocent. I kept the story for ten years. Somehow, it made most of my boo-boos seem a lot easier to cope with.

For some reason, my students like to share their intimate secret stories with me. I can never keep a secret. I usually tell the whole class, particularly when the student is absent. It is one way to keep my students from missing my class.

*Boo-don is actually a Chinese term, it means "not proper." I would not want to use the actual native word of Chi-gu's.

After our next lesson, we shall conclude our flower lessons and move on to the exciting project of working with a variety of other rice paper. You may want to prepare at least a roll of Assorted Rice Paper (OAS) to get ready for the lessons to come.

LESSON 10
HYDRANGEA 2
Composition

We were strangers to each other when you opened this book. Now, I hope you trust me as your teacher and friend. When we began our flower lessons, you were not sure of your ability. Now, you are a confident brush painter. There are many reasons to celebrate. Let us begin the fireworks together.

STEPS

See Fig. 10-1.
Let us study the steps toward our masterpiece.

1. Do the host flower above the 1/2 mark of the paper, off center to the left.

2. Do the guest flower to the lower right of the host flower; overlap the two flowers to establish the focus of the composition.

3. Work the dark leaves. Do skirts below the flowers, and two groups above the flowers.

4. Do the lighter leaves. Work a couple of leaves on the lower left side, and three leaves above the flower to develop the height of the composition. Add another light leaf on th right side.

5. Add the perimeter clusters of flowers on the upper left.

6. Do the perimeter flower clusters on the upper right.

7. Do the vase, and the composition is completed.

Since we have covered the two main flowers in our last lesson, you can put in the flowers. We will begin detailed discussion on the rest of the composition.

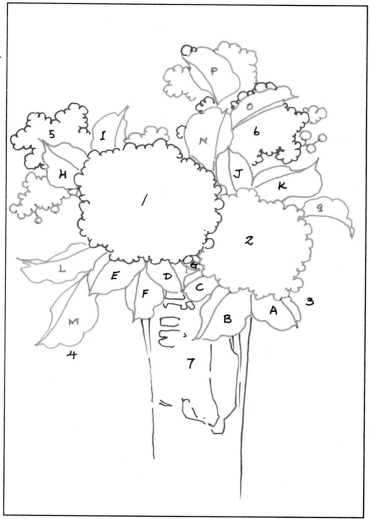

Fig. 10-1 Steps of the Composition

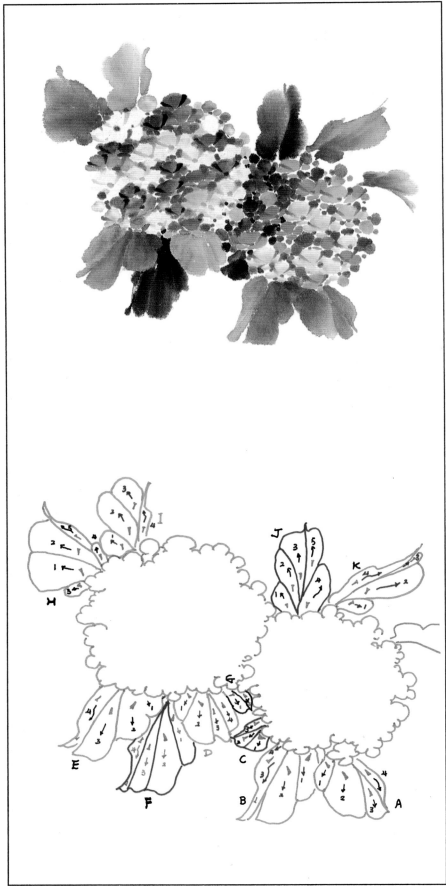

Fig. 10-2 Dark Leaves

Dark Leaves

See Fig. 10-2.

The dark leaves are the leaves showing topside.

Most of the leaves need to establish a wide base to show that they are rooted below the flowers, not along the edge of the flowers. Work the root area of the leaves by carving around the flowers to ensure overlapping.

Use the beginning of the strokes to establish the center vein of the leaf. Use the side of the brush; work a series of strokes to develop the host side of the leaf (the side that is closer to the viewer). Do the guest side smaller.

Lower Skirts

Use the Large Flow Brush, load 1/3 medium Green + 1/4 strong Indigo, and blend the tip. Work Leaves A and B below the guest flower on the right. Leave no gap between the two leaves.

Leaf A: Hold the brush diagonally, with the tip pointing to 11 o'clock. Do Stroke 1, 2 of Leaf A with the side of the brush; tuck the strokes along the edge of the flower. Extend Strokes 3, sliding along the right shoulder of the previous stroke. The continuation of the right side of these strokes shows the course of the center vein. Complete the left side of the leaf. Do the right side of the leaf with shorter or narrower strokes, and extend the tip.

Reverse the direction of the brush tip to do Leaf B (study the small triangles on the diagram).

Reload the colors, and add 1/8 strong Indigo + 1/8 Ink; work dark Leaf C.

Rinse the brush, load 1/3 Green, and make Leaf D lighter. Then add 1/4 Indigo, blend the tip, and do Leaf E. Reload the same colors, add 1/8 strong Indigo + 1/8 Ink, and work Leaf F. Leave a hairline space between it and the existing leaves to avoid blending. Reload the same colors; do Leaf G to seal the area between the two flowers.

Upper Left Pair

Rinse the brush, load 1/3 Green + 1/4 Indigo, blend the tip; and then do Leaf H. Make Leaf I lighter by only loading the Green.

Upper Right Pair

Load 1/3 Green + 1/4 Indigo, add 1/8 strong Indigo + 1/8 Ink, and do Leaf J. Rinse the brush, load 1/3 Green + 1/4 Indigo, and blend the tip. Work Leaf K.

Light Leaves

See Fig. 10-3.
Brush: Large Flow
Colors: 1/3 medium Green + 1/8 strong P. Magenta, blend the tip.

Lower Left Side Leaves

Do Leaf L by holding the brush diagonally, with the tip pointing between 2-3 o'clock. Do Stroke 1, 2 with the side of the brush, tucking the strokes along the edge of the flower. Extend Strokes 3, 4, sliding along the left shoulder of the previous stroke to show the course of the center vein. Complete the lower side. Begin Stroke 5 with a little pressure; taper the pressure and extend a small stroke (6) to show the tip of the leaf. Do Leaf M the same way as Leaf L, only heading lower.

Leaves Reaching Upward

Hold the brush diagonally, pointing the brush tip to 6 o'clock; work the left side of Leaf N, then fan the strokes to complete the leaf. Do Leaf O as a folding leaf, with only one side showing and its baseline revealing the course of the center vein. Add Leaf P to develop the height of the composition.

Do leaf Q to extend the left wing of the composition. It is a liaison between the top and the lower groups, a third point of a triangle for lighter leaves.

You must have seen Leaf Q in the previous diagram---a leaf without name and ID, without explanation. You might have thought of doing the leaf, but you are not sure, thinking you do not want to get involved with an illegal alien.

Leaf Q was an afterthought. I added the leaf after the lesson was done. I revised my diagrams to include this leaf. It was late at night, my diagrams were all over the table, and I made a mistake.

It is nice to let my students know that I choose to live with my mistakes, as long as the boo-boos are not in biblical proportions.

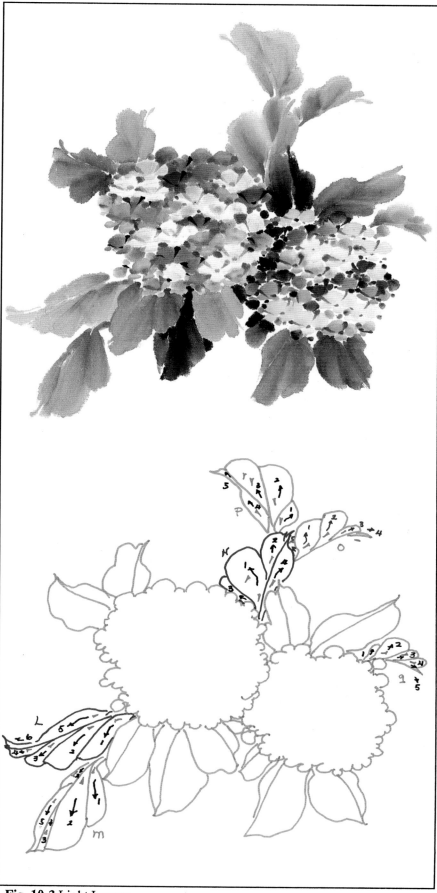

Fig. 10-3 Light Leaves

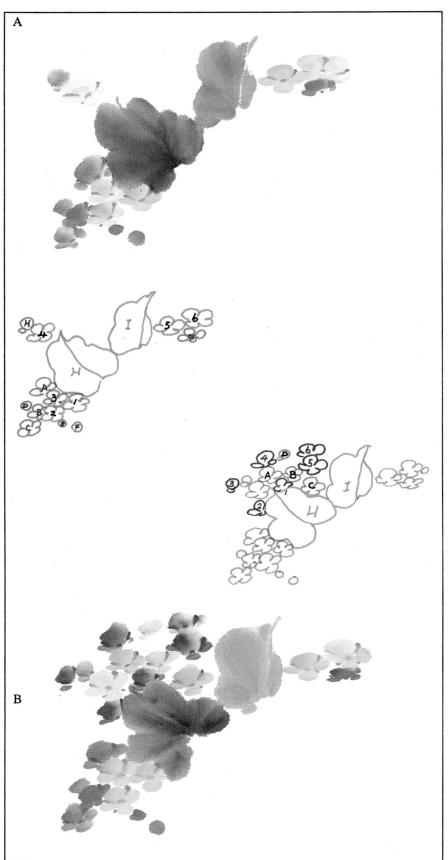

Perimeter Flower Clusters

See Fig. 10-4.

Spread the flowers in two clusters along the upper perimeter of the composition, so they form a triangle with the main flowers to anchor our composition.

Flower Cluster on the Upper Left
Peach and Warm Pink Petals
See Fig. 10-4 A.
Brush: Flow
Colors: 1/4 diluted White + 1/8 strong Vermilion
Do one group of flowers (1, 2, 3) on the lower left side of Leaf H, one group (5, 6) on the lower right side of Leaf I. Do one flower (4) as a liaison between the two groups and form a triangle.

Rinse the tip, load 1/8 strong Warm Pink, and add more flowers (A-H). Using the Happy Dot Brush, load 1/4 strong Warm Pink, and add division lines and center dots to the flowers.

Purple Petals
See Fig. 10-4 B.
Load 1/4 diluted White + 1/8 strong Magenta; add more flowers (A-D) to the center group. Rinse the tip, load 1/8 Winsor Violet, and expand the center group (1-6). Add details with the Happy Dot Brush (strong Magenta for light flowers, Deep Purple for the dark flowers. See Fig. 10-4 B.

Fig. 10-4 Perimeter Flower Cluster, Upper Left Side, Light Flowers

Dark Dots

See Fig. 10-5 A.

Rinse the brush, and load 1/6 strong Dark Brown; add more flowers and buds to solidify, to add more depth and interest to the contour of the clusters.

Using the Happy Dot Brush, load 1/4 strong Warm Pink + 1/4 Dark Brown; add stems to link the loose flower groups to the main ones.

Flower Cluster on the Upper Right
Pink and Purple Petals

See Fig. 10-5 B.

Brush: Flow

Colors: 1/4 diluted White + 1/8 strong Magenta

Do one group of flower (1, 2, 3, 4) under Leaf O, and add one flower (5) above Leaf O. Use the Happy Dot Brush, load 1/4 strong Magenta, and add division lines and center dots to the flowers.

Rinse the tip, and load 1/8 strong Winsor Violet. Then add more flowers (shaded ones), using Deep Purple with the Happy Dot Brush for details.

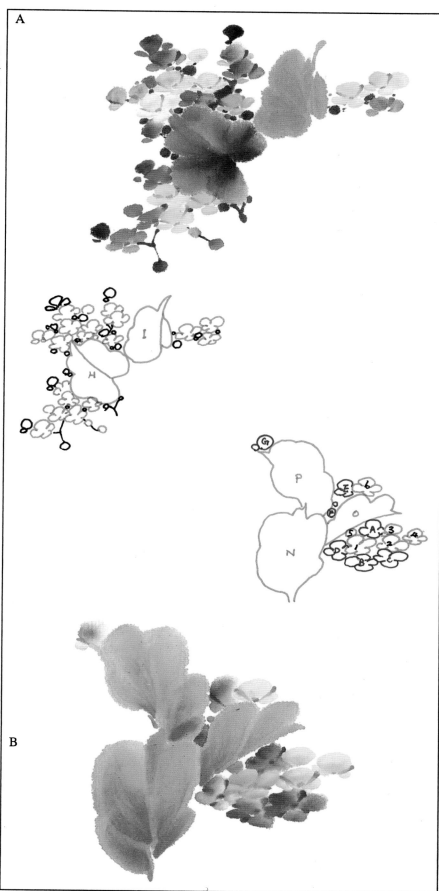

Fig. 10-5 Perimeter Flowers, Lower Dark Ones & Upper Right Light Ones

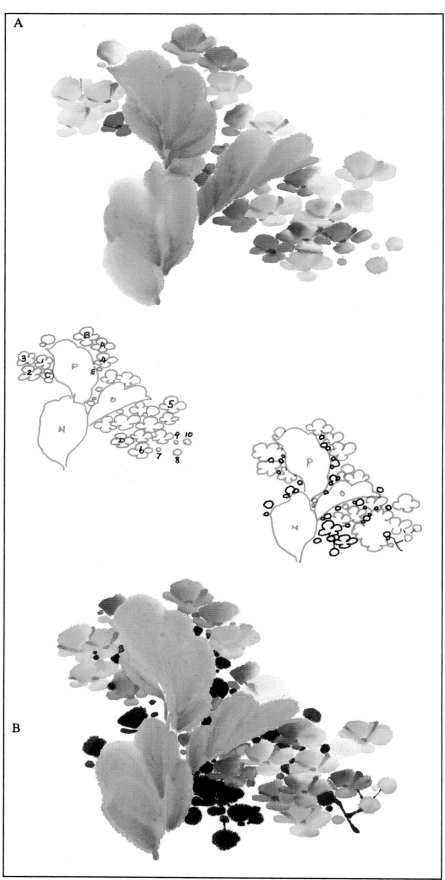

Peach and Warm Pink Petals
See Fig. 10-6 A.

Rinse the brush, load 1/4 diluted White + 1/8 strong Vermilion, and add more flowers (1-10). Rinse the tip, load 1/8 Warm Pink, and continue to build the cluster (shaded ones). Add details with the Happy Dot Brush (Warm Pink).

Dark Dots
See Fig. 10-6 B.

Rinse the brush, and load 1/6 strong Dark Brown; then add more flowers and buds to solidify the clusters and to add more interest to the contour of the clusters.

Use the Happy Dot Brush, load 1/4 strong Warm Pink + 1/4 Dark Brown, and add stems to link the loose flower groups to the main groups.

Fig. 10-6 Perimeter Flowers, Upper Right Dark Ones

Vase

See Fig. 10-7.

It is things like vases, bowls and stands that worry me the most. When we have come this far with a spectacular composition, we surely do not want to ruin it with a bad vase.

Let the vase be slightly off center. Shape it tall and slender. Do not show the base of the vase. Let the side of the vase extend, and project more height of the vase beyond the paper.

To make sure the vase is balanced, we use a sheet of 8" x 11" paper, folded it lengthwise. From the fold line, draw half the vase with a pencil, pressing hard enough to allow a trace imprint to show onto the other side of the folded line (See Fig. 10-7 A).

The top portion of the vase may not show, since it is under the flowers and leaves. Turn the shoulder of the vase softly. Do not curve the side line too much inward; we like the vase to show more stability.

Open the fold, and complete the other side that is the mirror image of the existing half shape. Darken the lines with ink.

Place the vase drawing paper under the rice paper, between the two main flowers, to guide your vase strokes.

Using the Large Flow Brush, load with 1/3 medium Winsor Violet, and work a couple strokes to show the right side of the vase (1, 2). Use the side of the brush, to develop a large shadow area (3); extend it (4), then turn with a small extension to taper the shadow (5). Do the left side of the vase with a skinnier stroke (6); extend with a finer line (7).

Reload 1/3 Winsor violet; add 1/4 Deep Purple + 1/6 Ink. Tilt the brush, with the tip pointing to 12 o'clock, and do a few horizontal strokes (8-11). Leave ample space; and keep it simple. See Fig. 10-7 B.

Let me congratulate you on the successful completion of our flower studies. There are many excellent books on flowers at OAS, I hope you will continue the fine work that you have started here.

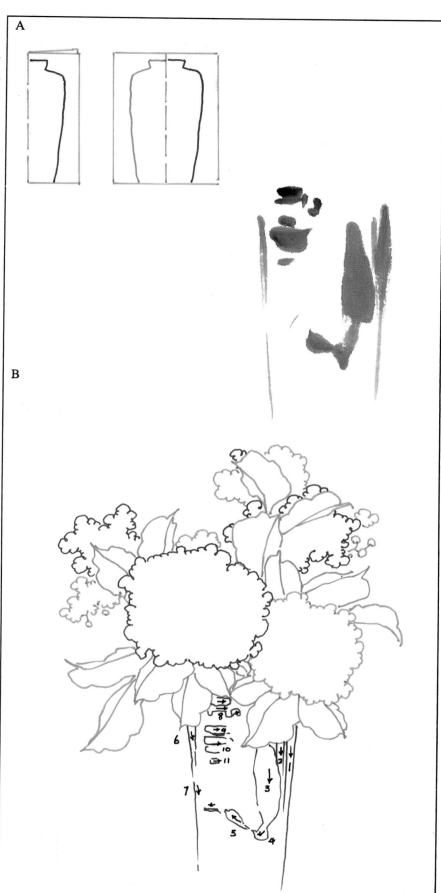

Fig. 10-7 Vase

Available on VHS Videocassettes:
Best Instructional TV Series "Chinese Brush Painting with Ning Yeh"

The "Emmy" award-winning program is now available on videocassette. Its delightful, informative, and clear step-by-step instructions have captured the hearts and minds of millions of art lovers. It, along with OAS fine kits and materials, will make your experience with Chinese brush painting a true journey into art. The companion guide to the TV series "Chinese Brush Painting: An Instructional Guide," is a must.

The TV Series consists of 20 1/2 hour programs:

1) **An Introduction**: Philosophy of Chinese brush painting, equipment preparation and care, and setting up the studio.

2) **Orchid Leaves**: Positioning the body and hand for Chinese brush painting and the initial strokes which form the leaf clusters of an orchid.

3) **Orchid Flowers and Composition**: How to paint the orchid flower and how to compose an effective orchid painting.

4) **Bamboo Trunks and Branches**: Background of bamboo paintings, anatomy of bamboo, materials and preparation, and detailed instruction for painting the trunk, ring, branches and twigs, and use of the bone stroke.

5) **Bamboo Leaves**: Painting the bamboo leaves and their formation in clusters along the trunk and branches.

6) **Bamboo Composition**: Bamboo composition, combining elements from the preceding lessons.

7) **Panda**: The habitat, habits and anatomy of the panda and the basic shapes and proportions of its head-- in profile and in front view-- and its body.

8) **Camellia Flowers**: Introducing color and the key concepts in constructing a flower, especially the basic strokes for painting a camellia as an open flower, in profile, and as a bud.

9) **Camellia Leaves and Branches**: How to paint leaves of various shapes and using different strokes to present different attitudes of a leaf.

10) **Camellia Composition**: The relationship between the flower, leaf and branch and how these elements are combined in a composition.

11) **Amaryllis Flowers**: The background and anatomy of the amaryllis and the materials used in painting it and other trumpet flowers. How to paint the front facing amaryllis.

12) **Amaryllis Composition**: Painting side-facing, back-reaching and bud amaryllis flowers and the bold stem, stalk, and leaves of a complete amaryllis composition.

13) **Peony Flowers**: The legends and symbolic meanings of the peony, its anatomy, and the techniques for painting the subtle shadings of the peony cup and layers of petals.

14) **Peony Elements**: The flower bud and surrounding elements of the peony plant and painting the leaves and veins.

15) **Peony Composition**: The nuances of composition of a flower painting, demonstrated with pink and red peonies, the yellow poppy and blue iris.

16) **The Head of the Horse**: The background and symbolism of the horse as a subject for Chinese brush painting, and painting the horse's face, neck and mane.

17) **The Body of the Horse**: The completing elements of the horse's body, legs and tail, including proportional relationships and leg positioning and techniques for rendering a sense of movement and energy in a horse painting.

18) **Landscape**: The significance of Shan-Shui, the Chinese name for landscape painting, and how the artist projects depth, dimension and focus in a painting.

19) **Signature and Seals**: How to select a signature and the personal seals which enrich the beauty and personal significance of a painting.

20) **Mounting Techniques**: Step-by-step instructions, including supplies and procedures, for mounting a painting to protect its color and surface and stabilize it for hanging._

THE BEST INSTRUCTIONAL TV SERIES

LEARNING CHINESE BRUSH PAINTING IS A PIECE OF CAKE

LESSON 11
PROJECTS ON SIZED PAPER
Misty Mountains, Umbrellas, Farmer & Buffalo

ART WORKS
Fig. 11-1 Paintings on Cotton Paper
A. Misty Mountains

B. Umbrella Ladies

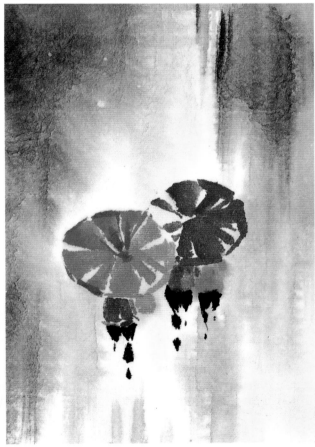

C. Farmer and Water buffalo

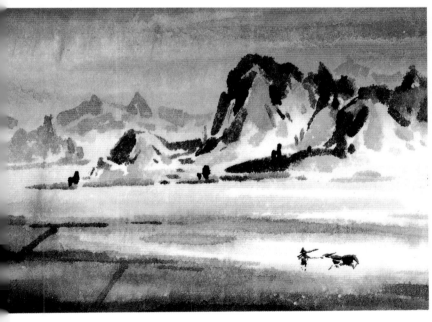

Fig. 11-2 Material Setup

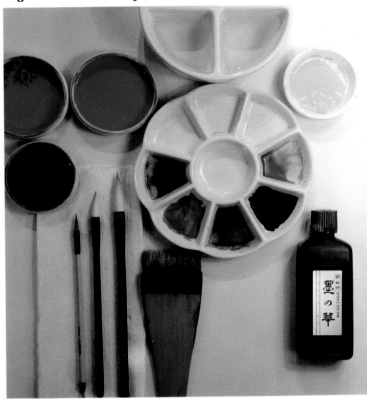

Fig. 11-3 Material ID

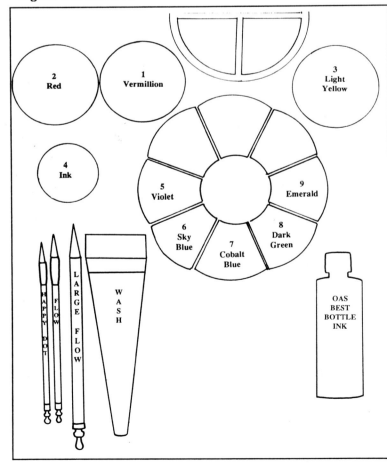

MATERIALS
See Fig.11-2 and follow the preparation steps.

Rice Paper
Cotton, Ma, or **Jen Ho**
All sample paintings of this lesson are done on Cotton. Cotton is the most reasonable sized paper. It is easy to use.

Ma paper is better than Cotton, more durable for repeated wash, and shows more depth of colors. Both Cotton and Ma are white.

Jen Ho paper is off-white. It gives wonderful texture and works great for washes. It is my favorite paper for landscapes.

All three papers are included in the OAS Assorted Roll (2 sheets each). Try this lesson on all three papers.

Brushes
Happy Dot: Details
Flow: Small areas
Large Flow: Large areas
Wash: Shading

Colors
Chinese
Vermillion
Red
Light Yellow

The Light Yellow is closer to Lemon Yellow; it works great with rice paper, and it is much less costly than the watercolor tubes.

Winsor Newton
Prussian Green
Charcoal Gray
Winsor Emerald
Winsor Violet

Koi
The Koi color tubes (very reasonable) are available at OAS
Cobalt Blue
Sky Blue
I use some Koi Colors in landscapes to cut the cost down.

OAS
Ink (OAS Best Bottle)

See Fig. 11-3 to identify the materials.

PREPARATION

Rice Paper

Use Cotton, Ma, or Jen Ho, each sheet about 16" x 24".

Colors

Test prepared colors on Double Shuen to match Color Dots Chart (Fig.11-4).

Fig. 11-4 Color Dots: (On Double Shuen)

1 Vermillion		6 Sky Blue	
2 Red		7 Cobalt Blue	
3 Light Yellow		8 Dark Green	
4 Ink		9 Emerald	
5 Violet			

Use an inexpensive brush (like OAS Basic Hard Brush) to prepare the colors.

1. Vermillion

Wet the chips; soften the Vermillion with water but keep the color strong.

2. Red

Wet the chips; keep the color strong.

3. Light Yellow

OAS has Light Yellow chips, which are closer to Lemon Yellow; a wonderful color and very inexpensive. Put the chips in a separate dish for repeated use. Wet the chips; keep the color strong.

4. Ink

Fresh; pour about 1 tablespoon into a saucer.

5. Violet

Mix **Vermillion** with **Winsor Violet**. Keep the mixture strong.

6. Sky Blue

Soften the color; keep it strong.

7. Cobalt Blue

Soften the color; keep it strong.

8. Dark Green

Use 1/3 **Prussian Green** to 2/3 **Charcoal Gray**; mix with your finger and develop thick, pasty dark green.

9. Emerald

Winsor Emerald diluted to medium, add a little Dark Green.

IDEA OF THE PAINTINGS

Misty Mountains

To catch the sunrise over the sea of clouds,
We get up at 4:30 in the morning and climb up to the hill top.

Layers of mountains are in different shades,
With peaks emerging from the clouds like chains of island.

Then the sun breaks through on the far end of horizon.
The clouds turn into a sea of gold.

Umbrellas

On an afternoon in the park,
We are caught in an early spring shower.

In the midst of green leaves,
Freshly polished by nature,
We hear the oriole-chatting sounds
From these ladies under their bright umbrellas.

Farmer and Water Buffalo

The calm river Li winds like a silver belt,
Tinted by the saffron glow of the summer sunset.

On the narrow path among the rice field,
Our farmer is going home for supper after a full day's work.
The scene is serene.

Both the farmer and the water buffalo are content
To be in a picture like this;
So are we.

This lesson shall open new directions to lead us into the enchanting world of landscape painting.

Notes from Mickey (Our Editor)
Dear Ning:
You might consider breaking up these lovely descriptions among the 3 lessons-in-one instead of giving all the lyricism in one place. It gives your student something to look forward to!

Mickey

Dear Mickey:
The nitty gritty instructions are taking up all the spaces for each of the lessons. I cannot even sqeeze one line of lyricism into the lessons. My students have tons of things to look forward to already. If they need lyricism, they can get their full enjoyment from my Red Book. Sorry!

Come to think of it, tell me Mickey, what is "lyricism?" I do not know this word...

Ning

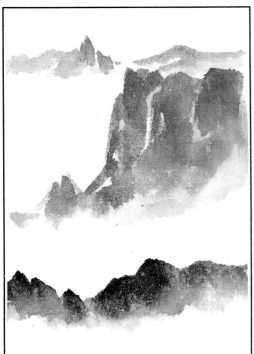

Fig. 11-5 Mountain Layers

Fig. 11-6 Mountain Layers, Diagram

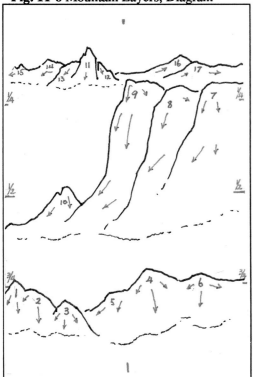

MISTY MOUNTAINS

Composition

The painting features three layers of mountains. The top and lower layers are horizontal and the middle one vertical in orientation (one can think of them as the three measurements of a lady).

The lower layer serves as an anchor for the painting. It is dark, with two ranges joining to form a "V." It is closest to the viewer, friendly and approachable. We build homes and plant trees to show more detail.

The middle layer is most prominent. It moves into the painting from the right side, showing an impressive peak and steep cliff as host and little mountains on the left as guest. Its color is lighter than the lower layer. This layer overlaps with the top layer and serves as a link to tie the elements of the composition together.

The top layer is smaller in scale, with dramatic change of color to show distance.

Steps

Lower Layer Mountains

See Fig. 11-5, 6. Use the Large Flow Brush. Load 1/3 medium Emerald, rinse the tip (about 1/8, to get rid of the Emerald on the tip), and load 1/4 strong Dark Green.

Move the strokes from the top (peak) down. Use a mopping, rather than a sweeping motion. Press the bristle body halfway down in front of the tip. The lower portion of the mountain is lighter (Emerald color) or clear (since we only load color 1/3 length). Do not carry the tip down. Do all the mountains with the tip pointing up, then lower the boom and mop.

Do each mountain with overlapping strokes. Stop the stroke 2/3 down the height of the mountain. Clean and dry the brush (or use a clear Flow Brush), and use the "dry" moisture left on the brush to soften and fade the color downward. This should be done quickly before the color dries. The remaining 1/3 height of the mountain is a transitional area for the mountain to melt into the embrace of the mist below.

Wet moisture will invite the colors down or leave a water mark. The clear moisture strokes should be so dry that they look textured, rather than showing puddles.

Begin from the left side. Start Peak 1 at about the bottom 1/4 of the paper. Do Peak 2 with a softer curve. The two peaks are leaning like a loving couple. Set Peak 3 a little apart, with its base a little lower. The baseline of the peaks fades into the mist layer. The mist, although horizontal, should show a fluffy quality. The center part of the mountain (I call it "nose") comes forward and therefore should be lower.

Do Peak 4 with the left side more vertical than the right side, to lead the mountains moving to the left. Do Peak 5 lower and darker; overlap its root behind Peak 3. Peak 6 is higher and lighter than Peak 5.

Middle Layer Mountains

See Fig. 11-5. Load 1/3 Emerald. Begin Peak 7 above the top 1/4 mark of the paper. Do Peak 8 slightly lower. Save a hairline space between the mountains to distinguish the shapes. Raise Peak 9; work a steep cliff, show a little curve to soften the stiffness. Anchor the root of Peak 9 with a small group of mountains (10). Fade the roots.

Top Layer Mountains

See Fig. 11-5. Work the main peaks (11, 12, 16, 17) with Violet; use light Vermillion for the other areas. Fade the roots of the mountains as we move along.

Defining the Mist Layers

See Fig. 11-7, 8.

When the mountains are dried, **wet the entire paper with a Wash brush.** Do not worry; once the paper absorbs the colors, the painted part will stay unaffected by the wash. This is another remarkable quality of the sized rice paper.

When the colors are too thick, some spots may bleed. Stroke the spots with the Wash brush a few times, and use a paper towel to blot the bleeding colors off the paper.

Keep the entire paper wet always, but avoid having puddles. Re-wet the dry areas with a spray bottle or the Wash brush.

The mist is the space we left below the mountains. The illusive spirit of the mist requires delicate suggestion to inspire the viewers' imagination. To highlight the mist, we darken the base of the mountain. Yet if we overdo it, the definition turns harsh; the mist is rigid (imagine, stiff mist!).

It is the nature of the mist to gather and to disperse, like a moody lady. Our mountain, being the gentleman it is, will accommodate such nature to bring out the vitality of the playful mist. That is why the mist shall come to our mountain, year after year. The multitudes of green on the mountain clearly showed the evidence of such enchanting rendezvous. Where was I? Yes, darken selected root areas of the mountain.

Lower Layer: Use the Flow Brush, and keep the bristle relatively dry. Load 1/6 with strong Dark Green, split the brush tip open and tilt the brush (point the tip to 6 o'clock), and set the tip along the mist line at the root of the mountain. Lower the boom to let the dark color fade upward into the mountain. Darken selected areas of the lower layer (A, B), leaving some areas of the foot of the mountain untreated, so the mist line is not rigid. With the tip pointing down, move the brush sideways to enlarge the shaded areas.

Middle Layer: Use the same method (C, D). Add some shadows to the side of the mountain or side of the nose ridge (E, F). Work a shadow area to the left and above the small mountains (G). Fade the color as it moves upward. Rinse the brush, and use "dry" clear moisture to brush along the top of the shadow to fade the color clear. The base of the shade needs to be dark. The top areas of the shade should fade, either blending into the colors of the mountain or fading into the space above.

Top Layer: The root of the top layer mountain is lighter. Load medium Dark Green with Violet. Work the selected areas (H, I, J).

Sky: Develop Vermillion and Violet puddles in separate saucers, both in medium consistency. Tilt one end of the Wash brush into Vermillion, letting the color move into 2/3 width. Load Violet on the same end; the Violet goes 1/3 into the width. Blend the brush. Hold the brush vertically, with Violet side on top, Vermillion in the middle, and clear moisture below. Work overlapping horizontal strokes to color the sky. Work the colors into the top layer mountain, then fade above the mist.

Showing Depth of Mist

See Fig. 11-9 and 11-1 A. Load the Flow Brush with 1/4 strong Dark Green; blend the tip. Tilt the brush, with the tip pointing to 6 o'clock. Move the brush sideways to darken the lower right corner (K). The color reaches about halfway into the space (mist) below the first layer of mountain, with its top edge fading clear.

Do four elongated triangles (L, M, N, O) to divide the space into a zigzag pattern of mist formation. Use "dry" clear moisture to brush along the top of the shadow to fade the color clear. Add tree dots and houses on the lower layer mountain.

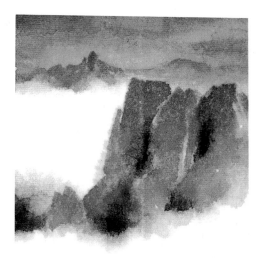

Fig. 11-7 Defining Mist Layers

Fig. 11-8 Defining Mist Layers, Diagram

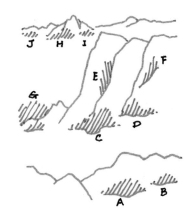

Fig. 11-9 Depth of Mist, Diagram

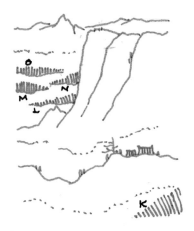

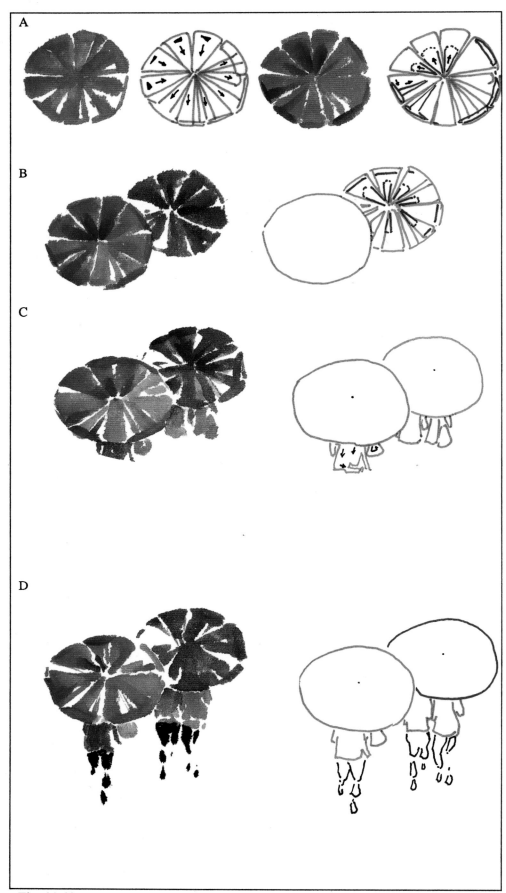

Fig. 11-10 Umbrellas

UMBRELLA LADIES

Umbrellas

Think of the umbrellas as an oval pie, with its center at the upper middle point. We shall slice this pie with strokes.

The Red One

See Fig. 11-10 A. Work the oval below the half mark of the paper, off center to the left. Load the Large Flow Brush with 1/3 medium Vermillion + 1/6 strong Red. Start from the upper left corner. Set the brush tip along the edge of the oval and bring the stroke into the center point by releasing the pressure. Work the rest of the oval area by moving the strokes from the center out. Do what comes naturally; there are no set rules. Leave some space open between the strokes. Add a few strokes around the ring of the oval to complete the circle.

Do not add moisture, Reload the Vermillion and Red; add thick Violet at the tip, accenting some shadow areas on the umbrella.

The Purple One

See Fig. 11-10 B. Load the Large Flow with 1/3 medium Cobalt Blue + 1/6 strong Violet. Do an oval shape overlapping the red one.

The Upper Bodies

See Fig. 11-10 C. Use the Flow Brush. Work the lady below the center of the red umbrella with Cobalt Blue. The shape suggests her left arm and lower back. Add a Vermillion bag for her to carry on the right side. The purple umbrella is shared by two ladies; do the left one with medium Vermillion + Cobalt Blue and the right one with medium Vermillion + strong Red.

The Lower Bodies

See Fig. 11-10 D. Use the Flow Brush with Ink. Do a few casual touches and dots; extend from the body to show upper legs, lower legs and the sole of the feet. When in motion, trotting through the rain, the shapes of the lower bodies are vague, incomplete. Less is better.

Moody Background
See Fig. 11-11, 12, 13.

When the umbrellas and ladies are dried, use the Wash Brush to wet the whole paper with clear moisture.

Develop Light Yellow and Emerald puddles in separate saucers, both in medium consistency. Work a puddle of Dark Green; keep it strong.

Light Shades
See Fig. 11-11, 12.

Load the Wash Brush with ample Emerald. Work the top side, setting the brush horizontally along the top edge of the paper, apply color with vertical strokes. Lift off the pressure as the strokes come down, think of willow clusters. Overlap the strokes to form a large shade, and work some smaller shades with single stroke. End the strokes unevenly; group them into host and guest.

Bring the Emerald shade down along the left side of the painting. Work the right side shade down also, but end earlier.

Work a few small vertical strokes with Emerald along the baseline. These strokes begin with no pressure; increase the pressure when they move down (opposite to the top strokes).

Although we intend to keep the umbrella ladies open, this intention should not be obvious. Occasionally, allow the shade to go through the umbrellas to render a more integrated spirit to the composition.

Save some streaks of space. Do not color every spot.

Load the Wash Brush with Light Yellow. Do a couple of shades in the upper middle area, carry a couple smaller strokes down to the lower area. Do another cluster of Light Yellow shade in the lower right side of the painting.

Dark Shades
See Fig. 11-13, 11-1 B.

Load the Wash Brush with strong Dark Green. Work the dark shade in while the light colors are still wet.

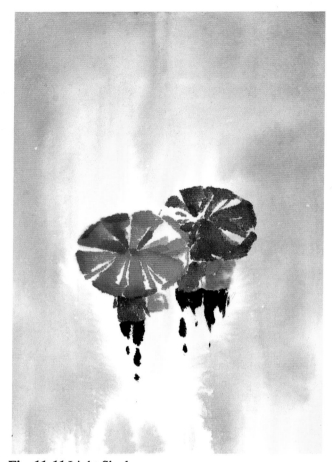

Fig. 11-11 Light Shades

Fig. 11-12 Light Shades, Diagram

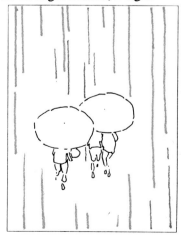

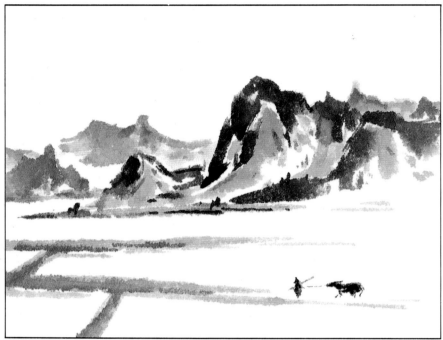

Fig. 11-14 Farmer and Water Buffalo, Shapes

Fig. 11-15 Farmer and Water Buffalo, Details

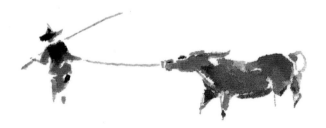

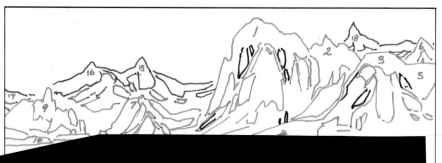

FARMER & WATER BUFFALO
Shapes
See Fig. 11-14, 15, 16.
Figure and Animal
Use the Flow Brush. Do these figures with medium Violet, then accent the shapes with Ink.

Host Mountains
Use the Large Flow Brush. Load 1/4 Dark Green. Start from Peak 1, to the right of the center line. Work strokes from the peak down, do the left side more vertically, and make a softer shoulder on the right side. Add a couple of lighter strokes to show the shadows on both sides of the nose (the bright area below the peak where the ridge comes forward). Do Peak 2 with lighter tone.

Reload the brush with Dark Green. Do Peak 3. Let its left side come down to join with a foothill (4); carry the right side (5) horizontally off the paper. Add Peak 6.

Do Peak 7, letting its right side fade behind Peak 1. Do the left side more vertically. Add a couple of shadows on the nose (lighter). Show the left tip of the Bank line (8) with lighter tone; fade it as it moves to the right.

After rinsing the brush, load medium Emerald. Color the noses of these mountains. Move the strokes down with more emphasis on the left side of each shape. Break the shape on the right side to allow the strokes to integrate with space. Keep some areas open to give an airy, misty feeling. Continue the bank to the right, and break the line as if saying: "to be continued..."

Using the Flow Brush, load 1/4 Dark Green + 1/6 Ink; add tree dots and accent the shadow areas.

Guest Mountains
Use the Large Flow Brush, load medium 1/4 Emerald + medium 1/6 Dark Green, and do Peak 9. While the host mountains are more vertical on the left side, the guest mountains are more vertical on the right side. This way, the two group of mountains will face each other. When they are stuck with each other for millions of years, they

Fields

See Fig. 11-17. Divide the space below the mountains into horizontal strips. Make the lower ones wider than the higher ones to project depth.

Use the Flow Brush, load 1/3 medium Emerald, and work the top field line (11) to define the river (the space above the line). Fade the line as it moves to the right. Add Line 12, with its left end higher, and lead it to go below the footing of the farmer and buffalo.

Work two field lines from the top down, with Line 13 heading to 8 o'clock and Line 14 to 7 o'clock. The change of angle is important to suggest lines leading to the vanishing point. Load the brush with Dark Green, accenting the lines while they are still wet.

Distant Mountains

Use the Large Flow Brush. Load 1/4 medium Vermillion + 1/6 medium Violet; blend the tip.

Do Peak 15 and 16. Save a layer of space below the peaks to suggest mist. Work Peak 17 a little lower on the left side. Add Peak 18 on the right; overlap its base into the mountains in the front.

Wash (Shading)

See Fig. 11-17, 11-1 C. When the painted elements are dried; use the Wash Brush to wet the whole paper with clear moisture. Keep the paper moist all through the washing phase; re-wet if necessary. Work Vermillion, Sky Blue, and Emerald in separate saucers, dilute the colors into medium consistency. Work a couple of puddles of Dark Green and Violet; keep the colors strong.

Fields and River: Load the Large Flow Brush with ample Violet, and shade the lower fields below Line 12. Work a couple of shorter strokes above Line 12 on the right side. Load Dark Green, and work into the violet, concentrating more on the lower areas. Dilute the Dark Green, and do a couple strokes below Line 11. Rinse the brush, load Sky Blue, and shade the same area. Add a couple of strokes of light Violet on the right side of Line 11. Use very light Vermillion to shade the river and the area around the farmer and water buffalo.

Sky: Load ample Violet, shade across the top, and add a shorter strip on the right side below the top area. Load Dark Green; work into the violet to add depth and variation. Rinse, load Sky Blue, then work a strip above the Sky Blue shade in the field. Color the lower sky with Vermillion; add some Violet above the mountains.

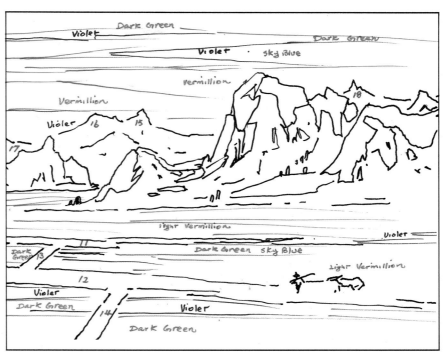

Fig. 11-17 Farmer and Water Buffalo, Shading (Diagram)

A Footnote: The greatest merit of this book is that it is done with step-by-step instruction in detailed sequence. Due to technical difficulties (I can write another book on this subject alone), I have not chosen to photograph each step of a painting. Instead, a new painting is done up to the previous step, then it is continued. This is a rather painstaking process.

It is virtually impossible to recreate a painting without altering it somewhere. The diagram of the Farmer and Water Buffalo is a typical case. In Diagram 11-14, the farmer is ready to go home, the water buffalo is yet reluctant to go. The distance between the two is rather long. In Diagram 11-1 C, the water buffalo decides to run, which puts the distance between him and the farmer much closer. It also prompted the farmer to run (Wouldn't you do the same in his situation?) The sphere of tranquility is somewhat diminished, but it is beyond my control.

Many people were attracted to Chinese painting initially with interest in flowers, but they invariably fell in love with landscapes. Even folks who have never been in China enjoy my presentation of "a dream journey."

Creating scenery takes you immediately away into another world where tranquility reigns---particularly when it is China, the land of mystic spirit, ancient glory, emerald mountains and cascading waters. You leave your worldly concerns behind, and allow your spirit to soar with the flying celestial nymphs.

Landscape painting is one of my strongest interests. Compared to other landscape artists in China, my work has more noticeable fusion of Western watercolors and traditional Chinese brush techniques.

Students soon realize that it is much easier to produce wonderful results working on scenery than on flowers. In flower painting, every stroke has to be executed right, or the whole painting is wasted. In landscape, each step improves the painting along the way. And, when we finally bring in the mist or send in the clouds, every painting turns into a dreamy wonderland.

Recently, I wrote a series of 12 instructional booklets entitled **Ning Yeh Painting Workshop Series 1**. Seven of the lessons are exciting landscapes; each offers a special area of basic exercise:

Venice of the East (Perspective)
This lesson provides an imaginative way to study perspective and Oriental structures: a building, bridge, and boat.

Temple of Heaven (Trees)
This study of trees demonstrates how to draw branches and trunks, how to group foliage and project depth in a forest. Painting the most beautiful structure in China is a bonus.

The Great Walls (Basic Landscape)
An easy technique produces breathtaking results to capture the spirit of Chinese civilization.

Cascades (Waterfalls)
You'll learn the wonderful power of suggestion, as well as the study of rock formations, pine needles, and mist with waterfalls. This is a very spiritual exercise to purify body and soul.

Li River Reflections (Mirror Image)
You'll learn unique shortcuts to present reflections in the water: fascinating, foolproof tricks.

Guilin Mountains (Study of Contrast)
This lesson is an important study of dimensional treatments. It highlights intriguing ways to work contrasting elements: A must for all artists interested in landscape painting.

Autumn in the Park (Fall Colors)
A truly magnificent masterpiece is the grand finale of this series. It definitely will bring you to the seventh heaven.

Each lesson is an **independent unit**. It takes you from the very beginning to the completion of a masterpiece. I hope you will try these lessons to keep up your good works.

LESSON 12
TEMPLE GATE
Miracle on Best Shuen

ART WORK
Fig. 12-1 Temple Gate

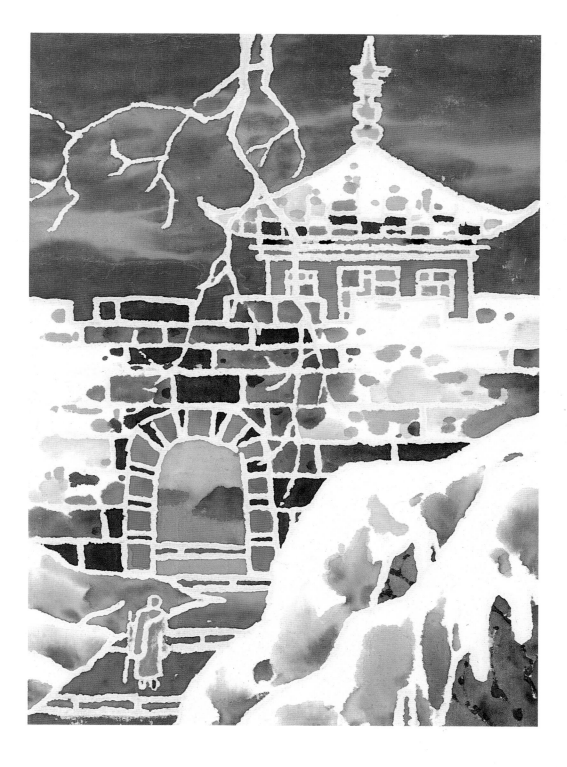

Fig. 12-2 Material Setup

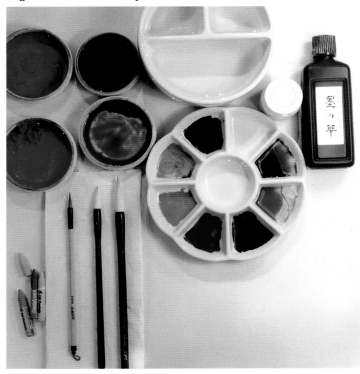

MATERIALS

See Fig.12-2 and follow the preparation steps.

Rice Paper
Cotton (draft)
Best Shuen

Brushes
Happy Dot: Details
Flow: Small areas
Large Flow: Large areas

Colors
Chinese
Vermilion
Red
Burnt Sienna

Winsor Newton
Prussian Green
Charcoal Gray
Winsor Emerald
Winsor Violet

OAS
Ink (OAS Best Bottle)

Koi
The very inexpensive Koi color tubes are available at OAS
Cobalt Blue
Yellow Ochre

Pelikan
White

Miscellaneous Materials
Oil Pastel Sticks (or Crayons)

Masking Tape

Hot Iron

See Fig. 12-3 to identify the materials.

Fig. 12-3 Material ID

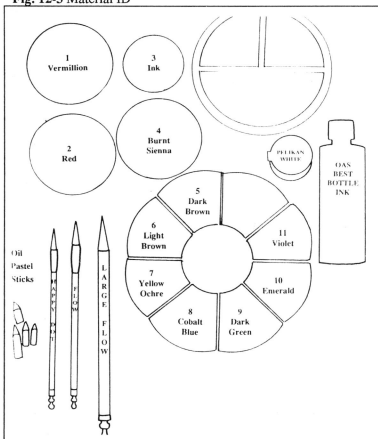

PREPARATION

Rice Paper

Cut a sheet of Cotton Paper (16" x 24") to do the draft, first with pencil. After everything is done to your satisfaction, darken the lines with black magic marker or dark Ink.

Cut Best Shuen Paper into the size of Cotton paper (16" x 24"); cover on top of the Cotton. Trace the lines with Oil Pastels (or Crayons), preferably using different light colors for different subjects.

Use two sheets of Cotton paper (the draft one and another sheet, or 2 blank ones) to sandwich the Best Shuen paper. Put all three sheets together on top of your felt.

Press the sheets with a hot iron. The Cotton paper is used to absorb the excess of the Oil Pastel. The Oil Pastel is now melted into the Best Shuen paper.

Paint on the side which has the Oil Pastel drawing. Eventually, the painting is shown from the backside.

Colors

Test prepared colors on Double Shuen to match Color Dots Chart (Fig.12-4).

Fig. 12-4 Color Dots: (On Double Shuen)

1 Vermillion		7 Yellow Ochre	
2 Red		8 Cobalt Blue	
3 Ink		9 Dark Green	
4 Burnt Sienna		10 Emerald	
5 Dark Brown		11 Violet	
6 Light Brown			

Use an inexpensive brush (like OAS Basic Hard Brush) to prepare the colors.

1. Vermillion
Wet the chips; soften the Vermillion with water but keep the color relatively strong.

2. Red
Wet the chips; keep the color strong.

3. Ink
Fresh; pour about 1 tablespoon into a saucer.

4. Burnt Sienna
Wet the chips; keep the color strong.

5. Dark Brown
Mix Vermillion and Burnt Sienna with Ink. Keep the mixture strong.

6. Light Brown
Mix Dark Brown with diluted White; keep the mixture medium.

7. Yellow Ochre
Soften the color; keep it strong.

8. Cobalt Blue
Soften the color; keep it strong.

9. Dark Green
Use 1/3 **Prussian Green** to 2/3 **Charcoal Gray**; mix with finger and develop thick, pasty dark green.

10. Emerald
Use **Winsor Emerald**, diluted to medium.

11. Violet
Mix **Vermillion** with **Winsor Violet**. Keep the mixture strong.

IDEA OF THE TEMPLE GATE

The temple bell is ringing for morning study in the monastery. The ancient gate is half-covered with snow, and the golden tip of the gate tower glistens in the purple glow.

Our master monk is climbing calmly up to the gate, with his heart filled with peaceful thoughts.

I wish this book will bring you many hours of tranquil happiness. The joy of learning and new discovery is one of the greatest gifts. I hope the fellowship we share will last for a long time to come.

This lesson opens another gate for a new approach to use the unique merits of the rice paper. The Best Shuen paper is thin; it allows all the colors to sip through. Some colors, such as Vermillion, are even brighter shown from the back side (Vermillion is a mineral color; it is heavier).

The Oil Pastel serves as a resist. It makes each element stay within the defined lines.

The Oil Pastel lines are white on the reverse side. The sensation of a winter wonderland with intriguing space divisions is breathtaking.

We will have fun with this unique gift from the Best Shuen paper. Keep this method a secret; try to let people guess how you did it.

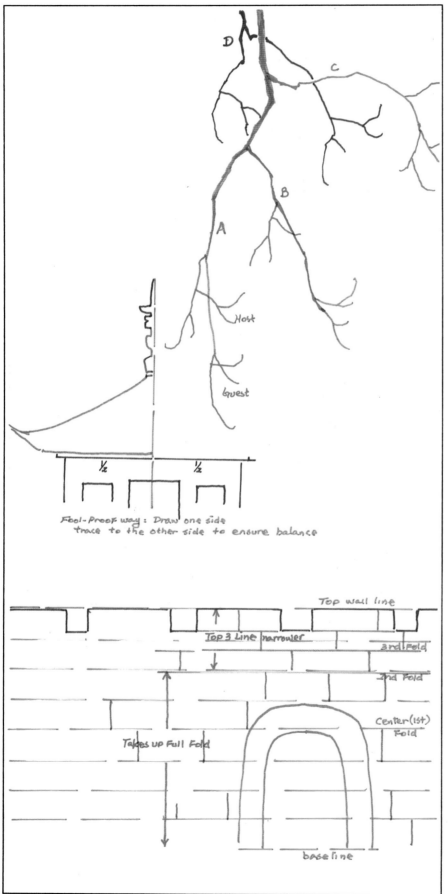

Fig. 12-5 Draft of top Branches, Wall and Gate

110 LESSON 12

DRAFT OF TEMPLE GATE

See Fig. 12-5, 6. Do a draft on Cotton paper; then trace the drawing with Oil Pastel onto the Best Shuen. The final masterpiece is the reverse image of our drawing.

Divide the draft into 8 parts (two columns, four rows). Mark along the top and both sides to guide you. Use a soft pencil to draft the front elements first, then move to the back.

Top Branches

Draw the overhanging branches off center to the right. Make the main branches on top thicker. Do not show straight lines; do them slightly curved and gnarled. Turn the twigs upward. Do not show chicken foot (branches coming out all at one point). The branches divide the sky into interesting shapes and make shading more manageable.

Begin with the longer branch (A). Swing it to the middle. Work two groups of twigs near its end; think of them as host and guest. The tip group accentuates the point, and the other crosses the main branch. Keep the twig clusters tight; leave space in between to show more in-and-out pattern. Do not line the twig tips or round them off and turn the grouping into clusters of lollipops.

Do two more main branches (B, C) along the right side of the longer branch. Add twigs. Notice the width change of the branches. Work a shorter branch (D) crossing the longer branch; add twigs.

Front Groves

There are two snow-covered bushes in the front. Draw Grove 1 from the left side below the 1/2 mark. Roll it horizontally to the middle, then turn sharply downward. The lower portion of Grove 1 is the left side of the path; do it with a soft curve. Draw Grove 2, avoiding parallel lines. Develop pockets at the lower parts of the groves. Show a few icicles, then add some branches in these pockets where the snow fails to cover.

Master Monk

A hat on our monk seems to deplete his holy grandeur. Let his bald head be exposed. Being a Kung Fu master, he is not afraid of the cold. If you see him face to face, you will see steam rising from his head. He wears a comfortable robe, with a satchel tilting across, and carries a staff. Like all distinguished men, he wears large shoes. Draw his feet big, but vary the shapes to show he is in motion.

Slope on the Right

Do the slope (4) on the right side of the path. Develop a sharp point above the lower portion of Grove 1. Run its baseline relatively parallel to the edge of Grove 1 to show the path. Widen the path as the line moves down. Draw its top line horizontally first to show the sharp tip. This treatment makes the path move inward rather than upward. Elevate the top side of the slope as it moves to the right.

Divide the slope with a flat "Y." Cut the lower part with another line.

Wall and Gate

The center section of the composition is made up of a wall (5) with a gate (6). Some of us have trouble doing horizontal lines. Fold the paper along where the top edge of the wall is supposed to be. Do the middle top line of the rampart first, then move left and right to do lines of equal intervals.

Define the baseline of the wall above the tip of Slope 4. Draw an arch gate (6) about half the height of the wall. Do the gate from the top middle point, move to both sides, and come down. Draw another arch to frame around the gate. Divide the frame into blocks of the stone pattern.

Fold the paper, matching the top wall line with the baseline. Fold three more times across. Draw the ramparts and stone patterns of the wall, following the horizontal creases. Concentrate the pattern along the branches to allow the colors of the stone (which remains white) to offset the branches, on both sides of the gate above the foreground. Leave some areas open to show snow. Add a guest group of lines on the upper left section of the wall. Divide the horizontal stripes with vertical bars.

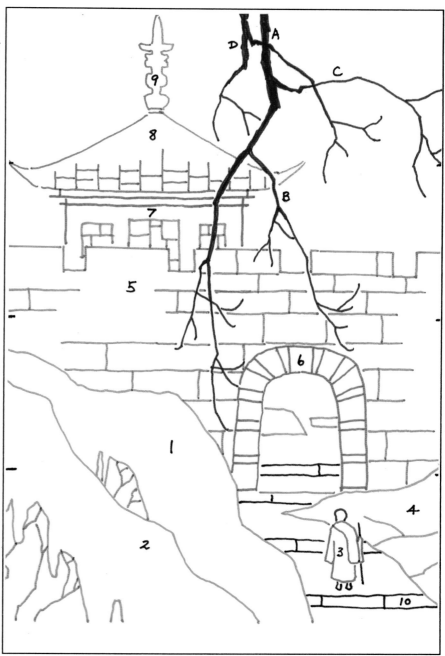

Fig. 12-6 Temple Gate, Draft Completion

Build the window section (7) of the tower. Do the vertical lines on both sides. Connect the top with a couple of narrow blocks. Draw a larger window in the middle and two smaller ones on each side. Add the dividing bars inside the window.

Extend both sides of the top of the block, and turn the ends up evenly. Find the middle point of the roof, and draw both sides of the roof from top down, showing a triangle with a flat top and tilted sides. Divide the lower part of the triangle with vertical lines; show varying height. Add tile lines across unevenly. Build an impressive top ornament with sections.

Fig. 12-7 Draft with Oil Pastel

For people who cannot balance anything, I suggest matching the two sides of the window section and folding the paper vertically to find the middle point of the roof. Do the left side of the roof, then fold the paper and trace the shape to the back of the paper. Open the paper and trace the back images to the front. You will have everything balanced.

OIL PASTEL

See Fig. 12-7.

Tape Cotton paper draft on the table. Cover it with Best Shuen Paper, and then tape the Best Shuen paper to ensure that no shifting occurs during tracing. Trace the draft with Oil Pastel onto the Best Shuen paper.

Sharpen the Oil Pastel stick. Use sharpeners with a large opening. Since Oil Pastel is very soft, it may be hard to sharpen it to a fine point.

Use light-colored Oil Pastels; it does not matter what colors (they shall all be clear on the final painting) as long as you can see the lines clearly. Light colors give us a more accurate image of what the spaces will look like in our final painting. Use different colors on different subjects to avoid confusion during the coloring.

Warning: Do not draw the branches in the lower grove areas and the rocks inside the gate with the Oil Pastel. They are done with Watercolors later.

Pay attention to the small areas: Head of the monk, top ornament, window divisions, and stone crevices. It is the inside areas encircled by lines that need to keep open for coloring.

Taper the tile lines on the roof and wall to ease the lines into the space.

These Oil Pastel lines work as a resist to define shapes; it is important to connect the lines and seal off gaps to ensure that colors of one shape do not run into another.

Once the Oil Pastel lines are completed on the Best Shuen paper, remove the tapes. Use two sheets of Cotton paper to sandwich the Oil Pastel drawing on Best Shuen paper. Press the paper with hot iron on your felt. The Cotton paper absorbs the access of the Oil Pastel. The Oil Pastel is now melted into the Best Shuen paper.

The real fun part of this painting is about to take place.

COLORING

Place the Best shuen on your felt, with the Oil Pastel drawing facing upward.

We can begin coloring from anywhere in this composition. The sequence here is done for the sake of teaching clarity. It is best to color the nearby elements together, and to carry one color into another to get a more integrated spirit. Try this approach on your own sometime.

See Fig. 12-8.

Details

Use the Flow Brush. Wet the tip of the brush, and load each color several times. Begin by loading 1/4 length of the bristle with a medium tone; blend the tip. Then, load 1/8 with a thick tone, blend the tip. It is best to show some variation within each color and shape.

Master Monk
Head: 1/4 Ochre + 1/8 Burnt Sienna.
Sack: Vermillion,
Robe: Cobalt Blue.
Shoes: Dark Brown.

Gate
Mix Vermillion + Red, for larger shapes. Use Dark Brown to color the crevices.

Steps
Dark Brown.

Windows
Use Ochre, Cobalt Blue, and Emerald. Color sections of the window by alternating these colors.

Eave
Do the lower bar with Cobalt Blue. Do three blocks of Red on the top bar, and fill the rest of the areas with Ink.

Tower Tip
Use Ochre and add Dark Brown for the shadow strips.

Grove Branches
Do a few branches; thread them through the snow openings of the groves on the lower left side.

Rocks
Use medium Violet; do a couple of shapes inside the gate to show the rock formation in the temple garden. Keep their baseline horizontal.

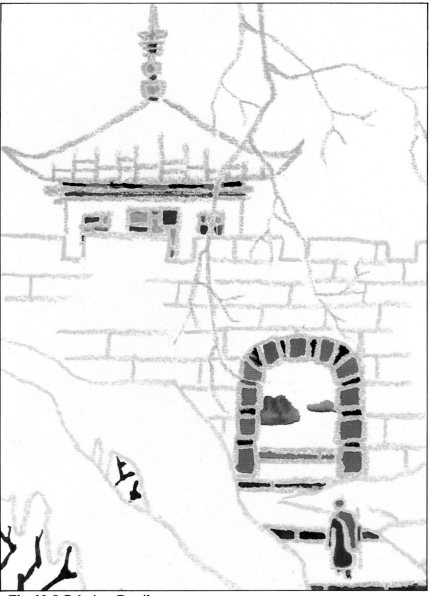

Fig. 12-8 Coloring: Details

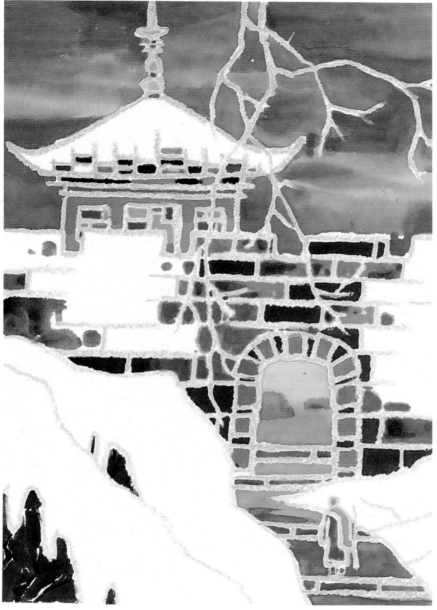

Fig. 12-9 Coloring the Large Areas

Larger Shapes
See Fig. 12-9.

Window Wall
Use the Flow Brush. Color the lower sections between the windows with Vermillion; then add Red to color the top section.

Roof
Use the Flow Brush. Color the lower tiles. Load Dark Brown, develop a host area in the middle, and spread to both sides. Add a few Burnt Sienna tiles in between. Make the tile columns uneven. Leave some unpainted to keep the top space (snow) company.

Gate Wall
Color the areas near the branches, on both sides of the gate and above the snow-covered groves. Work the Dark Brown blocks first. Then load 1/4 Burnt Sienna + 1/8 Dark Brown to connect and expand the shapes with uneven edges. Add a few blobs extending along the perimeter of the colored blocks. These blobs or dots provide an exciting addition, like islands off shore, as if saying "To be continued..." They break the monotony of the spaces and integrate the spaces with the shapes.

Grove Pockets
Use the Flow Brush; add Dark Green between the grove branches and seal the pockets below the snow.

Sky
The structure and branches have divided the sky into smaller areas. Work one area at a time as long as you can, and carry the same color into another area. Work horizontal strokes, overlapping them to extend the coverage.

Bring Violet and Vermillion to separate dishes; dilute the colors to a medium tone. Work a couple of Vermillion strips above the roof, and on the lower right area of the sky. Do the rest of this area with violet. Stronger violet is applied to the top of the sky and areas above the roof and wall.

Path
Use the Flow Brush. Color the blocks below the figure with Violet. Change to Vermillion and color the blocks above the figure.

Inside the gate, use light Violet at the base, and fade to light Vermillion on top.

Integrating the Shapes and Spaces
See Fig. 12-9.

It is always a primary objective for us to marry the painted shapes with the spaces. We do it by fading the shapes, by breaking the solid masses into smaller islands, and by shading the spaces.

Send Happy Dots
The dots are Ambassadors of Good Will from shapes to the space: The cavalry officer who behaves like "Dances with Wolves."

Use the Flow Brush, load Light Brown, and extend more dots into the spaces on the roof and the wall. These dots relate to the painted shapes, like islands to a continent. Make sure they accentuate the variation of the existing shapes; for instance, elongating a peninsula, rather than filling a gulf. To make the shape more interesting, do not turn it into a monotonous edge. The dots also help to add interest in the space. It is important to cluster the dots, not to scatter them all over the space. Prominent spaces will remain open.

Shading the Snow
Use the Flow Brush, load 1/4 light Violet + 1/6 medium Violet, and shade the lower portion of the snow areas.

Pointing the tip down or sideways to the left, work spontaneous strokes to shade the lower portions of the snow areas on the groves and the slope. Use lighter Violet to shade portions of the snow areas on the wall and roof. Allow the colors to fade into the spaces. Arrange the shades into clusters, showing host and guest.

The Masterpiece is on the Backside
I do not have to tell you to turn the paper over now; you must have done it a hundred of times already. Is this wonderful? Explore the possibilities. You can only enjoy this experience through the Best Shuen Rice Paper.

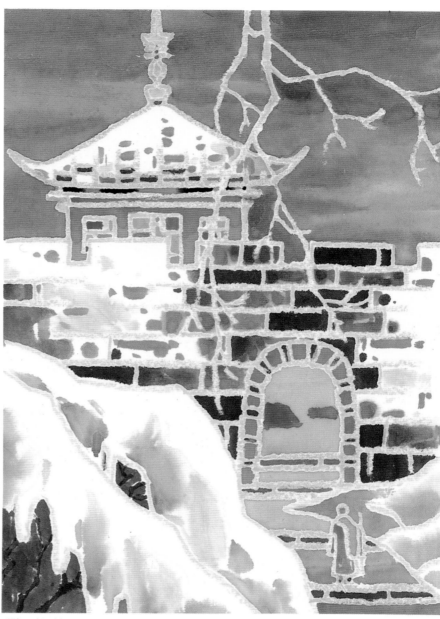

Fig. 12-10 Integrating the Shapes and the Spaces

Books and Publications by Ning Yeh:

An Album of Chinese Brush Painting:
80 Paintings and Ideas

This hardcover album contains 80 full-color, full page, compositions of Ning Yeh. Each painting lists all the colors, brushes, and paper used.

Accompanying each of the beautiful original paintings is a story. The tales reveal the spiritual background of the subjects, legends and romances, and artistic observation and experiences of the artist. They are shared with a casual, humorous, earnest, and intimate style which touches everyone in a special way. To this day, the Album is still the pride and joy of the artist. It is indeed one of the most beautiful, enjoyable, and inspirational works of art--both painting and writing.

Chinese Brush Painting:
An Instructional Guide

A complete, step-by-step instruction book (now in 6th edition), this guide is designed to lead a beginner from holding the brush to finishing floral, animal, and landscape compositions.

The subjects include Grass Orchid, Bamboo, Panda, Camellia, Amaryllis, Peony, Horse, Landscape, Signature and Seals, and Chinese Mounting Technique.

This book has 20 lessons; each is accompanied by a half-hour instructional video which is available at OAS. The entire TV video program won the Emmy Award as the Best Instructional TV Series (1988).

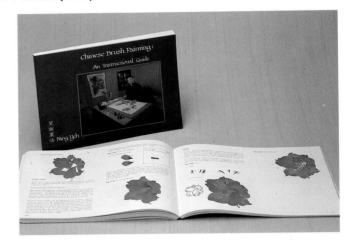

The Art of Chinese Brush Painting

This is Ning Yeh's first art album, published in 1981. The original plates of the book have been destroyed. It is an out-of-print hard cover book with very limited copies left. Seventy-two finished paintings are included in this album. The book includes discussion of philosophy, basic subjects, and seals.

Ning Yeh's Workshop Series 1

The 12 lessons of this series share the same format like this book. Instead of in one book, the lessons come in 12 separate booklets, each with color illustrations concentrating on one whole sheet. The series is composed of 7 landscape subjects, 1 horse, 1 figure, and 3 floral (Rose, Canna, and Iris--which is also included in this book).

LESSON 13
SAIL HARBOR
Rubbing Technique

ART WORK

Fig. 13-1 Sail Harbor

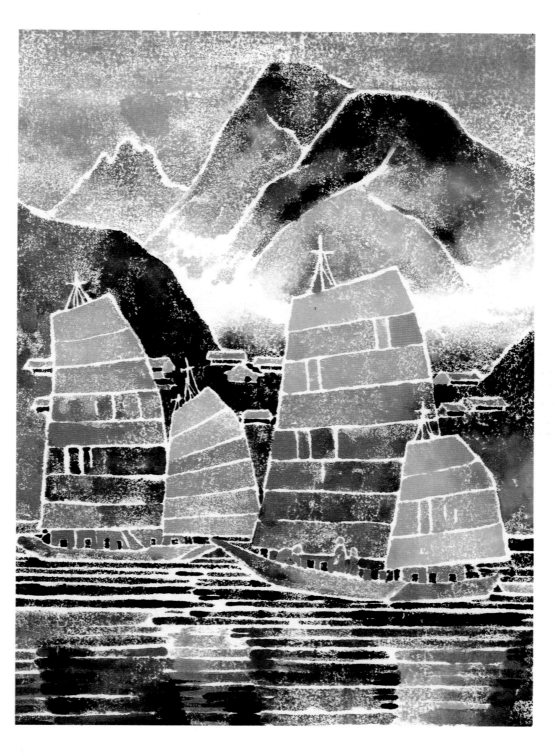

Fig. 13-2 Material Setup

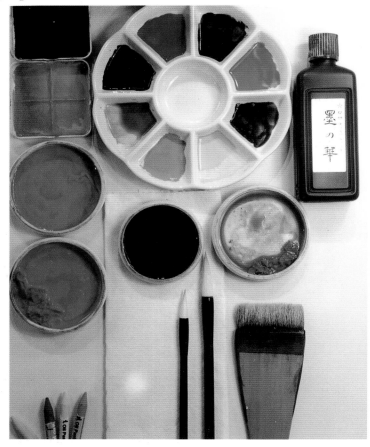

MATERIALS

See Fig. 13-2 and follow the preparation steps.

Rice Paper
Cotton, 2 sheets; use it to draft and as a cover during the rubbing.
Glass and **Rub**; paint on Glass and rub onto Rub.

Brushes
Happy Dot: Details
Flow: Small areas
Large Flow: Large areas

Colors
Chinese
Vermillion
Red
Burnt Sienna

Winsor Newton
Prussian Green
Charcoal Gray
Winsor Emerald

OAS
Ink (OAS Best Bottle)

Fig. 13-3 Material ID

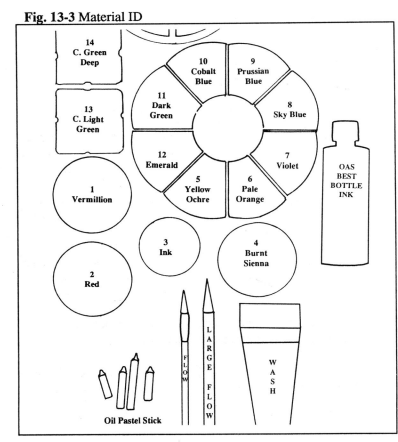

Koi
The very inexpensive Koi color tubes are available at OAS
Chrome Light Green
Chrome Green Deep or **Viridian**
Violet
Cobalt Blue
Yellow Ochre
Sky Blue
Prussian Blue
Pale Orange

Miscellaneous
Oil Pastel Sticks (Crayons)

Masking Tape

Hot Iron

See Fig. 13-3 to identify the materials.

PREPARATION

Rice Paper

Cut a sheet of Cotton Paper (16" x 23") to do the draft, first with pencil. After everything is done to your satisfaction, darken the lines with black magic marker or dark Ink.

Cut the Glass Paper into the size of the Cotton paper (16" x 23"); lay it on top of the Cotton. Trace the lines with Oil Pastel, preferably using different light colors for different subjects.

Use two sheets of Cotton paper (the draft one and another sheet, or 2 blank ones) to sandwich the Glass paper. Put all three sheets together on top of your felt. Press the sheets with a hot iron. The Cotton paper is used to absorb the excess of the Oil Pastel. The Oil Pastel is now melted into the Glass paper.

Tape the glass paper onto your painting table with masking tape (do not use felt, so the paper can be taped flat); both the top and the base of the paper should be taped.

Cover the Glass Paper with the Rub Paper, with all four sides of the Rub extending beyond the edge of the Glass a little.

Tape one side of the Rub paper. Cover the Rub with another Cotton paper, then tape the Cotton the same way as the Rub paper.

Colors

Test prepared colors on Double Shuen to match Color Dots Chart (Fig.13-4).

Fig. 13-4 Color Dots: (On Double Shuen)

1 Vermillion		8 Sky Blue	
2 Red		9 Prussian Blue	
3 Ink		10 Cobalt Blue	
4 Burnt Sienna		11 Dark Green	
5 Yellow Ochre		12 Emerald	
6 Pale Orange		13 C.Light Green	
7 Violet		14 C. Green Deep	

Use an inexpensive brush (like OAS Basic Hard Brush) to prepare the colors.

1. Vermillion
Wet the chips; soften the Vermillion with water but keep the color relatively strong.

2. Red
Wet the chips; keep the color strong.

3. Ink
Fresh; pour about 1 tablespoon into a saucer.

4. Burnt Sienna
Wet the chips; keep the color strong.

5. Yellow Ochre
Soften the color; keep it strong.

6. Pale Orange
Soften the color; keep it strong.

7. Violet
Mix **Vermillion** with **Violet**. Keep the mixture strong.

8. Sky Blue
Soften the color; keep it strong.

9. Prussian Blue
Soften the color; keep it strong.

10. Cobalt Blue
Soften the color; keep it strong.

11. Dark Green
Use 1/3 **Prussian Green** to 2/3 **Charcoal Gray**, mix with your finger and develop thick, pasty dark green.

12. Emerald
Winsor Emerald diluted to medium; add a little Dark Green.

13. Chrome Light Green
Soften the color; keep it strong.

14. Chrome Green Deep
Soften the color; keep it strong.

IDEA OF THE SAIL HARBOR

"Red Sails in the Sunset," "I Saw the Harbor Light...." This is a fascinating project. Every stage is full of wonderful delight. The method is fool-proof, with different results for each artist.

The Glass paper is non-absorbent; it also does not wrinkle or buckle easily. It is a dream to use as a printing plate. Colors will stay wet on this paper.

The Oil Pastel serves as a resist. It makes each element stay within the defined lines. It gives a beautiful quality similar to wood carving, yet, it is so much easier than carving wood.

The Rub Paper is very absorbent. It stays smooth. Because of the rubbing, the scenery appears naturally misty.

This is the last lesson of this book. I hope everyone has had a bountiful journey and is ready to set sail on a new journey.

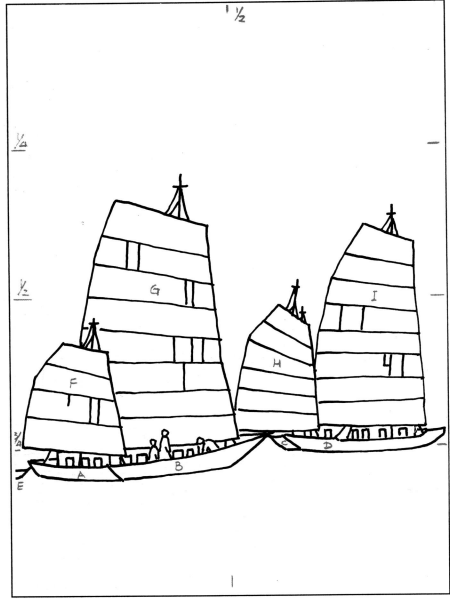

Fig. 13-5 Draft of Sail Harbor

DRAFT OF SAIL HARBOR

See Fig. 13-5. The final Masterpiece is the reversed image of our drawing. This drawing is the most important part of the painting.

Use a soft pencil to draft on a sheet of Cotton Paper; use a soft eraser (like Pedigree) so it does not damage the paper. Fold the Cotton Paper into eight parts, two columns, four rows.

1. Boat Body: There are two large sail boats and a small boat. Do the left large boat first; it is closest to us. Draw Shape A with its top side below the 3/4 mark of the paper. Make its right side slightly lower. Do Shape B. Do the boat on the right (C, D). Make the base line level and above the 3/4 mark. Add Shape E for the small boat.

2. Figures: Three people are on the deck of the left sail boat (1, 2, 3). Draw their heads like upside down eggs, and show their upper body.

3. Sails: Do the outline of the four sails (F, G, H, I). Make the right side of the sails more vertical. The left sides arch more.

Do Sail F first. Leave some room below for the cabin. Overlap Sail G with Sail F and make the base line a little higher. Do Sail H, make its right side end behind Sail G, and open the deep "V" space between the two sails. Make Sail I not as wide as Sail G; overlap it with Sail H and leave a narrow but deep space between the sails. End Sail I a little higher than Sail H.

Add Masts on the top right of each sail. Tilt the masts of the small sails more. Add one mast above Sail H to show more boats behind sails.

Lead two to three lines from the top of the masts; show the continuation of these lines below the sails.

Divide each sail with horizontal lines. To divide the sails evenly, mark the middle point of both sides of the sail, and draw the line. Mark middle point (or 1/3 point; such is the case for Sail H) of both side lines of each half, connect the points with lines. Do a few vertical lines to add interest.

4. Cabins: Do vertical lines to define the cabins of each boat. Add blocks to show windows.

*Add lines to complete the inside dimension of the boat body. These lines can be easily ignored. Do pay attention to them.

Draft (Continued): see Fig. 13-6.

5. Houses: Do clusters of houses along the 1/2 line. Show them along the edges of the sails to add interest to the monotonous sail lines. Make sure the roof and baseline run horizontally. The wall is vertical and short. Oriental houses have more extended eaves; extend the roof beyond the walls.

6. Foothills: Do a shoreline above the 3/4 mark; thread it across the sails horizontally (fold the paper is a good idea). Do the slopes to show a valley. The left foothill (1) is lower and the right (2) higher.

7. Mist Layer: Do a dotted line to show where the mist is in the valley.

8. High Mountains: Do Mountain 3 from the top peak down. Make the right side more vertical and ending lower, the left side more horizontal and ending higher. Use a dotted line at both ends (Use dotted line to serve as a reminder for tapering and fading). Add two even lines to show the nose (4) of the mountain. Taper the lines on both ends, making the nose lines end lower than the shoulder line of the mountain. The nose is the middle ridge of the mountain which comes forward. It is brighter and closer to us. Do Mountain 5, and show its nose (6). Further mountains show higher roots.

9. Distant Mountain: Do Mountain 7; show three uneven peaks. Add its nose (8).

10. Sky: Dotted lines show patches of colors.

11. Water: To ensure the lines in the water run horizontally, we can fold the lower 1/4 of the paper horizontally a few times to guide us.

Extend a few lines from the base of the boats to anchor them. Work the lines in clusters. Show their ends in and out (do not line them up), and with different intervals.

Below the lines near the boats, do four groups of lines to show the mirror image of the sails. We can fold the paper along the baseline of the left boat and trace the sail on the back of the paper. Do the same along the baseline of the right boat for the other two sails. Then, work the cluster of lines guided by the traced line from the back.

After the pencil draft, darken the lines with dark ink or a dark marker.

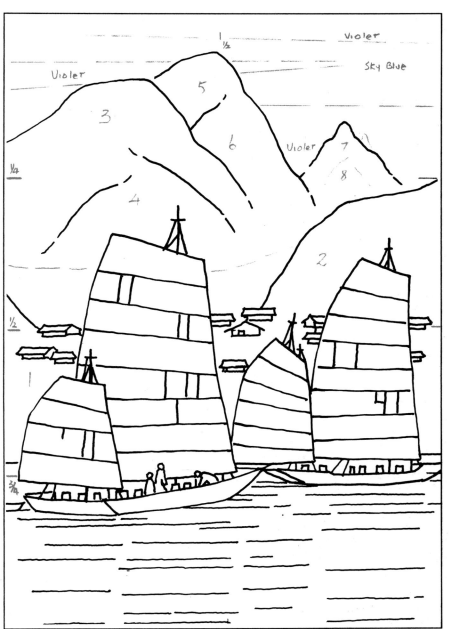

Fig. 13-6 Sail Harbor, Draft Completion

Fig. 13-7 Draft with Oil Pastel

OIL PASTEL ON GLASS

See Fig. 13-7.

Tape the Cotton paper draft on the table. Cover it with the Glass Paper; then tape the Glass paper to ensure that no shifting occurs during tracing. Trace the draft with Oil Pastel or Crayon onto the Glass paper.

Sharpen the Oil Pastel or the Crayon stick. Use sharpeners with a large opening. Be gentle; Oil Pastel is very soft. It may be hard to sharpen it to a fine point, but do the best you can.

Use light-colored Oil Pastels; it does not matter what colors (they shall all be clear on the final painting) as long as you can see the lines clearly. Light colors give us a more accurate image of what the spaces will look like in our final painting.

Use different colors on different subjects to avoid confusion during the coloring.

Pay attention to the small areas: Heads of the figures, lines below the masts, houses, cabin windows. It is the inside area encircled by lines that you need to keep open for coloring.

Taper the lines of the root and nose of the mountain, as well as the lines in the water (lifting pressure on both ends). Do not use dotted lines like the draft. The dotted lines are on the draft to remind us to fade the ends.

On the draft are dotted lines for the mist layer and the sky. Please do not add these dotted lines with Oil Pastel. We may have to do flocks of white geese if you do that.

These Oil Pastel lines work as a resist to define shapes; it is important to connect the lines and seal off gaps to ensure that colors of one shape do not run into another.

Once the Oil Pastel lines are completed on the Glass paper, remove the tape from both the Cotton and the Glass paper. Use two sheets of Cotton paper (the draft one and another sheet, or 2 blank ones) to sandwich the Glass paper. Put all three sheets together on top of your felt. Press the papers with a hot iron. The Cotton paper is used to absorb the excess of the Oil Pastel. The Oil Pastel is now melted into the Glass paper.

As in Lesson 12, the real fun part of this painting is about to take place.

TAPE YOUR PAPER

See Fig. 13-8.

Tape both the top and the base of the glass paper (Oil Pastel Draft) onto your table (do not use felt, so the paper can be taped flat).

Cover the Glass Paper with Rub Paper, with all four sides of the Rub extending beyond the edge of Glass a little. Tape one side of the Rub paper. In class, I ask students to tape the top side to save space. If the table is large, tape the side opposite to where you put your equipment. It is better to tape the side line rather than the top line. You will see the rubbing progress better this way.

Cover the Rub with another Cotton paper; then tape the Cotton on the same side as the Rub paper. The Cotton is used to add body to the Rub paper; it also prevents smearing when you rub.

COLORING & RUBBING

Paint on Glass paper, while the colors are still wet; cover the Glass with Rub paper (along with the Cotton) and rub the painted part by hand to allow the Rub paper to absorb the image.

Work one portion at a time. For instance, color the heads of the figures, rub; color their cloth, rub... Coat each element with a thin layer of color. Do not allow colors to build a puddle inside a shape, they will go beyond the borders when you rub. If the colors get too wet, dry the brush, and use the dry bristles to pick the color up. Use dry bristles to blend the different colors, to make the transition from one color to another smooth. If it is too dry, or if you'd like to add a different color, you can always color and rub the same area several times to get the desired result.

Use Fig. 13-6 as reference.

Boats, Figures, and Cabins

See Fig. 13-9. Use Happy Dot or Flow Brush.

Boats

Color Shape A with Ochre on the right, B. Sienna on the left; add Ink along the base. Color Shape B with Ochre on the left, B. Sienna on the right, and Ink along the base. Color Shape C with Orchard and B. Sienna. Treat Shape D same as Shape A. Color Shape E with Ochre.

Figures

Head---Ochre with B. Sienna; Cloth---Cobalt (1, 2) and Violet (3).

Cabins

Red and Voilet, with Ink inside windows and in shaded area.

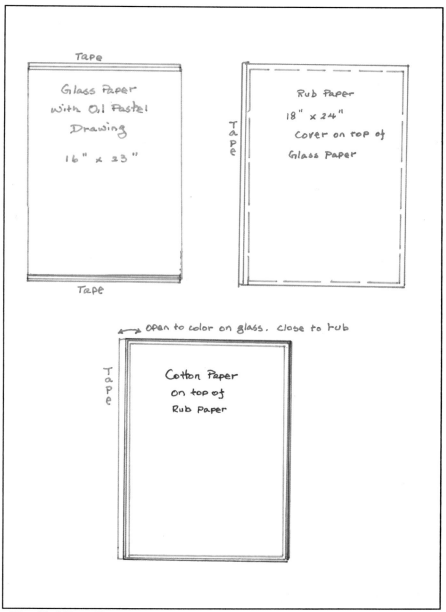

Fig. 13-8 Tape Your Paper
Fig. 13-9 Boats, Figures and Cabins

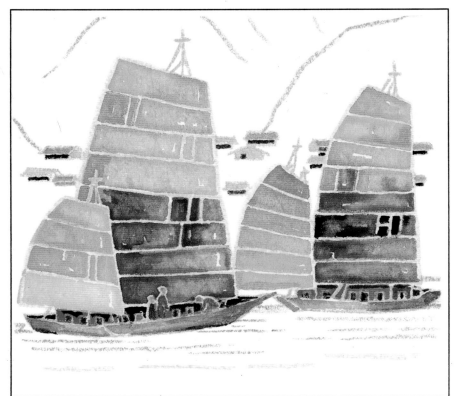

Fig. 13-10 Coloring of Sails and Houses (on Glass Paper)

Fig. 13-11 Coloring of Foothills and Water (on Glass Paper)

Sails and Houses

See Page 124 for coloring on Glass paper (the coloring is shown after the rubbing; your colors should be more vivid than the colors on Fig. 13-10 or 11. They resemble a girl's face after spending a night with Count Dracula). Page 125 (Fig. 13-12, 13) shows the Rubbing results; I am sorry to say that in this case, we really need to keep our Count happy.

Sails

See Fig. 13-10, 12. Use the Flow Brush.

For best results, color one section of the sail and rub that section right away. If one section involves several colors, do one color from one end, the other from opposite end. Use a brush with less moisture to blend the colors in the middle. Accent the colors by repeating some areas with more intense colors while the first coating is still wet. Examine the surface of the painted area from an angle. You can tell whether the surface is wet or if it needs a little more moisture or color. Again, if the rubbing is too dry or light, we can color and rub again. Avoid getting too wet.

Begin from the left side. Do Sail F with Pale Orange, and add some Vermillion in the top sections. Do the top sections of Sail G with Pale Orange and Vermillion. Do the mast area with a separate rubbing; carve around the mast and the lines with care.

Do the lower sections of Sail G with Violet and B. Sienna. Use more Violet along the edge of Sail F to show shadows and accentuate the contrast.

Work the top sections of Sail H with Pale Orange and Vermillion; add some Red for the middle sections and Pale Orange alone in the lower sections.

Use Pale Orange with Vermillion to do the top sections of Sail I. Use Violet and B. Sienna for the lower sections. Add some ink in the middle area of the sail.

Houses

See Fig. 13-11, 13.

Use the Happy Dot or the Flow Brush.

Use Ochre, B. Sienna, and Ink to color the houses.

Foothills and Waters

Foothills

See Fig. 13-11, 13. Use the Large Flow or Flow Brush for larger areas, and Flow or Happy Dot Brush for small areas.

A larger area may require several times of coloring and rubbing. It is important not to show hard edges between the phases. If you color only a portion of a mountain, dilute the unfinished edge until it fades clear. Caution: Use less moisture; let the edge fade dry, rather than having wet marks.

We can divide the foothills into several sections: Left Side---Area left of the sails: Use Emerald at the base, Chrome Green Deep in the middle, and Dark Green on top of the mountain and below the houses.

Center Area---For the two deep "V"s on both sides of Sail H, use Dark Green. Add some Ink below the houses, and in and around the mast lines. Do several rubbings. Do the "V" between sail G and H, then the area below the houses. Do each mast with one separate coloring and rubbing.

Seal the rest of the area and fade the colors upward toward the top of Mountain 2.

Right Side---top of Mountain 2 and right edge. Treat the area in and around the mast with a special effort. Doesn't it look great when the mast comes out just the way you wanted?

Color the mountain top with Dark Green. Rinse the brush, load Chrome Green Deep for the middle section and Emerald for the lower section. See Fig. 13-11, 13.

Water by the Boats

See Fig. 13-11, 13.

Use the Flow Brush, load Dark Green with Ink, and do horizontal strips along the sides and below the boats. Let the strips end unevenly to show the variation of ripples in the water. Change to Chrome Green Deep, then light Emerald, as the lines come downward.

Use Dark Green below the mountains; also, seal the areas between the sails and the boat bodies with Dark Green.

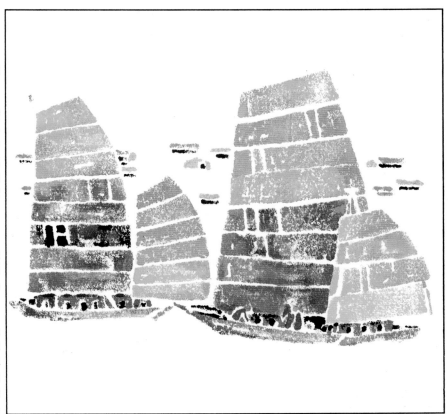

Fig. 13-12 Rubbing of Sails and Houses

Fig. 13-13 Rubbing of Foothills and Water

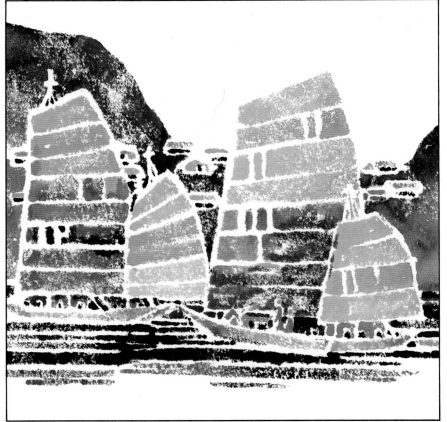

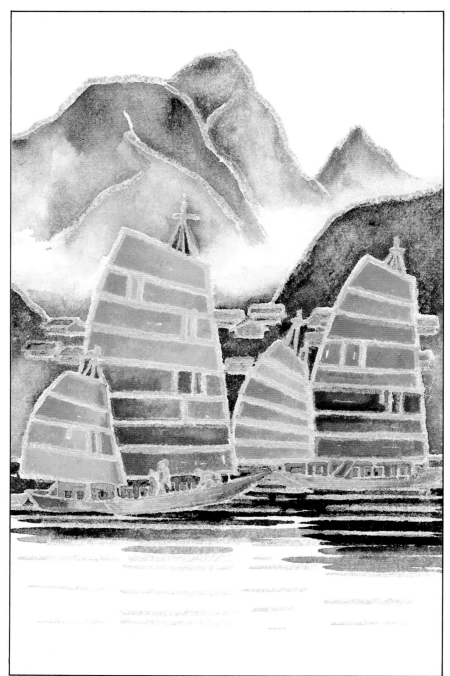

Fig. 13-14 Coloring Mist and High Mountains on Glass Paper

Mist, High and Distant Mountains

See Fig. 13-14 for coloring clues, and Fig 13-15 for the rubbing results.

Mist Layer

Value this strip of space, for it is the breathing room for the whole painting.

Color the lower half of the space left for mist with Dark Green (base), Chrome Green Deep (middle), and Light Chrome Green (top). Keep the top half of the space clear.

Use the Flow brush. Load 1/3 Chrome Green Deep, add 1/4 Dark Green at the tip. Pointing the brush tip toward yourself, move it sideways, coloring the base of the valley above the houses.

Rinse the brush; load 1/4 Light Chrome Green to go above the dark colors. Clean the brush, keeping the moisture dry; use the "dry" moisture to fade the top edge of the colors until it fades clear. Cover and rub.

High Mountains

Mast Area

Using the Happy Dot Brush, load Chrome Green Deep; go in and around the line area of the tall mast. As the color moves away from the mast, add Chrome Light Green; fade the edges.

Nose 4

Use the Flow or Large Flow Brush. Color the shape with Chrome Light Green. Move the strokes from the middle portion of both sides. fade the color as you move up into the top area of the mountain. Fade the color with "dry" clear moisture as you move down to the mist layer. Add Chrome Green Deep along the top edge of the sail and both sides of the nose along the ridge. Cover and rub.

Mountain 3

Use Chrome Green Deep on the top side; as the color moves down, clear the brush, add Emerald, and fade the color as it reaches the mist layer. Add Dark Green to the peak of the mountain and the areas above the ridgeline of noses. Make sure the Dark Green blends into other colors smoothly (by fading its edge). Cover and rub.

Mountain 5 and Nose 6

Use Cobalt Blue on Mountain 5 and both sides of Nose 6. Use Chrome Light Green in the center area of Nose 6. Fade the color with "dry" clear moisture when moving down to the mist layer. Add Dark Green on the peak, above the ridge and on both sides of Nose 6. Cover and rub.

Distant Mountains

Use the Flow Brush. Load Voilet to do Mountain 7 from the peaks downward. Add a little Cobalt Blue for the nose (8). Fade the colors as they move down.

Sky and Water

See Fig. 13-16 for the coloring on Glass Paper. See Fig. 13-1 for the finished rubbing.

Sky

Use the Large Flow Brush. Work Violet in the upper right corner, and the middle left strip across the tall peak of the mountain. Use Sky Blue to fill the remaining area of the sky. Mix Violet with Sky Blue; color the lower area of the sky near the mountains.

Water

Work the water area with horizontal strokes. Besides the Oil Pastel strips, we can keep additional strips of spaces open between the strokes. End the strokes unevenly. Make the ends squared, or extend the ends into points.

Study the space left between the strokes. Trim it down to a fine hairline. Or show a zig-zag pattern.

Use the Flow Brush. Color the reflections of the sails. Use Vermillion for the two smaller sails, Violet and B. Sienna for the two larger sails. Do each sail with several rubbings. Make lines end unevenly. Occasionally, add Chrome Green Deep on Vermillion, and Prussian Blue on Violet while the colors are still wet (or add the colors after the first colors are dried with another rubbing).

Work the remaining spaces on both sides with horizontal strokes of Chrome Green Deep, as the strokes move down, add Prussian Blue.

Do the gaps in between sails with a mixture of Chrome Green Deep and Prussian Blue. Add some strips of Ink.

The masterpiece is completed.

The potential of using Glass Paper with Rub Paper is endless; When you can control the moisture, you do not need to draw lines with Oil Pastel. Develop your draft in Ink, and place the draft under the Glass paper. When you develop shapes, just keep a hairline space between the shapes where the draft line is. You can achieve wonderful results. Fig. 13-16 is done this way.

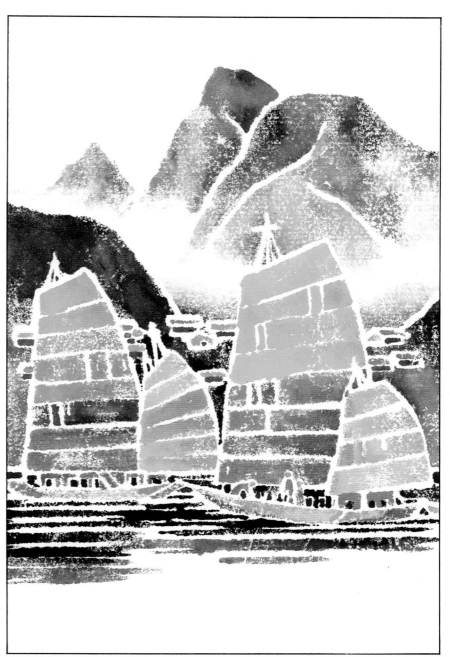

Fig. 13-15 Mist and High Mountains on Rub Paper

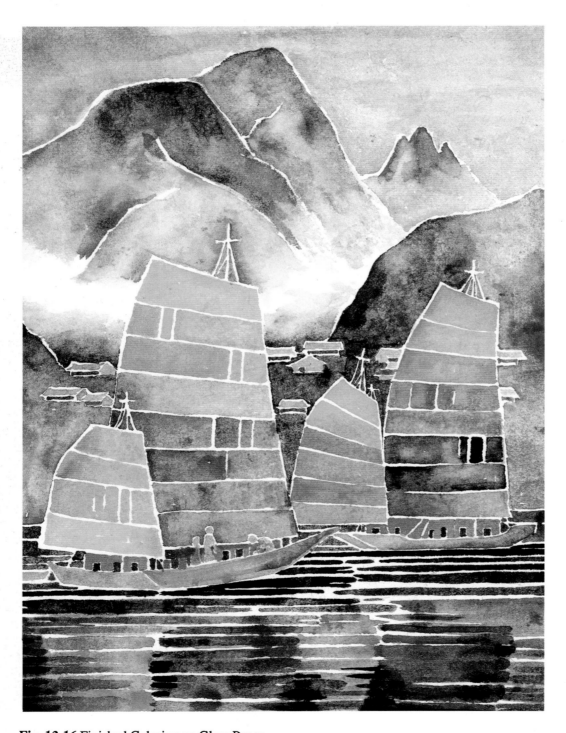

Fig. 13-16 Finished Coloring on Glass Paper

About Ning Yeh

Ning Yeh was born in Mainland China in 1946. He was given the name Ning, meaning tranquility, to celebrate the end of the war. The Yeh family has been famed in the field of brush painting for four generations. His father, a general in the Chinese army, is renowned for his horse painting.

Ning Yeh's art training started when he was seven, after the family moved to Taiwan in 1949. His daily practice included the Four Gentlemen (plum, orchid, bamboo and mum) and calligraphy. At the age of fifteen, the focus of his training turned to horse painting, his family tradition. He proceeded with floral and landscape paintings and gradually developed his own style.

In 1969, the United States Deputy Secretary of State invited the young artist to come to the United States for an exhibition tour. Ning Yeh accepted scholarships offered by the California State Universities and by the Pearl McManus Foundation and subsequently received his Ph.D. degree with honors at Claremont Graduate School.

In the past twenty years, Ning Yeh's artistic efforts have generated an unprecedented response. His demonstrations, classes and exhibitions are in constant demand, and a large, sophisticated audience follows his work. A new generation of American artists and teachers of Chinese brush painting exists because of his teaching.

In 1981, Ning and his wife, Lingchi, founded the American Artists of Chinese Brush Painting (AACBP). This non-profit organization is open to all people interested in Chinese brush painting.

Along with their family and friends, Ning and Lingchi established OAS, Inc. (Oriental Art Supply). Over the past fifteen years, Ning Yeh's OAS has developed an impeccable reputation as supplier of the finest materials for Chinese brush painting through direct mail. The OAS Showroom in Huntington Beach, California is visited by art lovers all over the world.

In 1987, Ning Yeh became the first Chinese brush artist to air an instructional television series in the United States. The series of 20 half-hour programs, "Chinese Brush Painting with Ning Yeh," won the 1988 Emmy award for Best Instructional Series. It was also awarded the prestigious CINE Golden Eagle award for excellence to represent the United States and American cinematography in international festivals. He was given the National Teaching Excellence Award given by the University of Texas Study in 1989.

Ning Yeh is the author of the following books:

An Album of Chinese Painting: 80 Paintings and Ideas **Chinese Brush Painting: An Instructional Guide**

The Art of Chinese Brush Painting **Ning Yeh's Workshop Series 1**

A. B. C. of Chinese Painting: Book 1

Ning Yeh has two children. His son, Evan, is 21. He is a senior at University of California at Berkeley. His daughter, Jashin, is 5. She attends Edison High School.

Ning Yeh is a full-time art professor of Chinese Brush Painting at Coastline College in Fountain Valley, California. He has developed the most comprehensive brush painting program in Southern California.

Ning Yeh conducts a Summer Workshop Series at OAS in Huntington Beach. This hands-on Workshop Series is held in July each year. It attracts artists from all over the country. In addition, Ning Yeh conducts workshops throughout the United States.

Ning Yeh loves to travel. He organizes trips to the Orient every year.

For further information, please contact:

OAS P.O. Box 6596, Huntington Beach, Ca. 92615
Tel. (714) 962-5189 (714) 969-4470 1-800-969-4471